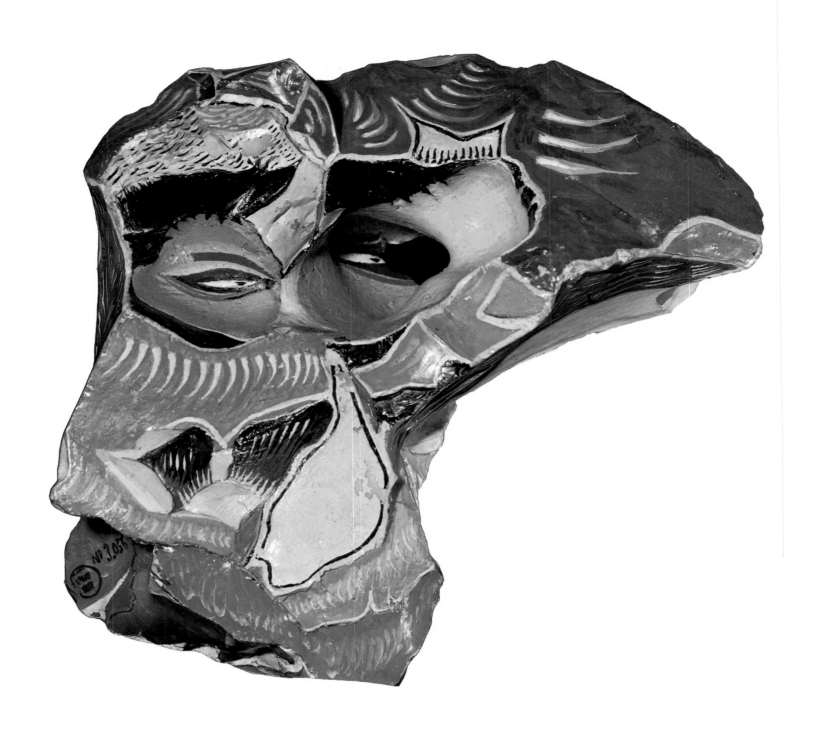

Text by Michel Thévoz—Foreword by

ART BRUT

ART BRUT

Jean Dubuffet

SKIRA

RIZZOLI
NEW YORK

On the title page:

Head by Charles Paris (born 1901).

Painted and varnished stone, 1968.

Published in the United States of America in 1976 by

Rizzoli INTERNATIONAL PUBLICATIONS, INC.
712 Fifth Avenue/New York 10019

© 1976 by Editions d'Art Albert Skira, Geneva

Translated from the French by James Emmons

Library of Congress Catalog Card Number: 76-12314
ISBN: 0-8478-0046-6

Printed in Switzerland

CONTENTS

FOREWORD

The consideration given to the work of professional artists has had the effect of conditioning the public, of creating a state of mind which makes it responsive only to the art displayed in museums and galleries or to art that depends on the same frame of reference, the same means of expression. Any works which, out of ignorance or obstinacy, depart from the accepted codes are given no more than a passing or condescending glance; or, at best, they are granted the status of a marginal art. Yet it may be that this is a misguided view. It may be that artistic creation, with all that it calls for in the way of free inventiveness, takes place at a higher pitch of tension in the nameless crowd of ordinary people than in the circles that think they have the monopoly of it. It may even be that art thrives in its healthiest form among these ordinary people, because practised without applause or profit, for the maker's own delight; and that the over-publicized activity of professionals produces merely a specious form of art, all too often watered down and doctored. If this were so, it is rather cultural art that should be described as marginal.

If the habitués of cultural art are willing to make the effort needed to get away from the art forms usually offered them, to break off the conditioning they have been exposed to and adjust their eyes to other ways of seeing and shaping, they will find in these works a liberation from constraint, an upsurge of innovation and resourcefulness, a breakthrough into unsuspected worlds that will make them think twice about the so-called "primitive" character of these works, as the pontiffs of the constituted art forms would have us regard it.

Though some have tried to find one, no common definition will fit these works, for they answer to endlessly different mental positions and keys of transcription, each of these being invented by the maker for his own purposes of the moment, so that the only common feature of such works is that they run on different lines from those of museum art. They do not meet us half-way, as the latter does. The standards and the references of cultural art fail to apply. Each of these works has its own standards, its own system of reference, to which one has to adjust.

Among the various notions challenged by Art Brut is the notion of madness. Here too, in the misleading view we are apt to have of madness, imagining it to mean the loss of all discernment and all sense of responsibility, a conditioning process is at work. It is a mistake to suppose that the works presented in this book were wrought out blindly by men and women who meant to produce something approaching cultural art. On the contrary, these works took shape in all lucidity: those who made them were well aware of their newness and peculiarity. Anyone who has practised art or even dabbled in it knows what steady and watchful purposefulness is required to see a work through in the same key and to fit every detail into that key. Knowing that, it is rash indeed to suppose that its maker has lost control of his brain-child. If he introduces an apparent incoherence, it means that he wants it to be that way. If the result seems staggering, he meant it to be staggering.

Whether the desire to produce a staggering work is blameworthy in itself or whether the inclination to depart from normal standards, cultural or otherwise, is an offense against social ethics and sufficient cause for internment, that is obviously another matter, and one that may be left to the psychiatrists. But it seems important not to confuse this inclination to challenge normal standards with mental deficiency. Or is the challenge to social standards and the pursuit of new solutions—carried beyond a certain point— to be pronounced an infirmity or a crime? Is mental health to be equated with acceptance of prevailing opinions?

Jean Dubuffet

INTRODUCTION

This book makes no claim to an exhaustive listing of the makers of Art Brut. Such a listing, which by the nature of things can never be complete, was begun and will be continued in the *Fascicules de l'Art Brut* [1-9] in the form of monographs, to which the writing of this book owes much. My purpose here is to provide a general survey of the subject and to illustrate some of its specific features.

Art Brut is characterized by the originality and rugged individuality of its makers. This being so, no attempt has been made to lump them together in any way. Nevertheless, the fact that Art Brut thrives in other places than those socially assigned to the "fine arts," the fact that it is largely untouched by cultural influences and institutionalizing, the fact that it is marginal, an outsider, all this eases the outflow of latent forces that are apt to remain bottled up in ordinary people, including artists belonging to the cultural sphere. Even though the makers of Art Brut are very different from each other, each having his own vein and faculties of creation, it is possible to survey the field of creative freedom which they open up and to single out certain privileged areas, certain resources of inventiveness.

For the purposes of this study, I have focused my attention on the Art Brut Collection built up by Jean Dubuffet and the Compagnie de l'Art Brut. It is true that this collection makes no claim to be all-embracing or exclusive. Other such works exist; for example, some works of an architectural character which unquestionably qualify as Art Brut and which remain where they were built. Some others, brought together in the first place for their allegedly pathological character, are still in the collections of psychiatric hospitals or in the hands of doctors. Something will be said about them here. The fact remains that the Art Brut Collection is the only one—or any-how the first in date and the most extensive—that has grouped, preserved and studied these cases of art creation solely on the basis of criteria of personal inventiveness and freedom from cultural norms. And these are the criteria that go to define Art Brut.

Among those who have helped in the making of this book, my special thanks are due to Jean Dubuffet and to Slavko Kopac, former curator of the Art Brut Collection in Paris.

The numbers in square brackets refer to the items listed in the Bibliography (page 170).

PREHISTORY OF ART BRUT

Art does not come and lie in the beds we make for it. It slips away as soon as its name is uttered: it likes to preserve its incognito. Its best moments are when it forgets its very name.

<div align="right">

Jean Dubuffet

</div>

What is Art Brut? The by now standard French term was coined by Jean Dubuffet: it means "raw art." Dubuffet not only created the notion, he also discovered and collected most of the works designated by this name. He has described them as "works of every kind—drawings, paintings, embroideries, carved or modelled figures, etc.—presenting a spontaneous, highly inventive character, as little beholden as possible to the ordinary run of art or to cultural conventions, the makers of them being obscure persons foreign to professional art circles" [11]. Again, in an essay entitled *L'art brut préféré aux arts culturels*, Dubuffet writes: "We mean by this the works executed by people untouched by artistic culture, works in which imitation—contrary to what occurs among intellectuals—has little or no part, so that their makers derive everything (subjects, choice of materials used, means of transposition, rhythms, ways of patterning, etc.) from their own resources and not from the conventions of classic art or the art that happens to be fashionable. Here we find art at its purest and crudest; we see it being wholly reinvented at every stage of the operation by its maker, acting entirely on his own. This, then, is art springing solely from its maker's knack of invention and not, as always in cultural art, from his power of aping others or changing like a chameleon" [11].

From these definitions, three essential features can be singled out. First, the makers of Art Brut are outsiders, mentally and/or socially. Second, their work is conceived and produced outside the field of "fine arts" in its usual sense as referring to the network of schools, galleries, museums, etc.; it is also conceived without any regard for the usual recipients of works of art, or indeed without regard for any recipient at all. Third, the subjects, techniques and systems of fig-

uration have little connection with those handed down by tradition or current in the fashionable art of the day; they stem rather from personal invention. In short, Art Brut is opposed to what may be termed "cultural art," including the avant-garde forms of the latter.

These fundamental characteristics will be referred to again and again in the course of this study. But, before going further, a word about the history of Art Brut—the history behind the works called by that name and the history of the notion itself.

As regards the history of Art Brut and the creation of such works in the past, we are reduced to guesswork and conjecture, for very few of them have survived from before the twentieth century. This for an obvious reason: works of this kind went unnoticed and were not preserved. The fact is that Western society long remained blind to whatever departed drastically from its own standards, as fixed and institutionalized since the Renaissance. These standards found their strictest formulation in the academic canons. They were based on the exclusive priority of optical representation and all the conventions deriving from it. Thus painting was governed by the principles—necessarily arbitrary principles—of monocular vision, a fixed viewpoint, unity of time, space and lighting, planimetric projection, linear and aerial perspective, etc.

The history of Western culture and more particularly the figurative arts, over the past two or three centuries, has been that of a slow and cautious shift away from this system of rules. The artists who aspired to break away from it were naturally led to take their stand on other representational systems, earlier or exotic ones. Thus in the nineteenth century the Romantic generation turned towards the East, the Realists went to popular imagery or Dutch and Spanish painting for inspiration, and the Impressionists to Japanese prints. These borrowings were assimilated slowly, in homoeopathic doses, as if these foreign bodies were only admitted on the condition of merging into the cultural organism, without impairing its unity.

Children, Madmen and Primitives...

Whatever its capacity of assimilation, Western culture has long persisted in dismissing three autonomous forms of expression (which one smiles today to see associated, so very different are they from each other): those of children, "madmen" and "primitives" (more will be said about these last two and the inverted commas they call for today). Actually the only common feature of these three forms of expression is the fact that they have been relegated to the same ghetto, on the same charge of illustrating a "pre-logical mentality" formulated jointly by ethnologists (Lévy-Bruhl), child psychologists (Jean Piaget) and psychiatrists (nearly all of them).

For about a century now, the cultural shift referred to above has gradually led Western society to change its attitude towards these forms of expression. It may be worthwhile to say something about the effects of this changed attitude, before dealing with the particular case of Art Brut.

To begin with what has been called "primitivism." For a long time the African and Oceanian arts were considered uncouth and inarticulate, unworthy of figuring in a museum, except as curios. Jean Laude has well analysed the ideological construct which arose hand in hand with the first ethnographic museums and which in the last resort served to justify colonial expansion in the name of the West's alleged cultural and technical superiority [52]. For the non-Western arts to be recognized as genuine cultural and artistic achievements, they had to be discovered by Gauguin, the Fauves, the northern Expressionists, and Cubists and Surrealists: by making explicit borrowings from them, these artists acclimatized them to our sensibility. Was it by chance that this recognition occurred at the same time as the dismantling and break-up of the colonized societies? Possibly Wagner's famous phrase has some relevance here: "Art begins where life leaves off." That view of art appears to be the first rule of André Malraux's "Museum without Walls," to which no object was admitted unless its existence on the secular plane had come to an end, even if this meant the destruction of the social milieu in

which it arose. Whether that destruction involved a real massacre or only cultural genocide does not matter in this context. The important point is that, at the very time when African and Polynesian statuary was recognized as genuine art, its inspiration failed and the production of these peoples was reduced to stereotyped objects catering for the tourist trade.

Curiously enough, the "non-acculturated" forms of expression within our own society have had much the same fate. For a long time children's drawings were regarded as mere doodlings, judged to be awkward, mistaken or accidentally correct, because they were evaluated in relation to the only system of representation considered to be accurate: the system governed by academic canons. One is not surprised to find that the first children's drawings to be thought worth keeping and studying, in the late nineteenth century, were those of "infant prodigies" who, at eight or ten, were already drawing like grown-ups [74]. Yet the way had been shown by the pioneers of a new teaching method, like Jean-Jacques Rousseau and Pestalozzi, who saw the child mind not as a still formless outline of the adult mind, but as a world with a structure of its own. Later, thanks to the work of child psychologists and psychoanalysts like Freud, Melanie Klein, Wallon and Piaget, much insight was gained into the successive stages of the mental development of young children. It was found that to each of these stages corresponded a specific system of figuration. They were even seen as preparatory phases leading up to a final proficiency. The point of view remained adult-centered. Here again our eyes have been opened by modern artists like Klee, Ernst, Miro and Dubuffet. Klee has gone on record as saying: "These gentlemen the critics often say that my pictures look like the doodlings and daubings of children. If only it were true!" [46].

The bias today appears to be going quite the other way. What before were dismissed as shortcomings are now idealized. Studios of child art and exhibitions of the "creative child" type are becoming more and more common. Their effect,

paradoxically enough, is to produce a standardization of artistic expression in children of an ever younger age group. For several decades now children have become aware of the value that grown-ups attach to their productions. They soon learn to play up to them and win applause. No wonder that children's drawings today, as compared with what they were half a century ago, betray a specific academicism of their own, whose inroads can be detected at an ever earlier age. Are they trying to escape from the conditions of their age group? Are they aping their elders? Both. For the creative power attributed to children more and more admiringly tends, by the fact of that admiration, to be reduced to the projective myth built up by the adult to counterbalance his own sterility. The artistic expression of children is on the way to being totally absorbed by this myth—the last stage of adult-centeredness.

Another vein of expression even more refractory to cultural norms has followed the same evolution: that of the "mentally ill." As long as madness was considered a perversion against which society had to protect itself by internment, no attention was paid to the drawings of the insane. But with the advent of positive therapy in the nineteenth century, madness came to be regarded as an illness, calling for research and medical care. Some psychiatrists then began collecting the drawings and pictures made by their patients as diagnostic material. The first studies published on the drawings of the insane, at the beginning of this century, aimed at working out a fixed correlation between certain stylistic features and the different forms of dementia identified by psychiatrists. Schizophrenia was at the center of these researches, as the psychosis considered to be the most prolific in this respect; according to the statistics of Dr Prinzhorn, 75 per cent of the drawings made in asylums were the work of schizophrenics.

The symptomatic value attributed to these drawings will be dealt with in a later chapter. Here it can be said at once that this purely clinical way of assessing them implies a systematic misunderstanding of the artistic act. Not until other disciplines like ethnology and psychoanalysis had made some contributions was it possible

to go beyond these over-simple conceptions. It was Dr Hans Prinzhorn, author of a fundamental study of the art of the insane, *Bildnerei der Geisteskranken* [62], published in 1922, who began to envisage the productions of his patients from an aesthetic angle. He tried to see the creative process from the inside by considering each style as the overall expression of the life experience of its maker. His work was followed up by others and monographs like those of Dr Morgenthaler on Wölfli [2], Dr Dequeker on Guillaume [25] and Dr Jacqueline Porret-Forel on Aloïse [7] have demonstrated the inventiveness and originality of these works.

But, once again, such works would have remained valueless in our eyes had it not been for the modern artists who took an interest in them and who, through their own adventurous speculations, have made us capable of responding to them. Paul Klee pioneered the way. In 1923 he declared: "In the works which we hope will come off, is it really equilibrium and calm that we express and communicate, or is it not rather the excitement by which we are possessed? What is the equilibrium of a composition but the pot in which that excitement boils?... You are familiar with Prinzhorn's excellent work. We can soon convince ourselves of this. Look, there is Klee at his best! And here, and here too! Look at these religious subjects: a depth and power of expression that I shall never attain to. A really sublime art..." [46] From the Symbolists to the Surrealists, there is no counting the artists who, more or less deliberately, and more or less successfully, have capitalized on the disordered workings of their mind and senses and dabbled in clairvoyance and psychic phenomena. The art of the insane has had an abiding fascination for them, and they themselves have sought to cross the threshold of that visionary world, even by the artificial means of hallucinogenic drugs.

And yet, in this realm too, it must be admitted that for several decades now the springs of creativity have been drying up. This may seem surprising in view of the fact that more art work than ever before is being produced by the inmates of psychiatric hospitals. Their output has increased in incalculable proportions, for psychiatrists and attendants, alerted by books and

talk about the psychopathology of expression, have changed their attitude towards it. Instead of thwarting their patients' efforts to express themselves, as they usually did in the past, they now encourage them. They are even disposed to attribute a therapeutic value to the practice of drawing and modelling. There is hardly a psychiatric hospital today that doesn't have its studio or workshop, and hardly one that fails to organize exhibitions periodically.

Paradoxically, this change of attitude is one of the main reasons for the diminishing inventiveness of the "mentally ill." The latter are not blind to the keen interest—symptomatological, therapeutic and even lucrative—that is being taken in their work. They themselves have access to the medical studies which have secured recognition for that work and they are not above looking in them for models: then, of set purpose, they produce "lunatic drawings." The hospital studio, the group exhibitions, the comparison with others and the praise lavished on all end up by creating the same propensity to imitation and affectation as in professional artists.

And at a deeper level one feels in their work a loss of inner compulsion and intensity. Formerly, in psychiatric hospitals, the creative individual had to cope with bullying and repression. His works owed their vivacity and virulence precisely to the climate of opposition and clandestinity in which they arose. They were his only possible reply to the totalitarian violence of such places. The doctors of the Waldau Psychiatric Clinic in Bern—the least repressive in this respect—have systematically preserved, luckily without any regard to aesthetic criteria, the objects fashioned by their patients. It is an impressive collection indeed. In it, put together with makeshift means, are dummy revolvers, daggers, keys, airplanes, parachutes, shoes and huge socks—so many symbolic weapons and emblems of release. These objects are the forerunners of Art Brut: they show quite nakedly the deeper urges behind it, which have nothing to do with aesthetics but spring from violence and the most radical protest (see page 33).

One can understand why the work of psychiatric inmates has now taken a different turn, why it is no longer genuine. Therapeutic encouragement and paternalist benevolence act as a conductor towards "normalization"; they are in effect a much more subtle and efficient means of repression. Institutes for the "psychopathology of expression" are designed to neutralize that *living utterance* which madness can be, to maintain against it the positions taken up by medical science, to check the movement of reciprocity that these works desperately call for—in a word, to defend the line of segregation between reason and unreason where it is threatened most.

A further blow has been dealt by the widespread use of nerve sedatives. The fact is that chemotherapy has completely changed the face of psychiatric hospitals. Cases of isolation for life and the most spectacular forms of dementia and inspired delirium have practically disappeared. It is not for me to judge whether this change is on the whole an advance. While nerve sedatives have reduced physical suffering, they have also induced a mental degradation and stupefying effect whose result, where art work is concerned, has been a decline and loss of the creative faculties.

Cultural Colonialism

So in the end the three forms of expression I have dealt with have had a similar fate. Each was long ignored or despised, owing to the academic, ethnocentric or adult-centered prejudices of Western culture. Then, when the tide turned, the new attitude towards them was not so beneficial as might have been expected. First the victims of blank incomprehension, they next became the victims of a debilitating overcomprehension.

Like Orpheus, who by looking at her killed the woman he loved, Western culture seems doomed to distort any other form of expression by the mere fact of taking aesthetic notice of it. True, the transition from the former stage of outright destruction to one of pillage and then of anthropological and aesthetic interest has the advantage of saving and preserving the objects concerned. But, while cultural colonization has taken to milder methods, the end-result is much the same. The method now is one of ingestion, assimilation and homogenization. Having passed through this digestive process, the object ends up in a museum, that insatiable maw into which goes everything that can be described as art.

Is there any need to dwell on the malaise created by this "system of fine arts"? The museums are there to see that the works are preserved and exhibited. But this apparent function is part and parcel of a stifling ideological apparatus. The chosen work, framed and solemnized, becomes the object of devotion, commercial valuation and scholarly research which cut it off from the life-giving connection with people and things that its maker meant it to have. By a supreme paradox it may even become a pretext for emphasizing social cleavages. Pierre Bourdieu and Alain Darbel have shown how in practice the museum takes upon itself "the true function that the cultured class assigns to its culture, which is to impress on some the sense of belonging and on others the sense of exclusion" [20].

The connection between art and life being severed by the museum, one looks elsewhere in the hope of re-establishing that connection, as if, paradoxically, art today could no longer thrive except in uncultivated territory. This is the point

that Dubuffet has made in vivid terms: "True art is always where you least expect to find it. Where nobody thinks about it or utters its name. Art hates to be recognized and greeted by name. It makes its escape at once. Art is a personage with a passion for going incognito. As soon as he is detected and someone points a finger at him, he makes his escape leaving in his place a laurelled understudy who carries on his back a big label marked ART, and everybody regales him at once with champagne and lecturers take him from city to city with a ring in his nose. That is the false Mr Art. That is the one the public knows, since he is the one with the laurel and the label. As for the true Mr Art, no danger of him sticking labels on himself, not likely! So nobody recognizes him. He goes about everywhere, everybody has come across him and bumps into him twenty times a day at every street corner, but no one has any inkling that this might be Mr Art himself who is so well spoken of. Because he doesn't look the part. You see, it's the false Mr Art who looks most like the true one and it's the true one who doesn't look like it! That's why it's so easy to go wrong. And many people do go wrong" [11].

I shall deal later with the fundamental distinction between Art Brut and the non-acculturated—but in the end colonialized—forms of expression discussed in the previous section. They do however have this in common: Art Brut has suffered from the same segregation, made even more sweeping by the absence of that ethnological, educational or medical interest which came into play in the other fields and helped to save a certain number of works. This explains why so few vestiges of pre-twentieth-century Art Brut have survived.

Certain works of the past have nevertheless found a place in art history as presenting a strongly marked character of originality and heresy in relation to their cultural context. Here and there, among them, are a few that stand out sharply and might be worth considering from the angle of Art Brut. But a coverage of them would no doubt be tedious. The reader can find them out for himself by referring to the books on "fantastic art" (admittedly a hold-all notion which can be made to fit the wildest groupings and most incongruous medleys).

It may be noted too that, in certain periods of social and mental change, a time-lag and an antagonism have occurred between the cultural norms and the new forces challenging those norms. Then, a jolt a bit more violent than usual was enough to open a breach in the ideological ramparts and release the new and freer forms of expression. The sixteenth century, or more accurately that part of it known today as the Mannerist period, was fruitful in works of this kind. Even these owe their survival to the fact that certain social groups came to see themselves reflected in them, and so it happened that they were retrospectively taken up as new models of integration. Such works stand in the gap between a declining and a rising culture. But, though they do not quite belong to either and so are loosed from some historical constraints, they remain imprisoned in a cultural filiation.

Such works as may have really answered to the criteria of Art Brut and stood without cultural antecedents nor descendants have failed to survive for that very reason. It has happened however that certain recognized artists or writers have unexpectedly branched out in a direction quite different from their usual line of work, as if in a fit of absentmindedness or a sudden rebellion against accustomed forms. The results would never have survived had they not been signed with a famous name; and they are found, surprisingly enough, to break away from the cultural orbit more sharply than the reputedly "fantastic" works that have come down to us. Such is the case in particular with certain "mediumistic" drawings by Victor Hugo. But before coming to these, a few words about Rodolphe Toepffer, another curious and contradictory figure, whose writings and drawings are worth pausing over.

Rodolphe Toepffer

Born in 1799, this Genevese storyteller and cartoonist produced the bulk of his work between 1830 and 1845. For him it was an escape hatch from the stifling atmosphere of a culture to which, first as a schoolmaster, then as a professor at Geneva University, he outwardly conformed. The art criticism he wrote, dealing with the painters of his time, is rich in comments which show how uncomfortable their virtuosity made him.

"It is all very sad. But if painters (most of them) could unlearn what they know, they would usually gain by it. And yet, if they cease to study, they move backwards fast and are soon painting daubs. Daubs in front, daubs behind. A sad business, and a contradictory one too. I just can't see what is to be done.

"The thing is that knowledge always tends to be reduced to a system. And systems degenerate into mannerism, and mannerism distorts talent, when it does not destroy it" [72].

Rodolphe Toepffer set out his views on art in a book entitled *Réflexions et menus propos d'un peintre genevois*. He criticized the slavish imitation of the model, recommending instead a selective or "ideal" representation which was no less conventional in his time. But in this same book he displays a wholly new and surprising interest for the graffiti scratched on walls and more especially for the rude figures that children draw with coal or chalk wherever they go:

"I have come across some, and so have you, which, awkward and badly drawn as most of them are, vividly reflect not only an imitative intention but also an intention of mind, to such an extent that the latter, precisely because of the draughtsman's ignorance of line drawing, is much more pronounced and successful than the former...

"Take one of those schoolboys who in the margin of their exercise books draw little figures which are already lively and expressive, and send him to drawing school to perfect his talent. Soon, as he begins to make progress in the art of drawing, the little figures he now draws so carefully on a sheet of white paper will be seen, as compared with those he scribbled at random in the margin of his exercise books, to have lost that expression and life, that vivacity of movement or intention, which one noticed in them before. At the same time, however, they will be seen to have become far superior in accuracy and fidelity of imitation" [71].

Toepffer himself drew with all the spirited freedom, untrammelled by aesthetic dogma, which he admired in untrained schoolboys. He must be credited with inventing the comic strip. He did so by taking advantage of the possibilities offered by lithographic transfer paper: it enabled him to draw and write almost simultaneously and so make the figures and text a unified whole. In opening up this new vein, he showed from the start an astonishing inventiveness, exploiting the expressive, philosophical and humorous resources implicit in the ever shifting interplay of pictures and text. He went even further in his *Essais de Physiognomonie* [70], the texts being written out by hand on transfer paper and studded with witty sketches. He displays a remarkable—one is tempted to say refreshing—lack of deference for the most elementary principles of art training as practised in his day. The reader may judge for himself:

"Here are some heads and a lady and gentleman which show in the highest degree not only broken lines but some pretty monstrous discontinuities of contour. Nevertheless, while for the draughtsman these are so many abbreviated forms concealing to best advantage his ignorance of correct and finished drawing, without too much detracting from the life, expression and movement of his figure, for the viewer they are so many blanks which his mind peoples, fills up and completes, easily and accurately. This leads one to think that, in the way of brisk, lively, sketchy drawing, there is everything to be gained by being ignorant. And without venturing to assert so strange a thing with absolute certainty, we may go as far as to say that, for ordinary sketches meant to express a bright, clear-cut idea, the eager feeling that hits it off is more effective than the trained hand which imitates it; that the abruptness which does violence to forms by skipping

quelquefois bien plus vive ou bien plus comique que l'on n'avait pas s'y attendre, c'est évidemment récréatif. Après tout ces visages vivent, parlent, rient, pleurent; tels sont bonnes gens, tels maussades, tels insupportables, et voici tout à l'heure sur la page une société avec laquelle vous êtes en rapport, de façon que vos sympathies et vos antipathies sont en jeu. Pour nous, nous avons toujours préféré ces partners-là à des partners de whist ou de piquet.

Parmi ces partners on en voit qui ont du bon assez, de l'intelligence de quoi, ou encore une niaise fatuité parfaitement suffisante pour les rendre en tout temps satisfaits d'eux-mêmes et contents de leur destinée, et on les laisse tels quels. L'on en voit aus-

si de qui l'œil, le nez, la bouche ou quelque autre trait signale quelque défaut ou quelque vice qui menace leur bonheur ou celui de leurs proches, et l'on cède au désir de les

en débarrasser.

Presque toujours aussi, parmi ces partners, l'on en découvre qui, mis en rapport les uns avec les autres peuvent donner lieu à une scène plaisante; alors on les assemble, on les complète, on trouve la scène qui a précédé celle-là, on invente celle qui doit suivre, et l'on est sur la voie de composer une histoire en estampes.

Ainsi, il est clair que lorsque la plume a donné comme ci-contre une bonne maman qui réconforte son garçon chéri, c'est que ce garçon chéri vient de recevoir quelque correction de son papa ci-contre, et l'on est libre alors de poursuivre le tableau des avantages d'une éducation première dans laquelle l'enfant a été sans cesse rudoyé d'une part, pansé de l'autre

13.

va d'étage en étage proposer l'achat d'une métaphysique pittoresque, à l'hyperbo- le portée à la fois sur la multiplicité et sur l'importunité obséquieuse de ses visites intéressées.

On boit à la liberté!

à l'égalité! à la fraternité! à la verti! à la Pologne! à la haine des Juifs! de Metternich! demmm... demmm... demmm...

Mr albert assassine d'étage en étage. au rez de chaussée au 1er au 2ème au 3e au 4e au 5e au 6e au 7

9.

Rodolphe Toepffer (1799-1846): Illustration from his "Histoire d'Albert," 1845.

over details gives a more spirited result than the cautious skill which lingers over forms and sets out every detail; and, finally, that in amusing or fancy-free subjects especially a bold ignorance which flings itself at an idea it has in view, at the risk of omitting a few lines and breaking up a few forms, will usually hit the mark more aptly than a better trained but more diffident talent which approaches it slowly through the mazes of an elegant execution and a faithful imitation...

"The graphic stroke, because of its easy convenience, its rich suggestiveness, its happy and unexpected accidents, is admirably suited to inventive drawing. One might say that all by itself it sets the sail and fills it, blowing the boat along. If I got the idea one day of making up the whole story of Monsieur Crépin, it was because, with a random stroke of the pen, I happened to hit on the figure opposite... From that came a whole story, the outcome not so much of a preconceived idea as of this figure type hit on by the merest chance" [70].

So Rodolphe Toepffer, in his drawings, went ahead and reversed the traditional approach to picture making, which subordinates the execution to the conception. He made the most of chance and clumsiness as sources of inspiration. By a playful, haphazard manipulation of the graphic elements, he contrived to produce figures much more expressive than premeditated skill could have made them. He concentrated on what was visually significant, without worrying about the end-result in representational terms. A century before the Surrealists he practised something akin to automatic writing. He drained reality of all the superfluities that did not contribute to his whimsical and witty effects. He may also be said to have bridged the age-old gap between writing and drawing.

It would be going too far to describe Rodolphe Toepffer as a maker of Art Brut. But he was very much an outsider with a most unusual aloofness from the prevailing cultural dogmas and a realization of their cramping effect on the creative artist. His own career is highly significant. His father Wolfgang-Adam Toepffer was a painter and intended to train his son for the same profession. Rodolphe therefore began by learning

18

Victor Hugo (1802-1885):
Drawing from a Spiritualistic Album.
Bibliothèque Nationale, Paris.

N A F 13353

to draw and in accordance with the strict academic schooling of that day he was even forbidden to touch oil paints until he had made the journey to Italy and studied the Old Masters: this was considered indispensable to an artistic career. But he began to suffer from eye-strain. It prevented him from applying himself to art studies for any length of time. His enigmatic eye trouble reached its height in 1818, just as he was supposed to leave for Italy, and the journey had to be given up. He gave up his art studies at the same time and turned to schoolmastering. From then on, drawing was only a sideline with him.

His providential eye trouble saved him from academic conditioning and left him free to scribble and draw as he pleased, without regard to "aesthetic" standards. One is naturally led to interpret this mysterious eye-strain in psychosomatic terms as a more or less conscious stratagem. Such cases are frequent among the makers of Art Brut: not having presumption or conceit enough to cope with established cultural principles, they shy away from them, finding a cunning pretext for downgrading the value of their own work and keeping it outside the artistic circuit.

The Mediumistic Drawings of Victor Hugo

Victor Hugo began to draw in 1836, when he was thirty-four, and produced a large and very miscellaneous body of drawings. They developed on lines independent of his writings, acting as a kind of counterpoint. Though a gifted and persevering draughtsman, Victor Hugo would never consent to be initiated into the recognized techniques of easel painting, etching or lithography [59]. He deliberately cultivated drawing as a marginal activity treated in techniques of his own, as if intent on avoiding any connections with the world of art and any temptation to imitate others.

He even tried to withdraw his imaginary forms from the control of the conscious mind by resorting to haphazard techniques—ink spots spread by rubbing or squeezing, scratchings, erasings, tearings, etc. He also resorted to unusual implements—the barbs of a bird feather, a crumpled piece of paper dipped in ink, a burnt match, red-hot curling tongs, a deliberately blunted pen. Théophile Gautier saw him at work:

Victor Hugo (1802-1885): Pages from a Sketchbook. Pencil and ink. Bibliothèque Nationale, Paris.

"How often, when I had the privilege of being admitted to the famous writer's home almost daily, have I followed with wondering eyes the transformation of a blot of ink or a coffee stain on an envelope, or the first scrap of paper to hand, into a landscape, castle or seascape of strange originality, where from the clash of gleams and shadows sprang an unexpected, arresting, mysterious effect that amazed even professional painters" [35].

Victor Hugo's own comments show the spirit in which he meant his drawings to be taken. On 5 October 1862 he wrote to his publisher Castel: "Chance has brought to your notice a few attempts at drawing made by me in hours of almost unconscious daydreaming with the ink left in my pen on the margins or covers of manuscripts... I very much fear that these nondescript pen strokes set down on paper more or less awkwardly by a fellow who has other things to do may cease to be drawings from the moment they claim to be such" [59]. In a letter to Baudelaire of 29 April 1860 he wrote: "I am very happy and quite proud that you should think so well of the things that I call my pen drawings. I ended up by combining pencil, charcoal, sepia, coal, soot and all sorts of odd mixtures which go to render roughly what I have in my eye or rather in my mind. It is good fun between two stanzas" [59]. "My drawings are a bit wild," he says in another place.

Working intuitively, Victor Hugo made the most of means and methods of execution which would have astounded the painters of his time, but which, as he shrewdly saw, were well suited to a vein of expression untrammelled by artistic standards. He used wholly original materials and techniques; he worked in unconscious moments or fits of absentmindedness; he cultivated an inspired awkwardness and wildness; he repudiated any artistic ambition; he even rejected the word "art" which he felt as an inhibiting factor. All

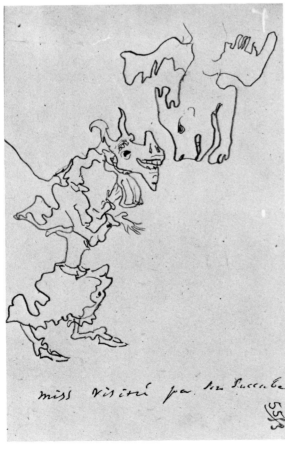

these traits will be met with again in the makers of Art Brut.

Another important point he had in common with them: he was inclined to let the mind prevail over the eye. He doubtless felt the emphasis laid by art on optical representation to be an undue muting of other voices. He liked to draw in a darkened room what he saw or imagined he saw on the wall. He told Camille Pelletan that "intangible creatures hover in the transparency of the air and one day, taking notes in his garden at Guernsey, he distinctly saw the diaphanous shadow of their wings flickering over his paper" [59].

Like Rodolphe Toepffer, however, Victor Hugo cannot be considered as a maker of Art Brut in the anti-cultural sense of the term. For though he liked to make play with blots of ink for the unexpected shapes that could be extracted from them, he only did so in so far as those shapes could be interpreted as landscapes or ruins and made to evoke compositions by Rembrandt, Piranesi or Célestin Nanteuil. In spite of their ludic character, it was only with reference to a pre-existing imagery that his blot drawings took on meaning. While they directly record an inner vision, the latter is shaped by a figurative tradition.

On the other hand, between 1856 and 1858 Victor Hugo made a series of drawings in four notebooks which, in their haunting singularity, come much closer to what is meant today by Art Brut [40]. Two of these notebooks, in the Bibliothèque Nationale in Paris, are designated as "spiritualistic albums." In 1853, during his exile in the Channel island of Jersey, Victor Hugo was initiated into spiritualism by Madame de Girardin. With his wife, his son and Auguste Vacquerie, he went in for table turning. In doing so he resorted to a method much in vogue at that time, which consisted in tying a pencil to a leg of the table and so recording its movements on a sheet of paper, in the manner of a seismograph. Presumably he took up a pencil afterwards and reworked the initial spiritualistic drawings. In any case, these enigmatic scribblings show a mixture of figures and inscriptions.

The drawings in the other two notebooks, in the Lucien-Graux Collection in Paris, do not appear to have originated in spiritualistic séances,

and yet they are even more mysterious. The monsters and freakish creatures in these sheets look as if they sprang into being from a sudden whim or lurch of the pencil. The sketching must have been a haphazard affair, aiming at no particular figure in advance. One can only suppose that it was deliberately kept free of any guiding or governing intention and left at the mercy of impulse. Here one wonders whether Victor Hugo may not have drawn with his left hand or his foot or with some device calculated to thwart any conscious purposes. Did he draw them in the dark or on a moving support? Did he take as his starting point the outline of some object, a stone or bark from a tree or even a cast shadow, which he first traced on the paper? One might suppose so from these remarks in a letter of 1825 to his brother-in-law P. Foucher:

"For the moment I am in a room next to La Miltière. The ivy climbing up the walls throws fretted shadows over my paper and I send you a drawing of them, since you wish my letter to contain something picturesque. Don't laugh at these odd figures drawn as if by chance on the other side of the sheet. Have a little imagination. Suppose this drawing to have been made by the sun and shadow and you will see something charming in it. That's the way those madmen known as poets go about their work" [41].

However he proceeded, one has the disturbing sense of a non-human drawing, since the specific gesture of the hand cannot be recognized in it. Monsters appear to arise accidentally out of these delineations, like those the eye detects in clouds or reefs. These freakish figures are so fleeting or equivocal that the artist had to reshape some and define others by the addition of a title, acting retrospectively on the image like a catalytic agent. These written or patterned after-touches in the genesis of the figures are suggestive of the dream process. The most remarkable thing about this series of drawings is that Victor Hugo completely disregarded the figurative forms endorsed by tradition. He conjured up these figures for their own sake, for the intrinsic interest of their strangeness. Commentators have tried hard to detect references in them to Bosch, Bruegel, Goya or Gustave Doré, but none of their suppositions are convincing.

Culture and its Discontents

I repeat: it is not my intention to seek out the precursors or antecedents of Art Brut, but simply to make it clear that, a century and more ago, there were men like Toepffer and Hugo who resisted the culture into which they were born. In art, the most innovating movements in nineteenth-century France sprang from a growing dissatisfaction with what was felt to be an oppressive system of art training and practice. The sense of what was being lost by submission to this oppressive system was expressed with singular clarity by the novelist and art historian Champfleury in 1869, in the introduction to his *Histoire de l'imagerie populaire* [21]:

"City people are often laughed at in the country when, in their ignorance, they mistake alfalfa for wheat. Print fanciers display not quite the same ignorance, but an equally conceited contempt for folk imagery because of its loud colors, which are nevertheless in perfect harmony with the nature of peasants. 'The barbarism of these colors!' they exclaim. Not so barbaric as the mediocre art of our exhibitions, where mere skill of hand is so universal that the two thousand pictures exhibited seem to have been cast in the same mold.

"The artistic awkwardness of folk art is closer to the work of men of genius than these betwixt and between compositions, the product of schools and false traditions.

"I maintain that an idol carved in a treetrunk by savages is closer to Michelangelo's *Moses* than most of the statues in our annual Salons.

"Both the savage and the man of genius are distinguished by a boldness, an ignorance, a departure from all the rules which make the two of them go very well together. But it is necessary to penetrate deeply into these rudimentary works and get away from the skill and *cleverness* of so many day laborers who call themselves artists."

There can be no question here of detailing the various movements which, from Courbet and the Realists down to the Surrealists, rejected the old heritage of forms and figurations. One particularly virulent group may be mentioned, however, which in some ways anticipated Dada: the Incoherents. In 1882 a journalist named Jules Lévy, reacting against the formalism and earnestness of the French bourgeoisie, organized in his Paris apartment an exhibition of "drawings by people who don't know how to draw." This was the prelude to the formation of the Incoherent group, which up to 1891 held exhibitions and balls and organized nonsensical outings. It is true that the group included some professional caricaturists like Willette, Chéret and Caran d'Ache. But even these professionals were bent on using humor and tomfoolery as a weapon against academicism. And they succeeded in arousing the ire of Gérôme, one of the leading Salon painters, who roundly denounced them as "the anarchists of art" [64].

Unfortunately, for all the interest taken by artists and writers like Toepffer, Courbet, Champfleury, Rimbaud and Jules Lévy in marginal forms of expression and "nonsense paintings," it occurred to none of them to collect and preserve them. So that any retrospective investigation is inevitably limited to works which, while breaking with culture, are nevertheless derived from it.

Even so, a few works comparable to Art Brut have survived for purely material reasons: they are works on an architectural scale and as such more resistant to wear and tear, and the added fact that from the first they were something of a tourist attraction also helped to preserve them from destruction.

HAUTERIVES (DROME)
PALAIS IDÉAL, SEUL AU MONDE — TRAVAIL D'UN SEUL HOMME

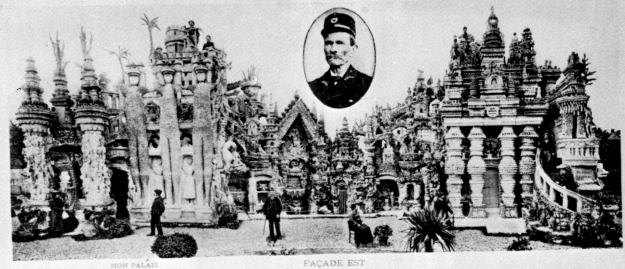

MON PALAIS

Auteur de l'œuvre du génie
Qu'avec plaisir nous contemplons,
Oh ! dis-nous par quelle magie
Tu fis ce que nous admirons.

FAÇADE EST

Pour faire cette œuvre sublime
Dont le monde est émerveillé,
Poussé par une ardeur intime
Vingt-sept années j'ai travaillé.

Le matin, dès que l'alouette
Entonnait son joyeux refrain,
Poussant ma fidèle brouette
Je partais chercher mon butin.

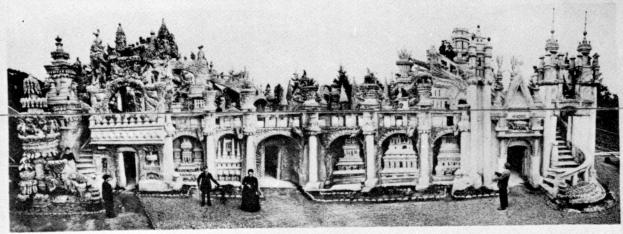

FAÇADE OUEST

Réunissant pierre sur pierre,
Je fis ce palais sans égal
Décoré par la France entière
Du nom de « Palais idéal ».

Bravant la chaleur, la froidure,
Et même l'outrage du temps,
Je forçais parfois la nature
Et triomphais des éléments.

Par cela j'apprends à tout âge
Qu'en se montrant persévérant,
Laborieux, rempli de courage,
On arrive à tout sûrement.

L'Auteur du Palais.

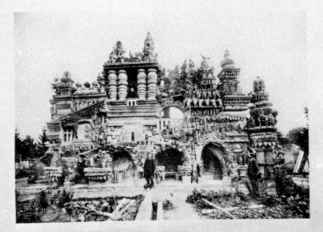

FAÇADE NORD

J'ai contemplé ton œuvre et j'en reste ébloui,
Humble et rude ouvrier, maçon aux mains sublimes,
Qui, sans maître, sans aide, et de cailloux infimes,
Construisis, patient, ce palais inouï !
Ne crains pas que ton nom périsse.

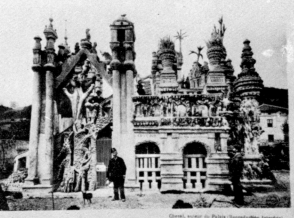

Cheval, auteur du Palais (Reproduction interdite)

FAÇADE SUD

Monument du génie et de la volonté,
Ces pierres, qu'avec goût assemble mon caprice,
Des siècles défieront la main dévastatrice,
Et, debout dans leur force et dans leur majesté,
Transmettront ta mémoire à la postérité !.
T. D.

24

The Palace of the Postman Cheval

Born in 1836, Ferdinand Cheval was a rural postman at Hauterives (Drôme) in southeastern France. During his rounds he dreamed of building an ideal palace, one that would "outstrip the imagination" [28]. He went on dreaming about it for twelve years without taking action. Like most people in his walk of life he assumed architecture to be a matter for professionals and art to be the monopoly of a caste. As he wrote in his autobiography: "I kept calling myself a madman and a fool. I was no bricklayer, I had never touched a trowel; no sculptor, I knew nothing of the chisel. I do not even speak of architecture, I had never studied it. I told no one about it, for fear of being ridiculed. I found myself ridiculous enough as it was" [44].

In 1879, on one of his daily rounds, he stumbled over a stone of unusual shape. It aroused his curiosity and led him to look for others like it. "It was a sandstone, weathered and hardened by time and exposure, so that it had become as hard as the rocks. It shows a sculpture so strange that it is impossible for man to imitate it: it represents all kinds of animals, all kinds of caricatures. I said to myself: since nature wants to do sculpture, I'll do my masonry and architecture."

For over thirty years, he went his daily round of fifteen miles with a wheelbarrow to bring home any stones of odd or fanciful shape that he could pick up in the hills and gullies. "Then tongues started wagging in the district and round about. Public opinion had soon settled the matter: 'It's just a poor fool filling up his garden with stones.' Everybody was prepared to believe that it all came of a diseased imagination. People laughed at me, blamed and criticized me, but as this kind of insanity was neither contagious nor dangerous, nobody thought it worthwhile calling in the mental doctor and so I was able to indulge my passion freely in spite of everything, turning a deaf ear to the scoffing of the crowd, for I knew that people always ridicule and even persecute the men they don't understand."

◄ The Postman Cheval (Ferdinand Cheval, 1836-1924): Prospectus for his Ideal Palace, built from 1879 to 1912 at Hauterives (Drôme), France.

With rudimentary tools (a trowel and a few basins to mix cement in), Ferdinand Cheval went to work in his spare time, which was mostly at night, and built his palace—85 feet long, 45 feet wide and 33 feet high. Inside, it is traversed over its whole length by a gallery which at each end winds into a kind of labyrinth. On top is a terrace also spanning the whole length, and giving access to two squat and massive towers, one at each end of the building.

Both inside and outside are ornamented at every point with reliefs, sculptures, shell mosaics, encrusted stones, grottoes, etc. Cheval's ambition was encyclopaedic. It resulted in a fantasmagorical world of plant and animal life, "figures of antiquity," druids and druidesses, towers and prickly pears, Pharaonic and Saracen tombs, Hindu monuments and Biblical scenes. Enshrined in the Palace are scaled-down models of a mosque, the White House, the Maison Carrée of Algiers, a medieval castle and a Swiss chalet. On it Cheval set an inscription in verse form, which may be literally translated as follows:

All that you see, passer-by,
Is a peasant's handiwork.
Out of a dream I have brought
The queen of the world.

While his Ideal Palace was indeed a work of the imagination, it embodies many of the postman's memories [73]—memories of prints by Gustave Doré, the imagery he had come across in the books of his childhood, the buildings and monuments he saw during his military service in Algeria, the pavilions of the Paris World's Fair of 1878 (just one year before he began work on his Ideal Palace).

But it is obvious that this very mixed assortment of reminiscences is not governed by the same principle of affiliated forms as architecture in general. They amount rather to a creative digression, a kind of hallucinatory migration through times and places. They stem from the same mechanisms of association and condensation as dreams do. These disparate borrowings play the same part in the building as "the day's

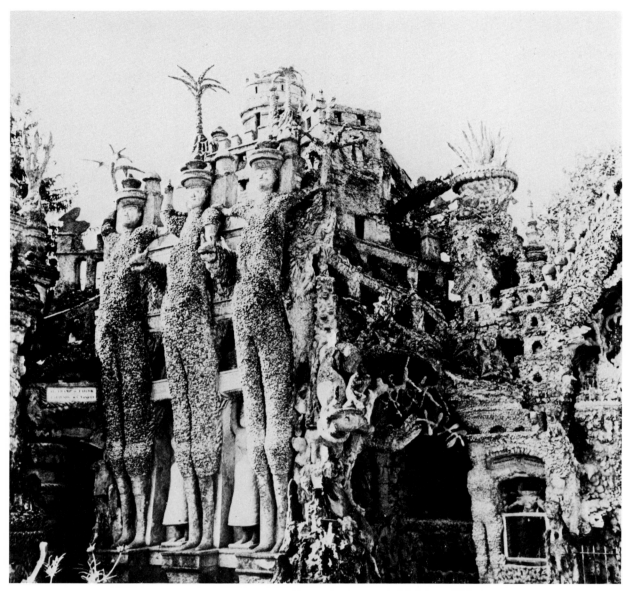

The Postman Cheval (Ferdinand Cheval, 1836-1924): Detail of the East Façade of the Ideal Palace, 1879-1912.

leftovers" which enter into the sequence of dreams. The encyclopaedic piling up of reminiscences amounts, paradoxically, to a negation of the principle of cultural filiation, which it cancels out by overemphasis, so to speak.

But can Cheval's Palace be called architecture in the conventional sense of the term? It narrowly missed remaining a purely mental construction and belongs rather to a "between world" (Klee's term) on the borderline dividing the real from the imaginary, so much does the fact of its actual materialization appear incidental. The Ideal Palace stands there like a dream unaccountably embodied in stone by some arbitrary, supernatural decision. The architectural process, then, is reversed. Whereas an ordinary building is originally designed as a dwelling place to which the architect can if desired give an imaginary extension, Cheval started out from a dream which in the end he made into a dwelling place; whereas a work of art in the usual sense is a material object figuring or evoking an unreality, the Ideal Palace is an imaginary object which has assumed the shape of reality ("it is like living in a dream,"

said Cheval). The reversal is all the more disconcerting because, inside the Palace, one meets with familiar buildings duplicated on a Lilliputian scale. The real is devaluated in relation to the imaginary: as in Lewis Carroll, it is at the mercy of the dreamer's whims.

In his autobiography Ferdinand Cheval has some shrewd things to say about madness, which apply equally well to other makers of Art Brut. It was not, he says, because he was crazy that he built his Palace; it was because he built his Palace that he was called crazy, and if he had let his imagination carry him much further, he would have been interned. On these points more will be said later.

A few other works of the same kind owe their survival to their monumental proportions. One is the rock sculptures at Rothéneuf on the coast of Brittany, between Saint-Michel and Saint-Malo: they were carved by a hermit, Abbé Adolphe-Julien Fouré, over a period of twenty-five years in the late nineteenth century [28]. The granite blocks of the cliff provided the stimulating support for a series of epic and mythical figures, based on the exploits of the Rothéneuf family, who for several generations were noted pirates and smugglers on those shores. The effect of strangeness is heightened by the difficulty of discriminating between natural erosion and Fouré's handiwork, between the carved figures and those hallucinatingly imagined as you pick your way through the chaotic mass of rock. Here again one is struck by the paradox of a monumental work whose effect, for all its massiveness, is to transport us into a mental space and confuse our sense of reality.

Adolphe-Julien Fouré (1839-1910): Rock Sculptures at Rothéneuf on the Brittany coast.

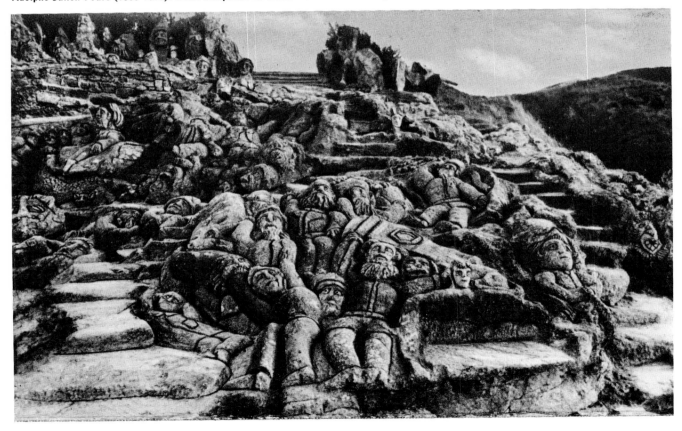

Clarence Schmidt and Simon Rodia

A few architectural and environmental works are also to be found in the United States. They are more recent, but all the more valuable as representing the rare vestiges of Art Brut in a country which has not shown much interest in it up to now.

Clarence Schmidt, born in 1898, was a stonemason in the Catskill Mountains of New York state. For thirty years he spent twelve hours a day building a large house set in a vast park. Unfortunately, being built of wood, it was destroyed by fire and is only known now from photographs. In its final form it was a seven-storey house of thirty-five rooms which had no architectural framework of its own but was backed against a natural hill and fitted over the rough ground on which it stood. Made of rough-ly squared timber and makeshift materials, the rooms were all connected by a labyrinth of passageways inset with miscellaneous objects. Living trees were also embedded in the building as structural supports.

The surrounding gardens were equally curious, the natural vegetation being cunningly mixed with tree-shaped pieces of scrap metal coated with tar, plastic flowers, dead trees wrapped in tinfoil, and assembled parts from old cars and bicycles combined with garden hoses and crockery. Pieces of mirror were inserted in profusion, reflecting light in every direction and creating an ever flickering unity in this heterogeneous world [13].

The same indecisive wavering between natural and artificial occurs in the Watts Towers in Los

Clarence Schmidt (1898-?): 35-Room House Erected at Woodstock, New York.

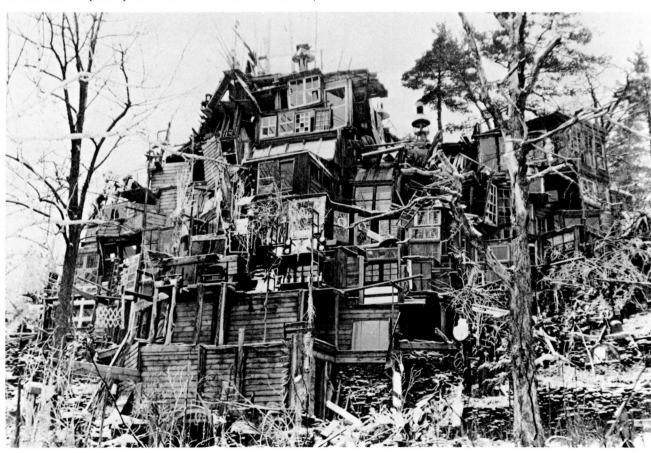

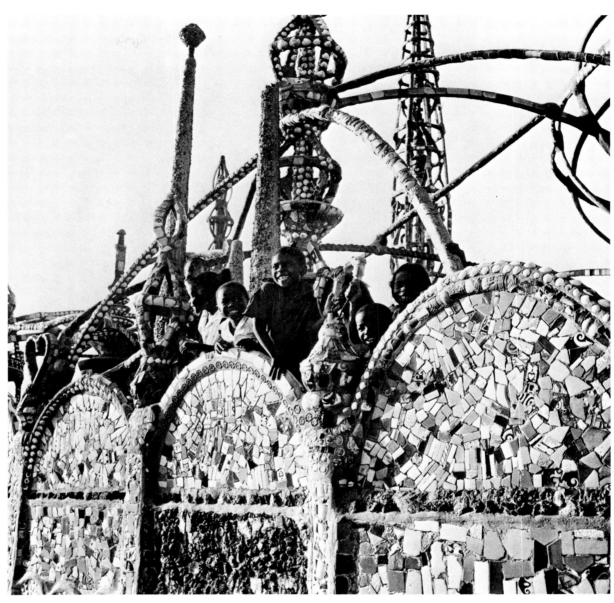

Simon Rodia (1879-?): The Watts Towers in Los Angeles, detail.

Angeles, which appear to have sprouted up like a monstrous plant growth. They were made by Simon Rodia, also known as Sam Rodillo, an Italian bricklayer born in 1879 who emigrated to the United States in 1890. He was surprised and frightened by the celebrity his towers brought down on him. In 1954, on his way to the TV studio to appear in a show on them, he jumped out of the taxi at a red light and disappeared. He was later found in a small town 200 miles from Los Angeles, where he had quietly settled. But he refused to give any reasons for his disappear-

ance: he had lost all interest in his towers and seemed to have no thoughts now for anything but politics [19].

It is a curious fact that, for all the pent-up excitement and intensity that men like Simon Rodia put into building their contrivances, they lose interest in them once the work is done and are indifferent to other people's reactions and even to the survival of their work. In this they stand fundamentally opposed to professional artists; they may be likened rather to children who build their sand castles and let the tide carry

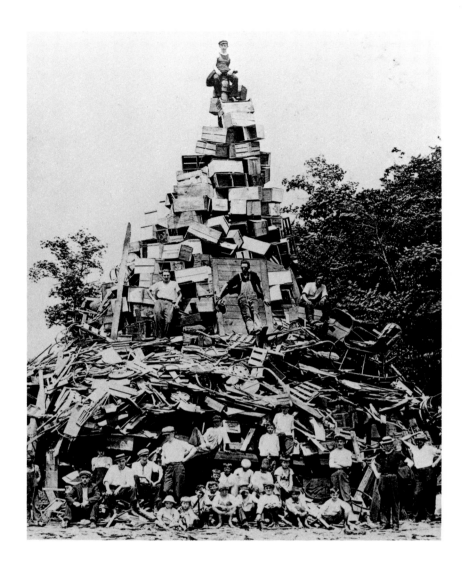

Post Card: Unidentified Tower of Crates, 1925.

them away. Similarly, Clarence Schmidt's house was burnt down and vandalism nearly wrecked the Watts Towers. Other constructions are deliberately precarious, like Stephen Sykes's 65-foot tower which he called "Incuriosity" and rebuilt three times in ten years [19], or the outlandish pile of crates only known from a photograph (see above).

There are still other examples of these "grassroots artists," as they have been called in the United States. One thinks of the enigmatic signs painted by Jesse Howard of Fulton, Missouri; the model city of wire mesh and colored concrete made by David Rousseau in Belle Plaine, Kansas, and suspended over a fish pond in his front yard; the assemblages made from a bewildering variety of junk by Dave Woods of Humboldt,

Kansas; the "Garden of Eden" built over a period of thirty years by S.P. Dinsmoor in Lucas, Kansas [19]; and, in France, the wall incrustations of Raymond Isidore in Chartres and the fantastic garden of the truck farmer Joseph Marmin in Vendée [28].

One marvels at the resourceful insolence of these builders, their disregard of accepted categories of judgment—anthropocentric and pragmatic categories which make us habitually assess things and events in terms of mutually exclusive opposites: the real and the imaginary, the natural and the man-made, the utilitarian and the aesthetic, the living and the lifeless, the permanent and the ephemeral. These builders continually overstep such borderlines, they jumble opposites together and multiply ambiguities. Their ignorance of ar-

chitectural and cultural traditions is too insidious and subversive for it to be put down to autism, to absorption in a mental world of phantasy. For in fact these builders, and the makers of Art Brut generally, are more attentive, more responsive and also more allergic than normally integrated individuals to the principles and conventions governing social life. And so they are more inclined to question these principles, to take liberties with them, to reverse or interchange or replace them, rather as linguists do with words to see how the system works. True philosophy is not the one that lays down certainties and classifies phenomena; on the contrary, it is the one that discerns the reasons for these categories and makes clear how arbitrary they are. These architectural digressions may therefore be considered as something in the way of a questioning and admittedly bewildering philosophy, and a philosophy not only hatched in the brain but materialized, embodied, experienced, felt and tested by all the senses.

Stephen Sykes (1898-1964): 65-Foot Tower called "Incuriosity" at Aberdeen, Mississippi.

The First Psychiatric Collections

I have referred to the interest which, from the early twentieth century, certain psychiatrists began to take in the handiwork of their patients. At first these objects and pictures were regarded only as diagnostic evidence. But some psychiatrists with a keener sense of art, like Auguste Marie, Charles Ladame, Walter Morgenthaler and Hans Prinzhorn, went beyond this strictly symptomatological stage and recognized the aesthetic quality of some of these works. From that point it was only a step to collecting them and studying and publishing them. So it is that the collections set on foot by these doctors contain the earliest surviving works of Art Brut.

One point, however, needs to be made clear: Art Brut cannot be equated with the forms of expression described as "psychopathological" by psychiatrists who have presumed to take an over-all view of the works produced by interned mental patients, as if those works had specific features in common. There are many makers of Art Brut who have never undergone psychiatric treatment and are perfectly sane. Conversely, the art products of interned mental patients are not necessarily Art Brut, far from it. In the collections of psychiatric hospitals, really inventive objects and pictures are the exception in a mass of works as imitative and stereotyped as the common run of works to be seen in art galleries. I shall try to show later that, where creative art is concerned, the criterium of sanity or insanity does not apply and that the would-be category of "psychopathological art" is meaningless.

The fact remains that a mental hospital, as a place of social exclusion and therefore of revolt and contestation, is or anyhow has been more conducive to free expression unfettered by cultural ties than, for example, an art school, and that there is more chance of finding Art Brut in it. And we do find it in some of these psychiatric collections, especially the earlier ones, and so plentifully that it is impossible to give anything

Collection of objects made by mental patients, ▶
belonging to the Swiss Psychiatric Society,
housed in the Waldau Psychiatric Hospital, Bern.

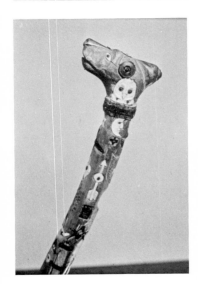

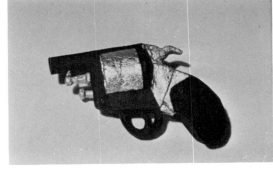

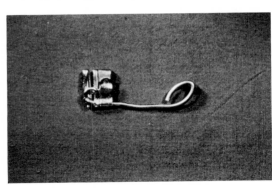

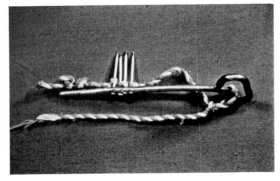

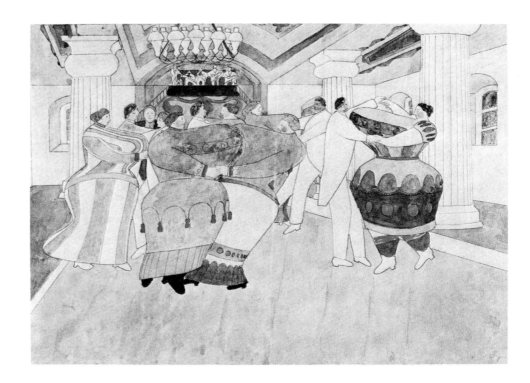

Gustav S.: Dancers in the Ball-Room.
Prinzhorn Collection, Heidelberg.

like a full survey of them here. One of the oldest and most interesting collections is that of the Swiss Psychiatric Society, on deposit in the Waldau Psychiatric Hospital in Bern. Beginning at the end of the nineteenth century, the Waldau doctors carefully preserved, as part of their patients' files, such writings, drawings and other handiwork as they considered significant. One of the pioneers was Dr Walter Morgenthaler. While on the Waldau staff from 1908 to 1910, he developed this collection into a small museum and contacted doctors in other Swiss psychiatric institutions, asking them to contribute works to it. Morgenthaler also made a close study of the creations of Adolf Wölfli, the most famous inmate of the Waldau hospital (see page 109). In 1921, a year before the appearance of Prinzhorn's pioneering book, *Bildnerei der Geisteskranken*, Morgenthaler published a monograph on Wölfli [2]; it is remarkable in many ways, but especially for the primacy of aesthetic over clinical emphasis. The Waldau collection continued to grow, in spite of pilfering and some regrettable sales which the Swiss Psychiatric Society saw fit to make, and it is now displayed in an attic room in the Waldau hospital in Bern. It includes works

by Adolf Wölfli, in particular a painted cupboard containing his bulky autobiography, some paintings by Heinrich Anton Müller, and a large quantity of writings and drawings of uneven quality, of which no inventory or checklist has ever been made.

Another early and unusually rich collection, begun by Dr Hans Prinzhorn, is that of the Heidelberg Psychiatric Clinic. Born in 1886, Prinzhorn spent his youth in Vienna and gave up a career as an opera singer to study medicine. He very soon realized the importance of Freud's work. Combining, as few psychiatrists of his generation did, an artistic temperament with psychoanalytical insight, he was able to appreciate the inventiveness shown in some of his patients' work without reference to academic standards. Well informed about avant-garde art and familiar with collections of African and Oceanian art, he discerningly interpreted the works of Karl Brendel, Heinrich Anton Müller, August Klotz, Peter Moog and August Neter not as distortions or aberrations, but as autonomous and elaborate systems of expression, capable of conveying and developing a unique personal experience. In 1922 he published his richly illustrated book, *Bildnerei*

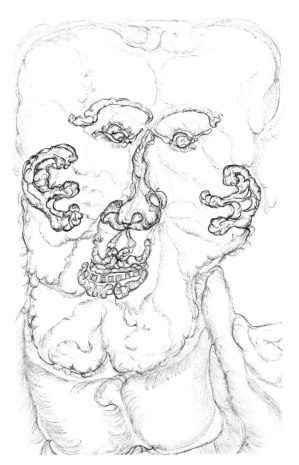

Karl Brendel (1871-?): Tadpole Man. Prinzhorn Collection, Heidelberg.

Otto Stein: Apparition. Prinzhorn Collection, Heidelberg.

der Geisteskranken [62], the first survey of the art of the insane, seen not from a clinical but from a "phenomenological" point of view. The collection of the Heidelberg Psychiatric Clinic now numbers over 5,000 works by some 500 patients.

Two other collections made by psychiatrists are worth mentioning. Though smaller, they are of particular interest for their quality. Both were bequeathed to the Collection of Art Brut.

Dr Auguste Marie (1865-1934), a pupil of the great neurologist Charcot, was one of the first French doctors to recognize the artistic qualities of his mental patients' works and in 1900 he began collecting them. Among the many artists represented in his collection are the so-called Voyageur Français or French Traveller (see pages 127-128), Emile Josome Hodinos, F. Kouw, the Comte de Tromelin and Victor-François [9]. In studying their works, Dr Marie grasped some of the specific features of Art Brut as later defined by Jean Dubuffet. Dr Marie commented on them as follows:

"Most of the works were made by very simple people who had never learned any art technique. Their spontaneity is a further proof of their 'originality,' for the influence of no master is discernible in them. What is naturally to be found in them above all are memories and reminiscences

35

Robert Gie (1869-?): Circulation of Effluvia with Central Machine and Metric Scale, about 1916. Pencil and Indian ink on tracing paper.

of everyday life, cast into forthright and uncommon forms. Many of the paintings were made on newspapers or even toilet paper, with a vehemence clearly showing a real need for self-expression. These people contrive to procure all the necessary materials when the storm of creation is upon them...

"Here we glimpse moods and feelings so far unfelt, and unexpected turns of expression giving us an inkling of immense and novel torments. Our language, like every native language, has not given us words to convey such feelings. So the patient had no option but to create a new and private language to express himself, to record these ideas, in painting and sculpture...

"The insane schizophrenic is released by autism (psychic isolation induced by individual delirium) from the restraints of his surroundings. When he expresses himself by word of mouth, by writing or drawing, or by any sounds or forms, he imagines himself beyond the reach of what people will say and what is acceptable, what is

'right and proper' in the eyes of the average man. The result is that these productions are relatively independent, the more so as his autism is more advanced and complete and his schizophrenia more accentuated" [9].

Dr Marie writes of course as a psychiatrist, committed to a medical point of view. However responsive to the creative power and originality of these works, he views them as the interesting outcrop of a mental state which he persists in describing in pathological terms. Nevertheless, he shows unusual insight into the social, material and mental conditions favorable to direct and spontaneous creation, uninhibited by cultural models.

Another pioneer in this field was Dr Charles Ladame (1871-1949), president of the Swiss Society of Mental Specialists. From the collections he built up in the psychiatric hospitals of Geneva and Solothurn, the work of two patients is illustrated here. One is Robert Gie. Suffering from persecution mania and hallucinations, he was in-

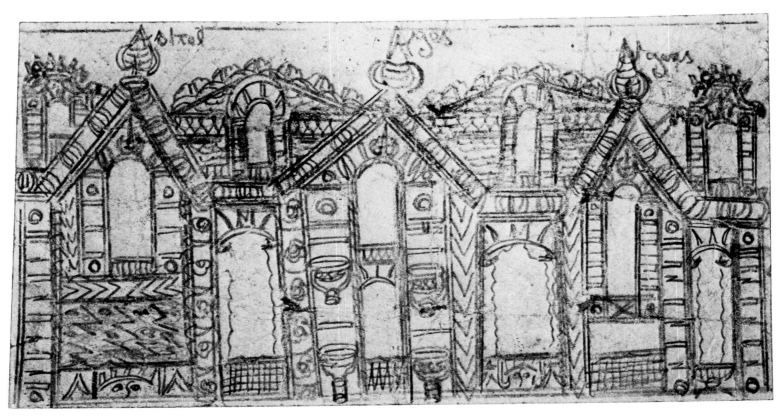

Jean Mar (1831-1911): House with Three Gables, about 1908.
Pencil on ochre paper.

terned in the Rosegg Hospital near Solothurn and began drawing in 1916 [3]. He was obsessed by the figure of a dehumanized, automated, remote-controlled individual, traversed by mysterious fluids or charged with cosmic currents. The other is Jean Mar, one of Dr Ladame's patients in Geneva. Locked up in his inner world, he seized on every scrap of paper that came to hand, exteriorizing his megalomaniac dream of being a mighty castle owner of royal descent, in drawings made with paradoxically rudimentary means.

It will be noticed that the inmates of mental hospitals who have produced art works are often designated by their Christian name alone, or by that and the first letter or syllable (such as "Gie" or "Mar") of their surname. This common medical usage, adopted for the sake of discretion, goes back to the time when madness was considered a shameful taint. I do not share that view and have accordingly given the artist's full name whenever it could be ascertained; in many cases, however, it has proved impossible to discover his or her true identity.

An Enemy from Within

The original Collection of Art Brut was made and named by Jean Dubuffet. It is important to be clear about the principles behind it. But before going into them, a few words are called for about Dubuffet himself, who has been the most active champion of Art Brut. His position is that of an outsider, standing in the no-man's land between culture and anti-culture. This position of his has been a pretext for the specious arguments of all those who are intent on compromising and neutralizing Art Brut and integrating it into the regular art circuit. If Dubuffet's own work could be said to have its place in the art establishment, in the avant-garde section of that establishment presumably, then by the same token, in view of his link with Art Brut, the latter could be seen in a cultural perspective. Once this was admitted, then by a gradual assimilation, starting with the most hybrid cases and pleading the necessarily arbitrary character of any category, the makers of Art Brut could be ushered one by one into the museums and the cultural circuit. A stop needs to be put to this insidious move towards *normalization*.

To suppose that Dubuffet himself is a creator of Art Brut is of course preposterous. His experience and grasp of culture and its means of diffusion, together with the place assigned him in the art world (if only because of the prices which his work commands on the art market, and which his detractors like to insist on), suffice to distinguish him from the makers of Art Brut as I have described them. Nor has Dubuffet ever claimed to produce Art Brut.

On the other hand, one would have to be blind not to feel the subversive energy of his works and their defiance of the prevailing system of art production and consumption. There is no need to spell out the point here. He has been a rebel from the start. Six months as an art student at the Académie Julian in Paris filled him with a lifelong repugnance for the social and cultural status of the artist. He determined to make himself a painter from scratch, in all innocence and rejoicing, as if museums, galleries and art dealers had never existed. In 1946, in his *Prospectus aux amateurs de tout genre* [11], he set forth his views on an art that could be practised spontaneously by anyone, not requiring providential gifts or acquired skills, an art flowing from the joy of life, not requiring initiation into a craft open to few. He turned his back on our cultural heritage and went to live with the Bedouins in the Sahara, until, in their expressions of the narrowness and solitude of their life, he came to see a culture not much different from any other. He had gone in search of utopias and he was disillusioned with them one by one, but in the end his lifework has had the most radical impact on the very citadels of culture, in those utopian places where the work of art is enshrined in its frame. Dubuffet came to realize that, stemming from his own culture, his work was addressed to cultured people and that all his discoveries were in the nature of a sacrilege, whether he wanted them to be or not. So he accepted them as such and came to terms with his sacrilege, making it an ally in his work of subversion, in his reversals and paradoxes. If one's attempts, however extravagant, to get away from the art establishment are doomed to be caught in a cultural web that proves to be indefinitely extensible, then why not reverse one's strategy, feign allegiance to the system and play the art game, while scoring off its cultural inhibitions so unfairly as to produce an explosive backfire!

There is a picture by Félicien Rops representing St Anthony: kneeling before a crucifix, the saint looks up at the emblem he has invoked to ward off the temptations of the flesh, only to see a naked smiling woman taking the place of Christ. If Dubuffet were to paint a crucifix, he would undertake to bring into the picture, into the sacred space of art, everything that is normally kept out of sight so that the performance can take place: the material means of producing the display, the pigments, the tools employed, the

Katharina (born about 1910): Human Body, 1965. ▶
Pencil and colored crayons on paper.

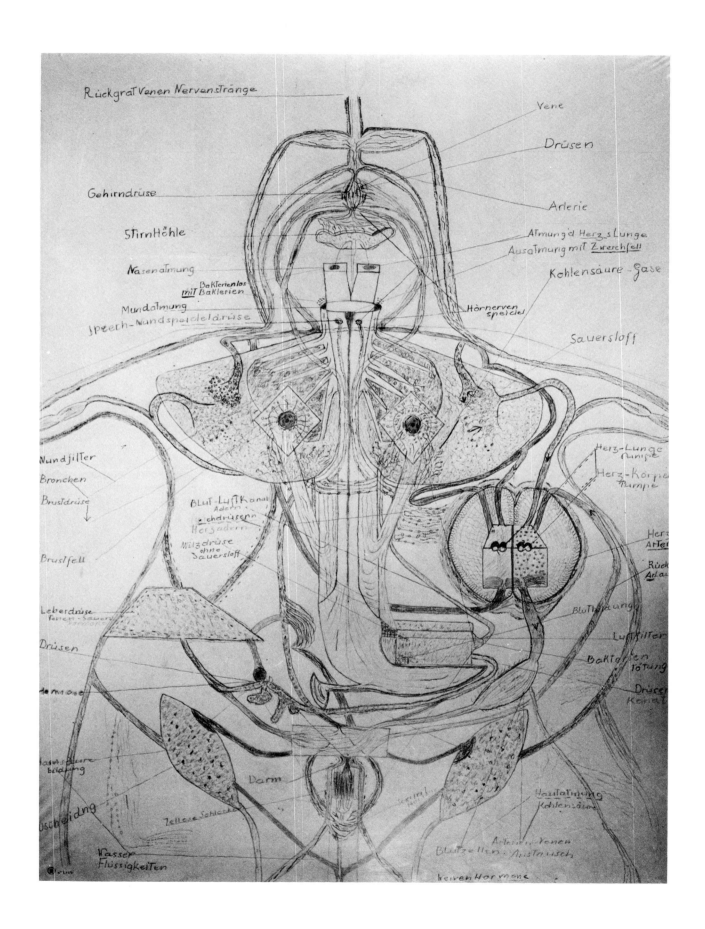

technical gadgetry, all the machinery normally kept behind the scenes in order to put over the illusion—even the illusions of non-figurative art.

Dubuffet, then, is no more an "artist" in the cultural sense of the term than he is a maker of Art Brut. Well, is he half-way between them? No, he is not. Now is as good a time as any to root out that inveterate habit of fitting art works into a sequence of adjacent categories. Take the French parliament: the deputies sit in a semicircle, in a fan-shaped order ranging from right to center to left. As applied to creative art, that fan-shaped succession of tendencies or categories has the same function as a parliament does to real social forces: it is a delegation or transfer of authority, in other words it is a device which, if it is to work, requires continual renewal to keep it from drifting out of touch with reality. As a worker in the cause of that renewal, Dubuffet must be defined in strategic terms as an *enemy from within*, using the cultural instruments and institutions at his disposal to wage war on culture.

But it is not my purpose to analyse his work; for that the reader can be referred to the monumental commentary of Max Loreau [56]. My point here is to expel the illusion that there are two distinct figures in Dubuffet, the "artist" and the discoverer of Art Brut, and cut short the speculations that illusion gives rise to. Bringing together the Collection of Art Brut was one stage in that trajectory of his which I have described above. The idea at the back of his mind was to introduce it into the cultural circuit, but as an engine of war for the purpose of shaking things up and overthrowing the established hierarchies. Moved up into the breach, these so-called aberrant works would then, in comparison, reveal their power: "For we must be clear about what we mean by a work of art and what we expect of it, and distinguish between cases when it is aberrant and cases when it is not. I fear that it is commonly considered good in cases when it is slack—I mean when the temperature is low and the dose small—and aberrant when it begins to be just too much of a good thing. If you take this view of the matter (as I do), you no longer see any difference in kind between Art Brut and (shall we say) cultural art but only a difference of intensity. Art Brut then ceases to seem aberrant.

It appears as the true work of art, and cultural art as a paltry, watered-down counterfeit" [11].

It is open to anyone to blacken the picture, to interpret Dubuffet's intrusion into the art system as a compromise and the housing of Art Brut in a museum as a comedown to the cultural level. Sarcastic disparagement is an easy enough attitude to take. There are people who feel relieved to hear about the source of Marx's income or Freud's jealous watch over his wife and make much of it, as if these private inconsistencies were a fatal flaw in Marxism and psychoanalysis, reducing them to more "human" proportions and enabling us after all to dismiss them from our mind. Culture addicts behave like people with a contagious disease whose only consolation is to keep an eye on others in hopes of detecting the symptoms of their own illness. And it is true that culture is contagious: in no case can a work of art entirely escape from it. Creative work cannot be carried out without a certain ambiguity, at times a certain duplicity, which makes it vulnerable to disparagement. One can always apply the argument of Zeno to it to show that it can never get loose from the net of imitative affiliation and that, strictly speaking, it is not creative at all. Such disparagement will always have formal logic on its side. Let it! Far better to take the other side and opt for positive contradiction and duplicity!

The Collection of Art Brut

Jean Dubuffet began prospecting for Art Brut during a trip to Switzerland in 1945. He got encouragement from the Swiss writers Paul Budry and Charles-Albert Cingria and the painter René Auberjonois. He visited Swiss psychiatric hospitals and looked over their collections. He had no thought then of forming a collection. His idea was to publish a book on Art Brut, and for this he gathered material and solicited essays (from René Auberjonois, for example, on the Swiss painter and draughtsman Louis Soutter [69]). Then he decided on a periodical publication and in 1946 approached Gaston Gallimard about it; the latter, after considering the project, in the end turned it down.

Meanwhile, the interest of a number of other people in France had been aroused. Some went into action and helped to enrich the collection which Dubuffet had now begun to make. In November 1947 the Foyer de l'Art Brut was opened in two basement rooms of the René Drouin Gallery in Paris. The constantly varying selection exhibited there over the following months included works by Wölfli, Crépin, Aloïse, Salingardes, Hernandez and Juva. In September 1948 the collection was transferred to a house in the Rue de l'Université, lent by the publishing firm of Gallimard. At the same time it was placed in the care of a company founded for the purpose, the Compagnie de l'Art Brut. In addition to Jean Dubuffet, the founders included André Breton, Jean Paulhan, Charles Ratton, Henri-Pierre Roché and Michel Tapié. Dubuffet, together with the painter Slavko Kopac (later to be curator of the collection), set up exhibitions of work by Wölfli, Aloïse, Gironella, Auguste Forestier, Heinrich Anton Müller and Jeanne Tripier. The Company soon numbered over sixty members and the collection kept growing. A series of booklets were published in 1948-1949, privately printed by the authors themselves: Gaston Chaissac, Jean Dubuffet, Miguel Hernandez, Slavko Kopac and Jean L'Anselme. In October-November 1949 the first large-scale exhibition was held at the René Drouin Gallery, showing 200 works by 63 artists. The catalogue contained Dubuffet's manifesto in favor of Art Brut as against the cultural arts: *L'art brut préféré aux arts culturels* [11].

But there was not much room in the borrowed house in the Rue de l'Université; there was no certainty about the tenure of the house, and no staff; financial resources were slender and a certain passivity prevailed among the members of the Company. By 1951, therefore, Dubuffet was ready to accept the offer of the painter Alfonso Ossorio to ship the whole collection to New York and set it up in the spacious rooms of Ossorio's house at East Hampton on Long Island. Beforehand, it was decided to break off activities in France and wind up the Company. Its dissolution at least had the positive effect of clearing up the ambiguities in the attitude of certain members. Thus in a letter of protest against the breaking up of the association, André Breton—not without some inconsistency—attacked the very notion of Art Brut and maintained that the "art of madmen" should be distinguished as a separate entity [11].

Prospecting began again in France in 1959, bringing to light a rich new assortment of works. These were added to the collection when it was shipped back to Paris in 1962 (after being exhibited at the Cordier and Eckström Gallery in New York in February 1962). Back in Paris, it was installed in a four-storey, fourteen-room building in the Rue de Sèvres, fitted up as a center of conservation and study, closed to the public but open to any interested visitors who asked to see it. Slavko Kopac became curator. The Compagnie de l'Art Brut was re-established in July 1962 with a hundred members.

A fresh impetus was given to its activities, resulting in significant acquisitions, either by purchase or donation. Now, too, the old project of a periodical publication was finally carried out and between 1964 and 1975 nine numbers appeared, each containing one or several monographs [1 to 9]. Many of them were written by Jean Dubuffet, some by Jacqueline Porret-Forel [7] and other authors. In April-June 1967 a selection of 700 works by 75 artists was exhibited in Paris at the

Magali Herrera (1914): "Mi testamento afectivo," 1966. Pen and Indian ink on drawing paper.

Joseph Crépin (1875-1948): Composition No. 32, 1939. Oil on canvas.

Simone Marye (1890-1961): Figure, Dog and Birds, 1959-1961. Pencil, colored crayons and ballpoint pen on paper.

Musée des Arts Décoratifs. Jean Dubuffet prefaced the catalogue with a text entitled *Place à l'incivisme* [10]. In 1971 the *Catalogue de la Collection de l'Art Brut* [12] appeared, listing 4,104 works by 133 artists. More than 1,000 additional works, which stood on the borderline between Art Brut and cultural art or whose makers had joined in the activities of galleries and museums, were listed among the "subsidiary collections."

Anxious about the future of the collections, Jean Dubuffet began to look around for a community that would undertake to provide a permanent home for them. Negotiations were entered into with the municipal authorities of Lausanne, in Switzerland, and with the support of the mayor, Georges-André Chevallaz, an agreement was reached. The collections were made over to the city of Lausanne, which engaged to provide for their conservation, administration and permanent public exhibition; and to house them the city purchased the Château de Beaulieu, an eighteenth-century mansion near the center of Lausanne, and engaged to fit it up for the purpose. The Compagnie de l'Art Brut in Paris was dissolved and the town council of Lausanne ratified the agreement in October 1972. In March 1976, duly installed in the Château de Beaulieu, the Collection de l'Art Brut opened its doors to the public.

Auguste Forestier (1887-1958): Model Ship, between 1935 and 1949. Assemblage of pieces of wood and other materials.

TINKERING AND SAVAGERY

It's a Fine Republic they've set up their fashions are a chip of the old block they have secrets and quaint ideas in their head it is no use playing with them, they resort to their side arms. Their war secret is not written down they keep it hidden in their minds it's a new model precision rifle nobody knows about it's a wooden wizard's rifle, make no Mistake.

Heinrich Anton Müller

Clément

Born in 1901 in a village of the Lozère department of southeastern France, Clément was one of fourteen children. The whole of his boyhood and youth was spent working on his parents' farm [1]. He had no schooling and never learned to read or write. Always fighting and quarrelling with his brothers, he tried to set fire to the house in 1925 with a bundle of banknotes representing the family savings. After that he was interned in an asylum. Used to freedom and an open-air life, he found detention unendurable and reacted violently, making twelve attempts to escape. This only made his lot worse: he was put into solitary confinement in a narrow cell which he scarcely left at all for two years.

After six months of solitude, Clément conceived the idea of carving the panelled wall of his cell, using the only tools he had: a spoon and the broken handle of his chamber-pot which he whetted on a stone. When these makeshift tools were taken from him, he contrived to make others. He ended up by carving the whole of the wall panelling which, after many vicissitudes, is now in the Collection de l'Art Brut.

Clément was released in 1931 and found a job as a farmhand. Questioned in 1964 by Dr Roger Gentis, to whom we owe the preservation of the panelling, Clément declared that he had done no further carving since his release from the asylum: once he had been set free, such work lost all meaning for him.

He divided up his wall into 189 small panels carved in relief (of which 181 survive), running vertically along the slats and horizontally in

parallel tiers. The figures are repeated in a more or less stereotyped way: two superimposed wheels, a figure in front view, three figures in a row, two superimposed animals, trees, etc. The figures are treated frontally, hieratically, without any concern for illusionist suggestion. On the contrary, Clément systematically flattened his forms against the plane, rough-grained surface, notching them with rude straight strokes, simplifying them to the point of abstraction and making them sometimes difficult to decipher.

In front of a perplexing piece of work, one's first reaction is to look for antecedents (in which previous works did the artist find his models?) or, failing that, to seek out kinships and analogies: a rooted cultural habit that impels us to neutralize the unknown by the known. It would be surprising indeed if, with the history of world art at our fingertips today from the cavemen onwards, we failed to find an analogy or two. But is this comparative method of any help in the present case?

First of all, Clément's carved panelling is characterized by repeat designs, a regular and continuous rhythm, like a figurative litany. The more so since the individual panels are set out in superimposed tiers and naturally ask to be perused row by row from left to right, like a written text. They are like the long figure processions of Byzantine mosaics or paintings, which are so arresting and strangely poetic in their very monotony.

Then, as one looks more closely at the designs, one can appreciate the ingenuity with which Clément translated the three-dimensional forms into the flat plane of the wall and the rectangular area of the individual panels. He freely combines different points of view, varies the proportions, emphasizes one part of the body and cancels out another, with no thought for anatomical conventions, but showing all the while a keen sense of plastic coherence and the telling ellipsis. The Romanesque artists come to mind, their bas-reliefs and sculptured capitals, for example, in which they show the same ingenuity in recasting their figures to fit the architectural support.

Further, Clément is seen to take curious liberties in schematizing and generalizing his forms. He seems to have deliberately avoided anything

like individualization and, *a fortiori*, anything in the way of psychological or anecdotal expression. The same device is common in African Negro carvers, who also refrain from any individual reference, because they think of their statuettes as "snares" designed to capture undifferentiated forces: the magic of the carving depends on the general scope of its forms. The comparison may even be extended to points of technique. Like the African carvers, who never used a roughing-out chisel but cut directly with a knife and got a powerful effect of broken planes, Clément made the most of direct cutting along the grain of the wood, even slicing it open with a gash. Here and there he worked in terms of negative volumes, obtaining relief not by projections but by sunk carving.

Further analogies with modern art come to mind. For example, the process of abstraction by which the lines of force are gradually made to extend from the figurative to the non-figurative, or rather to an extreme generality of figuration, as in Mondrian's experiments with the representation of a tree. Or take the check patterns: they are reminiscent of certain compositions by Paul Klee.

But is there any point in looking for parallels? Clément was illiterate and it would be absurd to suppose that he made any borrowings from other cultures or even from contemporary art. Indeed, it is obvious that his work is not an assemblage of borrowed elements. On the contrary, it stems from a wholly personal fund of invention. Which is not to say that this or that problem of figuration or technique with which Clément came to grips in the course of his work may not have been met and solved in comparable terms by other artists in other times or places. But these analogies are fortuitous. This is a case of expression in the *savage* state, using that word in its most positive sense. Clément's technical and figural resources are entirely his own, even though they may be found to occur singly in this or that culture, and he combines them freely— one is tempted to say *anarchically*—with an unfailing originality. So we have a much better

Clément (1901): Detail of a Carved Panel, 1930-1931. ▶

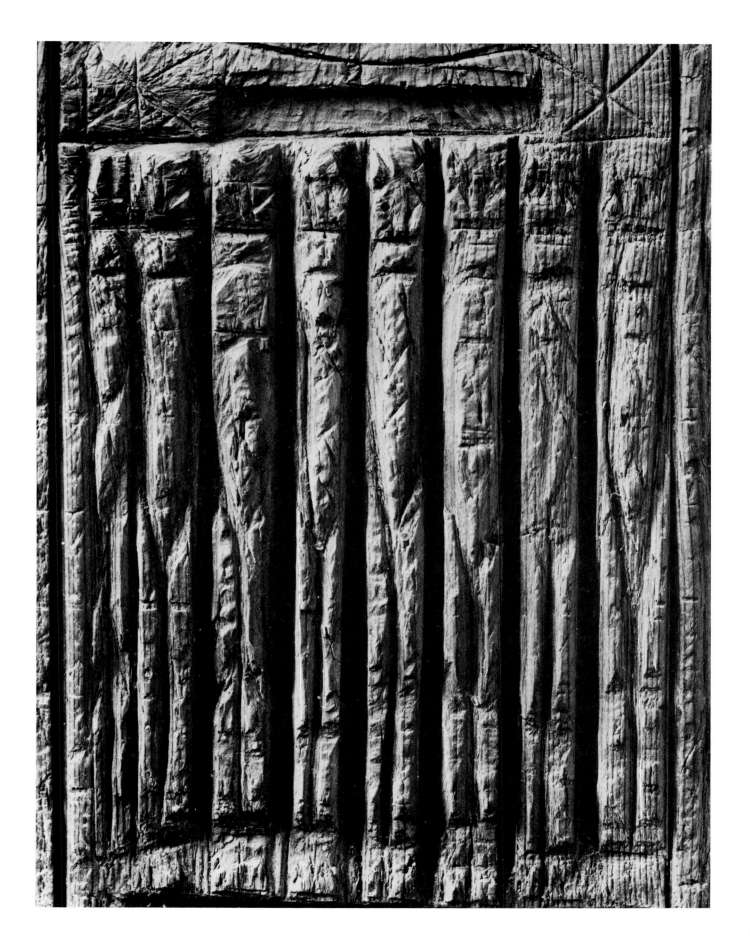

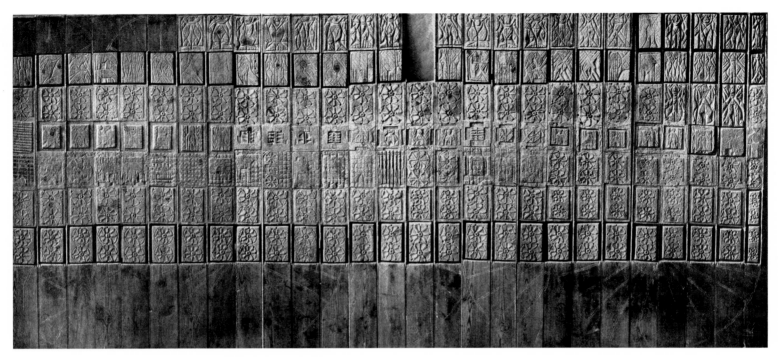

Clément (1901): Overall View of the Carved Panelling, 1930-1931.

chance of understanding his work by setting it firmly within its actual context than by looking for signs, doubtful at best, of outside inspiration.

His work is that of a prisoner, a man under duress, cut off from the world in spite of himself and compelled to live for two years in a state of unendurable solitude. For him, the act of carving was an act of aggression, a release of pent-up forces. The bursts of rage flash out in the repetition of motifs, a stubborn rage gradually controlled and in the end inventive. These long processions of figures have their underlying source, not in Byzantine decorations or Romanesque reliefs, but in what Freud called the "repetition compulsion," the emotional pressure of a traumatic situation which drives an individual to repeat a gesture or figure obsessively, to help him dominate that situation little by little. Clément reiterates the wheel design to mark the passing hours of the day, to exorcise the unendurable continuity of space and time. The check patterns repeat on the scale of the individual panel the overall structure of the wall panelling, which closes off the prisoner's world. In a sense Clément reproduces the patterns of his fate, to

give himself the illusion of acting upon it and gaining the initiative.

Once this figurative rhythm is worked out, he is free to make play with it, to deflect, reverse or syncopate it. The order imposed, the inexorable rhythm of the days, the obsessive patterning of the wall panels, all curiously combine to become the props and prompters of an unimpeded inventiveness. The repetition of figures functions like the constraints imposed by the rules of prosody, which are only apparent constraints, since they force the inventive faculty to outdo itself and come up with the most unexpected finds. Here perhaps is an essential paradox behind the work of any creative artist, who cannot set his course except on the basis of a given order. Thus the writer depends in the last resort on the inviolable system represented by the letters of the alphabet, and the musician on the notes of the scale. André Gide likened these constraints to the cord which seems to hold back the kite but without which it would never get off the ground. In inventing his own combinatory system, Clément brought the art of carving back to zero point and started afresh on his own resources, without the benefit of any cultural influence.

Art Brut and Child Art

If it is true that the maker of Art Brut, knowing nothing of established art forms and systems, regains a certain spontaneity and reinvents an idiom of his own, then perhaps his work can be likened in some ways to child art. One thing they certainly do have in common: the fact that neither has its source of inspiration in previous works. Neither is governed by that abiding principle of the psychology of art according to which "all pictures owe much more to the study of other pictures than to direct observation" (Wölfflin).

A child's first drawings spring from impulses in which the aesthetic element has no part. They are as yet indistinguishable from aggressive gesturing or the sheer elemental joy of scribbling or simply messing about. They correspond to the so-called "anal" phase of infant sexuality. What makes these initial drawings become more specific is not so much the often random recourse to pencil and paper as the child's jubilant discovery that a gesture can leave a mark and that the mark can be deliberately repeated. At this stage, the doodlings remain non-figurative. They are, rather, in the nature of a game over which the child gradually gains control as it finds that it can differentiate its marks, going from hatchings to spirals, to circles and so on.

An important stage is reached at the age of two or three, when the child becomes capable of establishing a relation between its pencillings and an object in its environment. It begins by recognizing this connection retrospectively in its scribbles, then goes on and seeks to achieve it deliberately, by means of a more intent control of the pencil and a better coordination of its gestures. The line is adjusted to a preconceived result (even if the mental projection of that result is continually modified during the execution of the drawing), and by the age of about four the child generally moves on to the stage of intentional realism.

What is important to note is that at this stage the child is led to seek original solutions to the figural problems it meets with, without yet referring submissively to the standardized system of figuration applied in its milieu. The drawings of

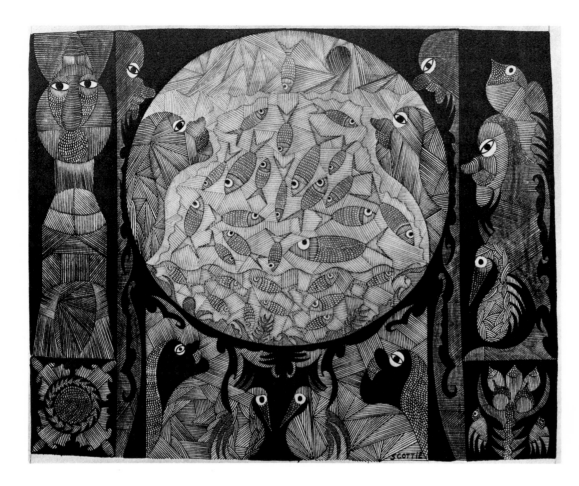

all children of this age, whatever the milieu or society to which they belong, have in common a very wide and very mobile range of expression. The conception of the drawing is at once open and unstable, the child continually modifying the pictorial principles it has adopted whenever they interfere with his ease or rapidity of expression. He never hesitates to change his scale or viewpoint in course of execution. Every drawing is an adventure, a sequence of problems with which he copes freely and inventively as they arise without keeping to any constant principles. Objects for him have an overall schematic configuration, after the manner of ideograms. He will linger at times over certain details, but suggesting them rather than representing them. The conception of space itself appears to be subordinated to this desire to convey the meaning without concern for visual resemblance, or at least for any unity of viewpoint. So it is that the inside and outside of a

house or bus are shown simultaneously, and the sides of an object are brought up to the surface, the child being intent on the fact of their existence, not on what the eye actually perceives. The predominant image of child art is the human figure, and it appears to be determined not so much by objective observation as by the child's subjective impression of its own body. Visual appearances are at times combined with those subjective impressions to surprising effect.

At this stage, then, children's drawings are marked by sturdy independence of figurative norms and a ready knack of capitalizing on any resources to hand which justifies the comparison with Art Brut. At the same time, however, those resources are largely a matter of fleeting intuitions which the child seems incapable of carrying through to any satisfactory completion. It is as if, at this level of his development, the human being gave glimpses of a dazzling wealth of possibilities

which, by some fatality, remain beyond his grasp and can only be looked back upon as so many lost opportunities.

Thereafter the child soon enters what psychoanalysts have called the "latency period," when the superego takes form under the impact of social and parental action and its interiorization. This is a process of conditioning which nowadays tends to begin and take effect at an ever earlier age. This means that, in their drawings, children are initiated earlier into conventional practices and attach greater value to them as a means of communication. From that moment, the pictorial rules peculiar to their cultural milieu prevail over the spontaneous expression, call it ludic or magical, which underlies Art Brut and true child art too.

One may assume, however, that the makers of Art Brut have to some extent escaped this repression, for reasons which I shall try to elucidate. They have had the power, given to few, of developing and fulfilling some of these buried potentialities, and of doing so with the forcefulness and purposefulness of adults. It is precisely this that distinguishes them from children: the purposeful, almost obsessive obstinacy with which they follow up a line of thought, and the technical mastery they acquire in their unremitting persistence. Into that obstinacy and persistence also enters a spirit of dissent, which drives them on to the furthest limits of a line of research which, in the eyes of other people, appears misguided and abnormal.

Scottie Wilson (1888-?): The City among Flowers, 1950-1951. Colored inks.

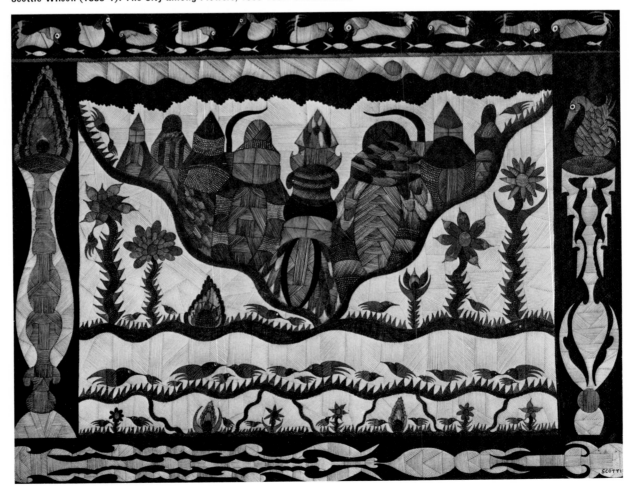

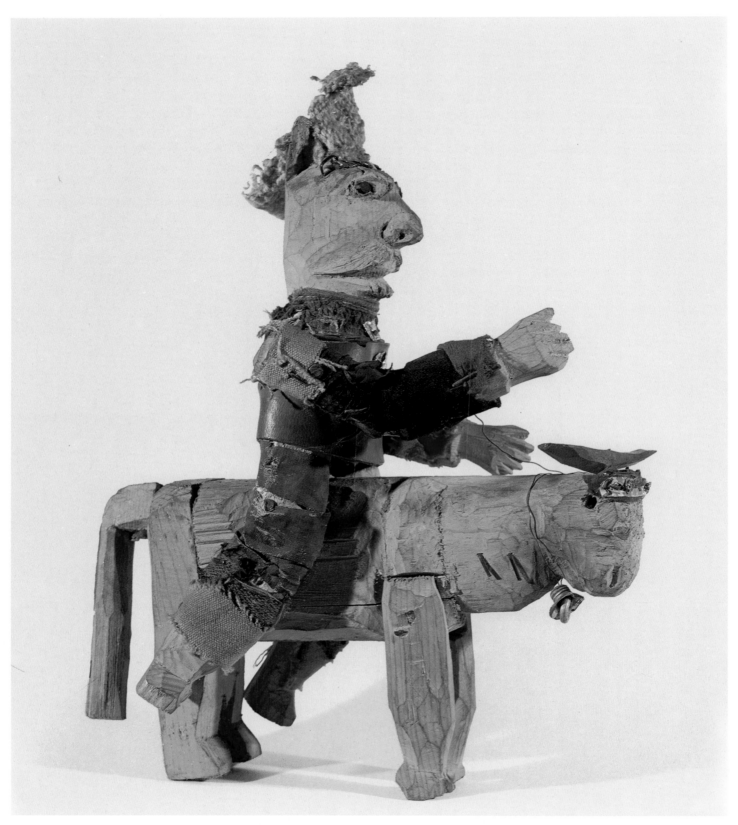

Auguste Forestier (1887-1958): Figure with Wolf's Ears Riding a Cow, between 1935 and 1949. Assemblage of pieces of carved wood and other materials.

Auguste Forestier and André Robillard

Born in 1887 into a family of small farmers in central France, Auguste Forestier was interned in 1914, at the age of twenty-seven, in the psychiatric hospital of St Alban (Lozère). He was interned, as Jean Dubuffet puts it [8], "for liking trains too much." Forever running away from home and work, he was arrested repeatedly for travelling on the railway without a ticket. In the end he derailed a train by piling up stones on the rails, because, as he explained, "he wanted to see the wheels of the carriages crush the rocks." A medical certificate describes him as follows: "Mental debility. A patient who is very proud of himself, constantly occupied in drawing and in carving bones from the butcher's shop. By working hard, contrives to carve them with a certain primitive art." Thanks to the tolerance of the hospital attendants, he was able to set up a rudimentary studio in a corridor. There he did his wood carving, his chief tool being a shoemaker's paring knife.

Forestier proceeded in a curious way, breaking his work up into distinct operations. First, he roughly squared in advance, one after another, a whole series of pieces of wood, with no definite figure or purpose in view. With this reassuring

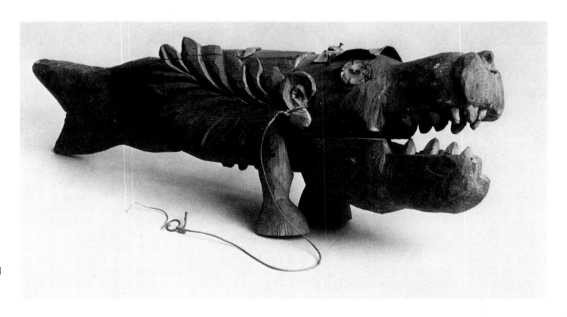

Auguste Forestier (1887-1958):
Winged Monster with Fish Tail,
between 1935 and 1949.
Assemblage of pieces of carved wood
with scraps of leather and bits
of a broken mirror.

53

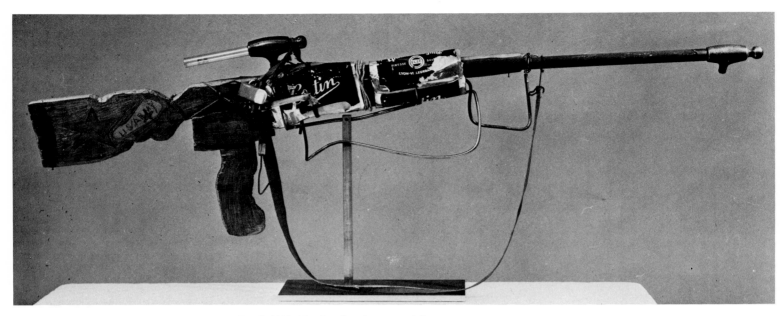

André Robillard (1932-?): Dummy Rifle, about March 1964. Wood and various materials.

stock of wood in readiness, he went on to make a second accumulation of odds and ends of any material he could pick up in the sweepings, the garbage from the hospital kitchen, the rubbish and leavings from the sewing room and the harness-maker's shop. With this stock of materials always to hand, he would dip into them whenever he felt in the mood, rapidly improvising as he went along, fitting or nailing pieces together and sometimes overlaying them with bits of cloth.

His works must therefore be considered as assemblages of pre-constituted elements rather than sculptures. In putting them together, Forestier makes no attempt to conceal the humble origin of his materials. On the contrary, he slyly contrives to suggest a certain sense of oddness and aberration by fitting a utilitarian object into a work where in fact it has no place. The effect of oddness is heightened by the forthright, unselfconscious spirit in which the assemblage is made, as if the maker wished to preserve the disparate, equivocal character of the parts and so took care to avoid integrating them into an organic whole. All this gives his work that savage aspect which the doctor had in mind when, in his report on Forestier, he referred to "primitive art."

Something of the same rugged savageness informs the work of André Robillard, about whom very little is known. Born in France in 1932, he was interned at the age of nineteen because of his ungovernable temper and aggressive behavior [12]. In 1964, in a sudden burst of activity which lasted only a few months, he set to work with scrap materials and made himself some dummy firearms. The Dadaists too had created works made up of ready-made elements lifted out of their original context; but they had done so in a spirit of derision and revolt against the smugness of official art. Robillard never thought of himself as entering the field of art at all, even as a parodist. It was a genuinely aggressive urge that led him to put together his dummy firearms, and though he never imagined that he could really make use of them, he did succeed in infusing them with a *magical* character that strikes the imagination and makes them seem like formidable weapons.

The Aesthetics of Tinkering

In analysing mythical thought and magical practices, Claude Lévi-Strauss has described them as a kind of *bricolage* or tinkering [55]. The handyman who tinkers with things is distinguished from the engineer by the fact that he is unable—or perhaps unwilling—to provide himself with tools functionally adapted to the object which he intends to make. As a matter of necessity or taste, he falls back on nondescript objects or fragments of objects which he picks up and keeps on the off chance that they may "come in handy." It often happens moreover that the idea of making some particular object only occurs to him while taking stock of his "treasures."

Now the mythical or magical mind, which professes to be quite as systematic as the scientific mind, if not more so, is forced to construct syntheses of the same type. But in doing so it does not create a functional, conceptual framework; on the contrary, it remains subject to the data of the senses and has to make shift with these. According to Lévi-Strauss, art stands midway between scientific knowledge and mythical or magical thought, owing to the fact that it integrates a contingency (that of its materials, of its subjects, etc.) into a structure (which gives the work its "meaning").

This is not of course a matter of clear-cut distinctions, but of poles which set up two opposing fields of artistic endeavor. At one pole is Western art since the Renaissance. Here the tendency has been for artists to conceive their work on the scientific model; that is, to provide themselves with means of execution freed from every contingency and designed to produce the effect they aim at. Oil painting and the easel picture have been found to offer the medium best suited to their purpose. At the opposite pole are the so-called "primitive" arts, which are related to tinkering inasmuch as the nature of the materials is here the deciding factor. Whatever the ritual requirements which must be met by a Dogon statuette or a Baoule mask, it is a striking fact that, as if by a miracle, those requirements tally with the shape, grain and knots of the piece of wood which the artist used, as if that wood were pre-destined for the very use he made of it. But let us beware of likening this "miracle" to the happy coincidences that sometimes occur in the most sophisticated modern art. The truth is that if this or that kind of tree is chosen by the carver, it is because that kind of tree is itself the object of a cult. As Jean Laude points out, "When the sculpture is carved according to the rules in the wood of a particular kind of tree, that sculpture, like the tree from which it was carved, partakes of the vital force of a spirit, an immortal ancestor on which a whole family of beings and things depend" [52]. This explains why a certain guiding initiative is left to the material itself, which is thought to have a soul of its own and an innate faculty of invention of which the carver is only the interpreter.

The point I wish to make is this: the emphasis placed by "primitive" artists on the raw material and accidents of execution is not a sign of technical inferiority. It simply means that they have chosen different options. Western artists seek to master their means of execution in order to obtain a transparent, unequivocal language of expression; they thereby succeed perhaps in rendering their subject with a maximum of precision. But this principle of rationality is based on the exclusion of all those implications which are not considered relevant to the meaning intended. The prerequisite and the drawback of that clarity of purpose are an elimination of any symbolic overtones. Of course it will always be possible for the psychoanalyst to detect a vulture in a Leonardo painting or traces of anality in Constable's impasto; but that is only to be taken as a symptom of inhibition. It is otherwise with the "primitive" artist and, *a fortiori*, the maker of Art Brut. They have no fear of being carried away by an overflow of unintended meanings. They welcome symbolic meanings and any overtones of suggestion, not claiming to be personally responsible for what their works may be or imply, nor supposing for a moment that those works confer any authority on the maker of them.

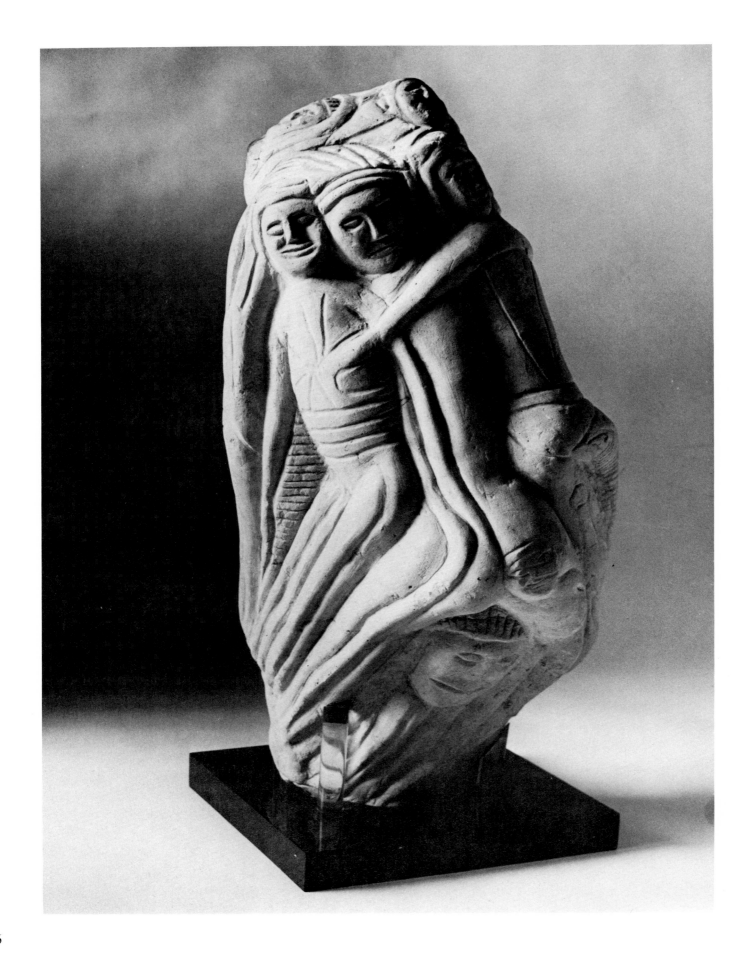

When the Materials Take the Initiative

Filippo Bentivegna (1885-1967) was born at Sciacca in Sicily, spent twenty years in the United States where he worked at many different trades, and then returned to Sicily where he remained until his death [9]. He was known as an odd character but enjoyed a certain consideration: people came to consult him on their private affairs and he acted on occasion as a water diviner. He took up sculpture on a piece of ground which he acquired in Sicily (but which he never farmed). He liked to carve heads in olive wood, in limestone and directly in the boulders on his land. With a good eye for the knots and gnarls of wood and the natural relief of lumps of stone, he made the most of them in shaping his figures.

He was fond of suggesting ambiguous figures, in unexpected combinations and transformations. These complex shapes, however, have nothing to do with those created by the Cubists. The latter combined several successive views of the figure or object, all more or less superimposed; they thus achieved a concentrated reprojection of space and time. Bentivegna did rather the opposite. He made play with the fact that a figure carved over the rounded surface of a stone is never fully visible from one point. Seen in receding perspective, it can never be quite caught by the eye in its entirety. Figures are continually changing and at the same time continually slipping from one's grasp. As one turns the stone, a woman's leg changes into a fish or some other object, in a kind of endless fade or dissolve.

Charles Paris, born in Paris in 1901, was a hired-car chauffeur by profession. He too reworked stones and chunks of olive wood to hallucinating effect. He did so, however, mostly by painting them, by setting off or heightening the forms suggested by the surface relief. In the result, it is as if the heads and faces had emerged of themselves and forced themselves upon him.

◄ Filippo Bentivegna (1885-1967): Embracing Couples, 1945-1950. Limestone.

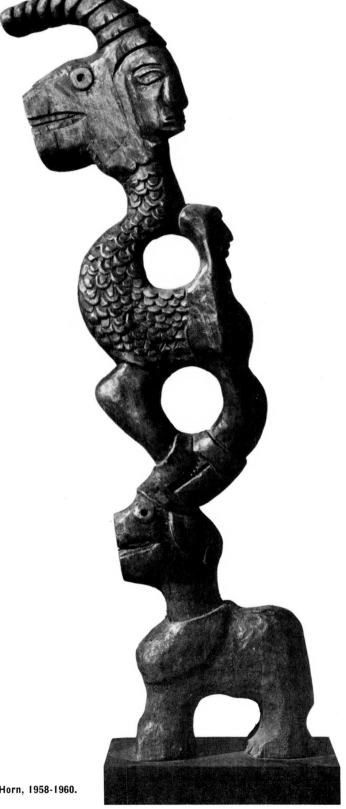

Bogosav Zivkovic (1920):
Figure Construction with a Horn, 1958-1960.
Wood carving.

Charles Paris (1901-?):
Left, Open Jaw of Painted Flint. Center, Round-Mouthed Head of Painted Stone. Right, Yellow Head with Green Eyes. Painted Stone. 1968.

The Yugoslav sculptor Bogosav Zivkovic represents an even more striking case of the materials taking the initiative [8]. Like the African carvers referred to above, he takes tree-trunks or boughs and elicits from them the figures potentially contained in them, simply clearing away the surplus wood around them. Such, anyhow, is the view he expressed to an art critic who asked him where he found his fantastic creatures, which look like a medley of the animal and vegetable kingdoms. "They are hidden inside the tree-trunk," was his answer. "They live there. I set them free, I release them from the matter that keeps them hidden" [17].

In one of his books the French poet Francis Ponge muses ironically on trees in spring, which throw out their leafage in every direction with the profusion of a too glib and self-assured orator: "They think they have a lot to say, they think they can flood the world with a variety of words. But all they say is 'trees'... Nothing in short can stop the outflow but this sudden remark: you can't get away from trees by means of trees" [60]. Zivkovic sympathizes with trees more than Ponge does. Jean Dubuffet understands his viewpoint and explains it very suggestively: "In the outlook of Zivkovic trees are all-important. They are his crystal ball, his vision-giving mirror, his reading glasses. He can see the world only in terms of trees; only through trees does the world take shape and logos. The form assumed by *space* in the art of Zivkovic is, curiously enough, a tree form. In his system of representation, a tree-like construction practically takes the place of traditional perspective" [8].

Although Bogosav Zivkovic is represented in the Art Brut Collection in Lausanne, he is sometimes taken for a "naïve" artist. But so much has been said above about the features which such works have in common with "primitive" art that it seems necessary now to clarify certain distinctions that must be made.

58

Art Brut and "Primitivism"

Considered from the point of view of his biological make-up, man is an extremely pliable creature. Unlike that of animals, his evolution is not determined by chromosomal heredity, but rather by the cultural heritage transmitted by education. That heritage differs from one society to another. In connection with child sexuality, Freud spoke of a "polymorphous perverse" predisposition: the infant, in his view, may combine in their embryonic state all the sexual possibilities which will later develop separately in the form of adult perversions [32]. This initial polyvalence can be extended to other psychic functions. Thus from an anthropological viewpoint one might speak of a "polymorphous social" predisposition: every individual, whatever the society to which he belongs, disposes at birth of an extraordinarily rich psychophysiological potential from which his education selects and develops certain virtualities to the detriment of others. Each culture shows a different pattern of potentialities developed and potentialities inhibited; in fact each culture is defined by that pattern. Lévi-Strauss has gone so far as to imagine the possibility of drawing up a table of these potentialities, analogous to a table of chemical elements, which would indicate at a glance the pattern peculiar to each society. For example, "the West, master of machines, shows a very elementary knowledge of the use and resources of that supreme machine, the human body. In this sphere, as in the related sphere of the interactions between the physical and the mental, the East and the Far East have an advance of several millennia over the West. They have produced such comprehensive theoretical and practical systems as the yoga of India, the Chinese techniques of respiration and the visceral gymnastics of the ancient Maoris" [54].

Lévi-Strauss has also shown how difficult it is for a culture to escape from its own patterns and take into consideration any human faculties alien to them. So it is that, when we try to evaluate the technical, intellectual or artistic level of a so-called "primitive" society, we are blind to whatever lies outside our own system of reference. The first colonists to come into contact

with such societies thought they were back in the Stone Age, not realizing that this technical backwardness was only one side of an unsuspected form of culture; not realizing that they themselves, with their myocardial infarctions and somatic disorders typical of the West, behaved like savages towards their own body. For one is forced to choose in Lévi-Strauss's ideal repertory; it is not given to us to draw freely on all the anthropological resources which he describes. The weekly yoga of the Western bureaucrat or the high-school boy's "trip" obviously do not take them very far in the re-education of the self and the body, but are more in the nature of a pathetic yearning for what they can never have.

Inevitably, then, the "primitive" strikes us first of all as a savage. This ethnocentrism has been particularly strong in the field of art. After a century of ethnological research into non-Western cultures, we have finally come to see that it is a mistake to equate those cultures with primitivism, sensual instinctiveness or "pre-logical" infancy. We can see in retrospect that the colonizers sought to justify their exactions by sneering at the culture of the societies which they destroyed. Painters like Vlaminck, Derain, Nolde and Kirchner were among the first to take a positive attitude to the arts of Africa and Oceania, making use of them in preference to their own cultural heritage. Yet they perpetuated the old idea of savagery and primitivism. No doubt these painters realized in a confused way that the exotic forms they admired embodied certain values and vital sources which had been hitherto repressed in Western culture. If they took them over, it was because in their eyes those forms represented a transgression of their own cultural patterns which they felt to be oppressive. And they were naturally inclined to interpret that transgression in terms of individualism and to see the African and Oceanian artists as spontaneous creators working entirely by instinct.

Today we know that these artists, for all their apparent spontaneity, were subject to institutional restraints; they had to obey religious and ideological injunctions and kept largely to traditional models. The fact that these injunctions and taboos formed in their culture a different pattern from our own made it seem at first as if they enjoyed a greater creative freedom. But when it became clear how binding were the cultural restraints imposed on these artists, their inspiration was seen to be no more exotic or instinctive than our own. They had appeared at first as savages to us, and we to them. Once this mutual misreading of the facts was cleared up, it was realized that both are equally subject to the dictates of their own culture.

Let this fact put us on our guard against assimilating "primitive" art to Art Brut. The latter is an art in open conflict with culture (understood as a collective system of values, myths, styles, etc.). It would be equally mistaken to interpret Art Brut as a recourse or aspiration to some *other* culture. Art Brut has no allotted place in Lévi-Strauss's table of anthropological patterns, not even in some still empty subdivision of that table. In relation to his milieu and cultural context, the maker of Art Brut remains fundamentally asocial.

There is of course no such thing as an individual totally "untouched by culture." The mere fact of learning to speak implies the assimilation of attitudes and ideas transmitted by language. The latter in itself represents a subtle "social superego" from which no one can escape. In the same way, there is no such thing as an individual who has never seen pictures and escaped from a certain visual conditioning. The mere fact that Art Brut is perceptible to us, however much of an aberration it may seem to some people, presupposes a common denominator, certain signs or means of expression which we recognize as such. What distinguishes the maker of Art Brut is that he uses these signs or means of expression in ways contrary to "common sense." He does not reject the established language of art—how could he?—but he systematically misuses it, he pervades it with a subtle form of meaninglessness which perverts or subverts it. Verbal and visual language is made up of signs which, to a large extent, fall into set patterns of usage, much as the objects do that surround us in daily life. This is where the maker of Art Brut comes in: to take up the comparison I started with, he appears like a satanic do-it-yourself man who, intent on his tinkering, ignores these set patterns, diverts forms and signs from their conventional use and

Joseph-Albert-Alfred Moindre (1888-1965): Moses, between 1940 and 1947. Gouache on drawing paper.

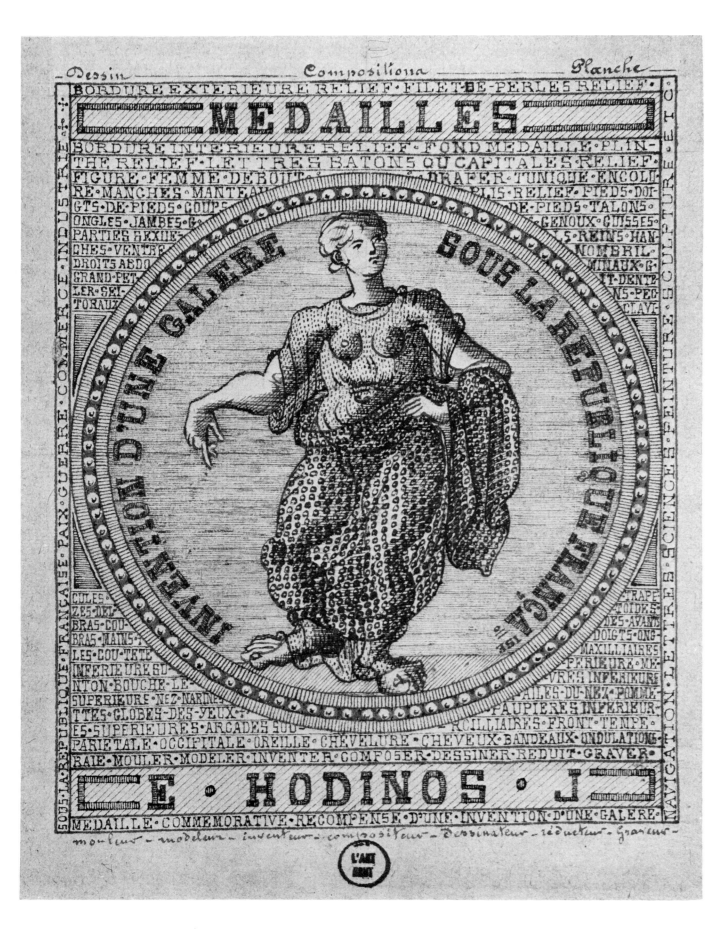

boldly goes ahead and inserts them in explosive combinations of his own.

Francis Ponge is a poet who in his own field shares something of this hostility to the established language and he helps us to understand it when he writes: "Words are ready made and express themselves: they do not express me. I stifle on them. Then it becomes useful to learn the art of *resisting words*, the art of saying only what you mean, the art of doing violence to them and subduing them... So let us hold words up to ridicule by doing our worst with them—by the simple misuse of words" [61].

But even these apt remarks by Ponge may lead us astray by suggesting a concerted attempt at subversion. No such motive applies here. The maker of Art Brùt does not take his stand on the ground of culture; he cares nothing about the effects his work may have in the field of art. It often happens that he will deny that it has anything to do with art (I shall come back to this point). His work in fact is a misfit in the world of art, and a highly expressive one; it lurches away from the established language of communication and by doing so suddenly brings to light what that language was designed to conceal. It is as if the pattern of rules laid down in Lévi-Strauss's table, with its system of compensation, proved to have a loop-hole and the mechanisms of inhibition broke down under the impact of unsuspected individual resources.

◀ Emile Josome Hodinos (1853-?):
"Invention d'une galère sous la République française,"
design for a medal. Pen and ink on paper.

Maisonneuve

Pascal Maisonneuve (1863-1934) was a second-hand dealer in Bordeaux, known for his truculent defiance of authority. He lost no opportunity of flaunting his anarchist and anticlerical opinions [3]. At the age of sixty-four he conceived the idea of ridiculing the rulers and prominent politicians of the day by making caricatures of them out of assembled shells. He worked on them for a year, then dropped them. But as he worked his initial motive of parody or caricature seems to have given way to something like a philosophical inquiry into facial expression.

Painters and poets have often remarked on the imperious attraction exerted by the human face in an imaginary space. One of them, Henri Michaux, has written:

"Draw with no particular intention, just doodle and let instinct take over, and almost always faces will appear on the paper.

"Leading what is to a large extent a facial life, one is also in a perpetual ferment of faces.

"As soon as I take up a pencil or brush, down on the paper they come, one after another, ten, fifteen, twenty of them. And mostly wild faces" [58].

How is one to explain this focus on the face? According to Gestalt theory, what captures the eye most immediately is the overall structure, the *form*, which is more than the sum of its elements and different from them; the latter are only determined secondarily, by the part they play in the whole, like the notes that go to make up a melody. The forms may have more or less force and pregnancy, according to their configuration, their unity, their symmetry, their completeness, etc. In keeping with this theory, the face must nevertheless be recognized as having a peculiar pregnancy of its own, for reasons which depend less on its morphology than on its formative role in the very genesis of perception. As René Spitz has noted [66], the face is, in the history of the individual, the first object that takes shape and stability in his visual field, for it is the object that monopolizes the infant's attention when it is being suckled, washed and tended. It therefore retains a prime libidinal value throughout one's

Pascal Maisonneuve (1863-1934): Head with Long Ears, 1927-1928. Assemblage of shells.

life, even having a tendency to rise up before the eye in hallucinatory form on chaotic surfaces (clouds and rocks) and in moments of distraction or reverie. It must be added that, up to the age of six months, the infant perceives faces only as a general phenomenon: it reacts indifferently with a smile to any face that appears before it frontally, whether that of its mother, another member of the family, an outsider or even a mask. It is only afterwards that the face becomes *personalized* in the child's mind, as it gradually becomes for him the seat of identity, of psychological inducement and emotional attachment.

This helps us to understand the strange power of fascination exerted by the shell faces devised by Maisonneuve. The transposition of the human face into the unexpected medium of seashells (or any other unusual material) serves to cut it off from the *person* to which it is normally attached and therefore to release it from the network of psychological implications in which it is normally enmeshed. The effect is to reveal the workings of the physiognomical machinery. Thus wrenched out of its setting, it is again reduced to a general phenomenon and can again arouse the primitive emotions of the child looking up at the large, soulless faces bending over it . . .

The effect is also to convey what I would call the *biological* power of the human face: the physiognomy and its code of meanings take shape and develop in the field of the imagination, much as the genetic pattern does in the environ-

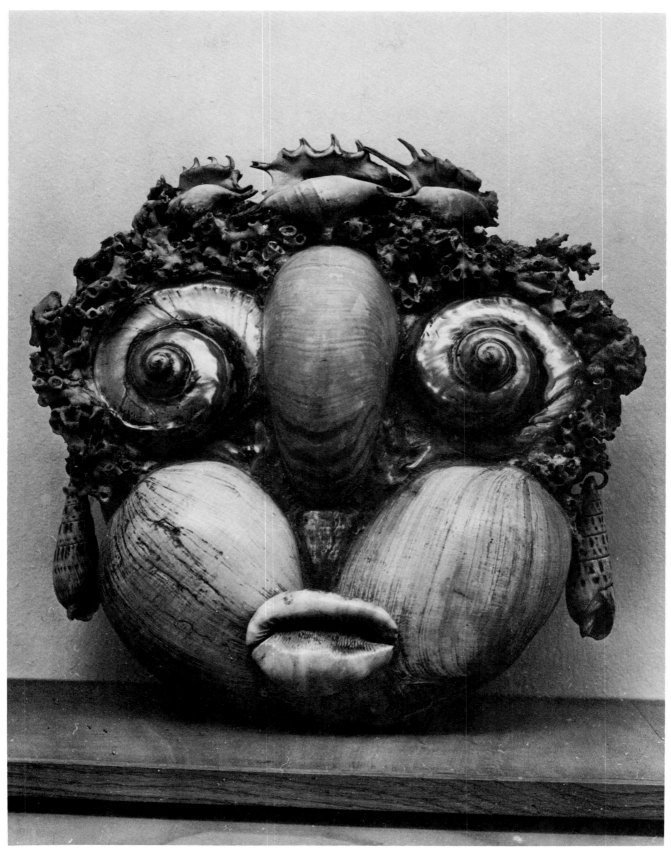

Pascal Maisonneuve (1863-1934): Faithless Woman ("L'éternelle infidèle"), 1927-1928. Assemblage of shells.

ment of the world. It is enough for its elementary outline to be given, and the human face comes to life in the most unexpected places and materials, investing them with its own features. The most spectacular way of conveying this power of proliferation is by trying to thwart it. Maisonneuve carries the experiment to its utmost limits. Taking forms as meaningful in themselves as seashells are, he yet contrives to reshape them into faces, to arresting effect. He makes play with the objective rivalry and conflict between the face as a whole and its component parts, the latter tending to revert to their original shape and nature as soon as we focus attention on them separately. The face continually takes form and breaks down under one's gaze, without ever quite achieving unity. This ever-shifting instability shakes one's belief in that personal identity which depends on the face for its recognition. And so it is brought home to us that Maisonneuve's heads go well beyond caricature and oddity: they turn our smile into a sense of uneasiness.

Paul End

"Tinkering" regarded as the inspired misuse of materials intended for other purposes is seen at its most obvious, and most striking, in assemblages, like those of Maisonneuve. But even in the case of drawings and paintings one can still speak of tinkering, applying the term here not to the technical means but to the system of figuration. The drawings of Paul End are a remarkable example of it.

Born in the 1890s in northern France, in the Pas-de-Calais department, Paul End had to start earning his living at the age of ten and became a worker in a steel plant [4]. In 1933 he was interned in a psychiatric hospital. He began to draw about 1937, copying the pictures in the French magazine *L'Illustration*. But his earliest surviving drawings date from 1948. Most of them were made with colored crayons on sheets of paper coated beforehand with white oil paint.

Paul End (1895-?): Landscape with a Car, 1948. Pencil and blue crayon on wrapping paper coated with oil paint.

Paul End (1895-?):
Landscape with Two Figures and Two Birds, 1949-1950. Pencil and colored crayons on wrapping paper coated with oil paint.

Eugène Gabritschevsky (1893-?): Coral Formations Rising from the Sea, 1939. Gouache.

What strikes one at first in these drawings is their syncopated rhythm, which seems to result from certain inconsistencies in the representation. Strongly marked figures and objects, like those in advertising imagery, are caught up in a network of straight lines belonging rather to the sphere of geometric abstraction. The construction of space is equally ambiguous. It is built up by means of juxtaposed planes, carefully respecting the two-dimensional order of the picture, as in the ornamental arts; but the surface is broken up here and there by emphatic diagonals receding into the picture with an effect of perspective.

These peculiarities are explained by End's manner of proceeding in the execution of his drawings. He began with a ruler and compass, apparently without any figurative intention, laying in straight lines and curves which combined in haphazard geometric figures. But as he drew he was tempted to interpret these lines in terms of perspective, so that almost as a matter of course the horizon opened up, the planes were marked out and recession suggested, giving rise to all sorts of objective forms. The draughtsman gave way confusedly to that temptation, without bothering about representational logic, unity of scale or any rule of pictorial coherence. He took pleasure, on the contrary, in conjuring up figures as unexpected and imperious as those of our dreams. Sometimes he reversed this procedure, tracing and combining various images taken from magazines, working them up into scenes of a haunting strangeness. He liked to capitalize on that singular credulity most of us have in front of pictures, letting ourselves be taken in by the most extravagant imaginings.

So there is no question here of an original conception of figurative art, one that could claim to have broken with the principles of unity of time and place. On the contrary, it is from the most conventional system of illusionism that Paul End takes his pictorial elements: naturalistic silhouettes, receding perspective, cast shadows, etc. But he uses them with the unselfconscious freedom of the do-it-yourself man, disregarding the contexts he takes them from and recombining them in free association. This procedure is again suggestive of the dream mechanism, which does little more than serve up "the day's leftovers," but without any regard for conventional logic.

Thus, contrary to what one might have supposed at first, this handling of the picture elements stems not so much from naïveté as from a certain jaunty insolence. Which calls for a further distinction.

Jean Radovic (1913): Victor Hugo fifty years on ("Victor Hugo cinquante ans après"), 1947. Ink and colored crayons.

Naïve Art and Art Brut

A naïve painter, by the usual definition, is a self-taught artist. As a rule he comes from the working class and has not had much schooling, or at least has none of the "culture of the cultured." He goes his way and does his work outside the normal circuit of diffusion represented by galleries and museums—anyhow at first. His style is shaped by the desire to render reality in careful detail, but without tying himself to the rules of conventional figuration; in this it is akin to the realism of child art. Perhaps the naïve painter is essentially characterized by this paradox: his inability—his highly productive inability—to conform to the academic principles which he nevertheless professes to follow.

For it is from academic art that he takes first of all his themes: religious, mythological and allegorical subjects, historical scenes, genre scenes, landscapes and portraits. He takes over its technique, which is generally oil painting and the easel picture. He even seems to adopt its values and often longs for academic honors (the Douanier Rousseau stood as a candidate for a vacant seat at the French Academy of Fine Arts). But he "artlessly" fails in his attempts to imitate that style. His perspectives go awry and his picture space builds itself up as best it can from a combination of different viewpoints; neither relationships of size and distance nor anatomical proportions are respected; the use of thick outlines and flat colors contradicts his efforts to achieve illusionism; unrealistic simplifications alternate with minutely delineated details. If naïve painters thus

Vojislav Jakic: Large Drawing with Inscriptions, about 1970. Ballpoint pen and colored crayons on two sheets of varnished Bristol board.

Albino Braz (1896-1950): Naked Woman with Birds, between 1934 and 1950. Pencil and colored crayons.

violate the laws of perspective, anatomical accuracy and unified lighting in spite of their bias in favor of them, it is not out of clumsiness and even less out of aggressiveness: it is because their way of seeing reality derives from the responses of childhood or, in some cases, from a longstanding folk tradition. They spontaneously rebel against academic rules, often in spite of themselves. In a word, the naïve painter has one foot in the world of cultural art, but cannot or will not make up his mind to set the other one in it, and it is this borderline situation of his that accounts for the paradox, the charm and also the fragility of his art. For how long can naïveté survive once attention is focused on it?

The notion of naïve art grew out of the ferment of French cultural life in the early 1900s. The public was charmed by this painting in its Sunday best which, flying in the face of all the revolutionary changes then reshaping art, perpetuated qualities of originality and wonder that were in danger of being lost. No doubt it answered to a certain nostalgia for a lost innocence. For what it offers is not so much a revelation as a projection of would-be blandishments, as is made clear by the lavish hyperboles of its zealots. "Freshness," "ingenuousness," "spontaneity," "sincerity," "innocence," "purity," "authenticity" and so on: these terms, applied obsessively to naïve art, are too hackneyed to carry conviction and not betray the uneasy conscience from which they spring. By their rose-colored denial of it, they testify to the trickery, prostitution and commercialism that threaten the whole of artistic life today.

This double-dealing is made worse by the fact of the recognition and institutionalization of naïve art by galleries and museums. Can naïveté, if conscious of itself and trumpeted to boot, continue to exist as such? Seeing praise showered on the naïve painters, one is quick to accuse them of artifice and disown them at the least sign that they may be playing up to the chorus of praise. What could be better calculated to spoil naïveté than that vigilance at once idolatrous and unrelenting? The appeal "Stay naïve!" is curiously like the "double bind" that psychiatrists tell us about—that parental demand impossible to satisfy because it is self-contradictory (like the unanswerable exhortation "Be spontaneous!" flung at his son by a vexed and bossy father).

Of course there are cases like the Douanier Rousseau, Louis Vivin, Camille Bombois, Morris Hirshfield and others who never swerved from their path and were able to adapt themselves to this contradictory situation. Perhaps some artists are so constituted that their dilemma acts upon them not as a hindrance but as a stimulus. Certainly these naïves cannot be suspected of mystification. But it must be admitted that they have become the object of a "mythification" which inhibits one from speaking naïvely about naïve painting and calls rather for an analysis and criticism of the eyes we look at it with.

They are eyes "shining with emotion," rather like the eyes with which we look at children's drawings. This emotion can be explained by the fact that both naïve and child art touch the secret places of the heart, without giving rise to any uneasiness. I have referred to the "polymorphous predisposition" of childhood, which presents in the savage and embryonic state an aggregate of anthropological potentialities from which society makes a selection. Naïve artists may be said to offer a certain resistance to that selection or anyhow they show a *partial* inability to conform to educational patterns. Children and naïves thus give free rein to faculties inhibited in most people. Now psychoanalysts have shown that the lifting of an inhibition creates a sense of uneasiness [34]. The conscious ego reacts by a reflex of displeasure and even horror against any impulse that threatens its system of defenses. If this is so, why do we react with emotion rather than uneasiness to the pictures of children and naïves? Because, in this instance, the transgressions I speak of never exceed certain limits and are never in danger of involving the viewer. One has the comfortable feeling that, however polymorphous their predispositions, the children will fit all right into the educational pattern and that the ingenuousness of the naïves, in spite of an occasional touch of insolence, can scarcely jeopardize their deferential attitude towards culture and its institutions. Savagery is kept within limits and can be contemplated without running any risks, like the animals at the zoo. And the emotion with which one responds to it is not devoid of a certain pat-

Miguel Hernandez (1893-1957): An Inhabitant of the Moon, 1946. Oil on wood.

ernalism. Just as the vindication of poverty always comes from the rich, so the vindication of innocence comes from the cultured, as if the latter felt and relished their power all the more for slackening the reins a little, but without ever letting them go.

With Art Brut, it is quite otherwise. Its makers are found to be indifferent to aesthetic and cultural standards or ignorant of them. They have no thought for the recognized subjects and techniques or established systems of figuration. True enough, they use the materials they find to hand and these bear a cultural imprint. But they handle them in a do-it-yourself spirit: tinkering is in their blood. These fossilized cultural elements are fitted into new and original combinations, rather like the metopes and architraves that one finds built into modern constructions in the neighborhood of archaeological sites. The effect of strangeness is the more haunting in that it stems from familiar things. What is more, the insights afforded into the hidden sides of human nature are deep and searching, not labile and fleeting as in child art. Once he strikes this rich vein, the maker of Art Brut is capable of devoting his life to it, unmoved by the remonstrances of his entourage. He follows wherever it may lead, improvising the instruments called for as he goes along, not caring whether he has reached or passed the point of no return. If we can keep up, he will take us to forbidden places, fearful in their fascination. Our first reaction may well be a horrified refusal to follow him on the darkening paths of psychopathological exploration. And even if we are able to go all the way, we soon find that the company we keep here does not produce that atmosphere of tender emotion and bonhomie that surrounds child art and naïve art. A visit to the Art Brut Collection in Lausanne is a trying experience; one cannot expect to come away unscathed. It arouses that gnawing uneasiness which a man always feels when carried beyond his bounds.

Gaston Duf

Born in 1920 in the Pas-de-Calais mining region of northwestern France, the son of a drunken and brutal father, Gaston Duf led from the start a blighted and broken life [5]. Puny, practically illiterate, suicide-prone and himself an alcoholic, he was dismissed from every job he took. At the age of twenty he was locked up for good in a psychiatric hospital in Lille. One day a doctor noticed some curious drawings half concealed in the lining of his clothes. Wisely, instead of trying to thwart this mania, the doctor supplied him with colored crayons and tubes of gouache. For six years Gaston Duf worked on drawings of continually increasing size, then left off and never drew again.

His favorite subject, an obsessional subject with him, was a strange, protean animal which he called a rhinoceros, but which obviously has little connection with the real animal of that name. In his hands it represents a kind of microcosm or generating principle of all real or imaginary forms. Philosophers have seen fit to take fire, water, atoms, essence, existence, etc., as the principle of their metaphysical explanations. Why not take the rhinoceros? The creation of the world, the appearance of life, the geological upheavals and the adventures of the mind might then be construed as the successive material and immaterial forms of an endless rhinocero-cosmic genesis. In any case one has the feeling that Gaston Duf is intent on putting his archetypal animal through all its paces, stretching, distorting or reshaping it as the fancy takes him, or oscillating between the hypertrophy of one part and the atrophy of another. When he turns to other themes, like Punchinello, a bird or common objects of everyday life, one soon realizes, from their swollen forms, their jagged contours, their odd protuberances, that these are further avatars of the rhinoceros.

Can this obsessional theme be accounted for by regarding it as the outcome of a childhood phantasy? After all, most children are apt to fix their terror of darkness on some monstrous animal, begotten by their imagination, and in some cases it refuses to be exorcized and survives into

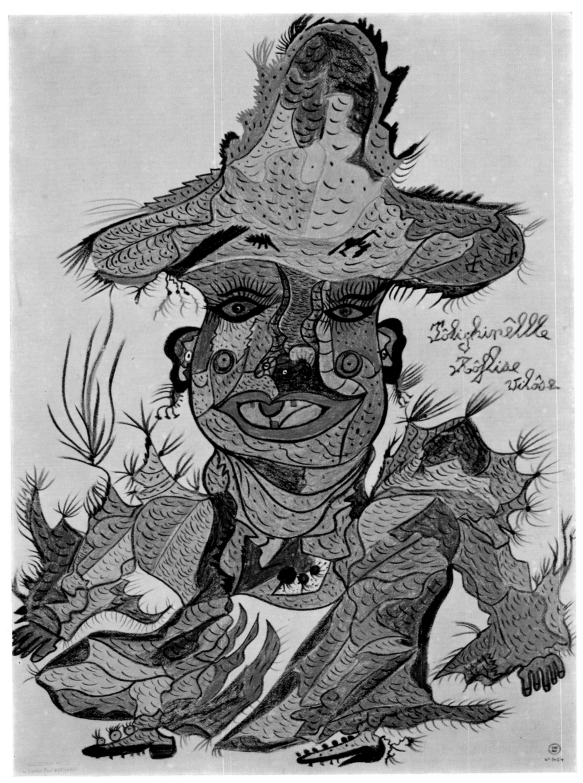

Gaston Duf (1920): Punchinello ("Pôliçhinêlle Rôflise Vilôse"), May 1956. Colored crayons on drawing paper.

adulthood. The psychoanalyst is usually applied to in such cases and he makes his attack on the animal, invariably interpreting it as the symbol of the "castrating father," until the over-imaginative subject is himself convinced of it. Thus most of the analyses related by Freud in the third volume of his *Collected Papers* [33] are concerned with the extermination of horses, rats and wolves haunting the patients' mind. When the latter, no doubt as a last resource, refocus their mental energy on their job or their wife and children, they are considered to be cured. In almost all these cases, the final transfer to work or family intervenes as a kind of "happy ending" which the psychoanalyst puts to the credit of his therapy.

It may be questioned whether this ecological slaughter, this mental and social normalization, represents a real gain for the patient. Anyhow, in the case of Gaston Duf, he was too far gone in his delirium for any therapy to retrieve him. One can only suppose that, having nothing to lose, he went over to the stronger side, that of his phantasmal rhinoceros, to which he gave free play, far from the family sphere—assuming it originated

there. But must his frenzied, compulsive creativity really be seen as having a pathological character? In a man hounded by fate as he was, one is tempted rather to interpret it as a fabulous revenge, an extraordinary extension and intensification of self in the inhuman animal world of his chosen emblem. One is left with the feeling that, having cast off all his social and mental moorings, Gaston Duf, unlike Freud's patients, bravely threw in his lot with the monstrous beast that we all have within us and keep down as best we can.

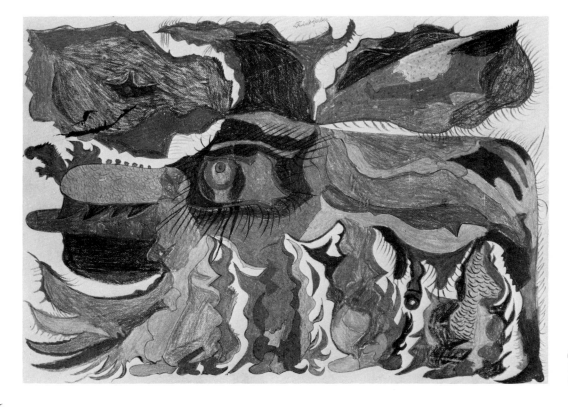

Gaston Duf (1920):
Rhinoceros ("Rinôçérôse"), 1950.
Colored crayons on drawing paper.

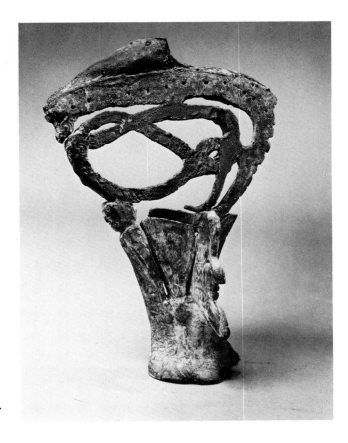

Pierre Kerlaz (about 1914-1967): Figures and Animals, 1965.
Shoulder-blade and flat bone carved and colored.

The Subversion of Categories

After drawing for six years, Gaston Duf abandoned all artistic activity (apart from a brief aftermath in 1956, in response to a solicitation from his doctors rather than any real urge). Is one to conclude that his creative resources had failed him? Not necessarily. They may have become lodged in areas so remote from our experience that they escape our notice. This possibility is not so far-fetched as it may seem. For it must be borne in mind that our grasp of Art Brut is always relative and limited in its extent. This is in the nature of things: the ability of any society to grasp what lies outside its own cultural patterns is very limited. Art Brut has long been a victim of this blindness, even more than the exotic arts. What has been salvaged is very little compared to what has been lost. And that salvage was often prompted by non-artistic motives. Doctors saved them for symptomatological or therapeutical reasons; adepts of spiritualism kept them for their mediumistic value.

The efforts of Jean Dubuffet and the Compagnie de l'Art Brut to form a collection and sanction the very notion of such art, combined with a decentering of the collective art sensibility over the last few decades, have finally brought Art Brut within our aesthetic ken. Even so, it occupies a borderline position: its makers are not concerned with communicating and defer to no recognized code nor to the rules of any recognized idiom. It may well be, therefore, that their creative range extends beyond the normal compass of our responses. Imagine a composer capable of bringing ultrasounds into play or a painter capable of ranging beyond the color spectrum: our grasp of his work would be incomplete, being limited by the scope of our acoustic and optical receptivity. Now cultural patterns can involve the same partial insensitiveness that physiological limitations do. This is just what happens when a Western anthropologist evaluates an alien culture, giving priority to utilitarian or artistic objects and disregarding the techniques

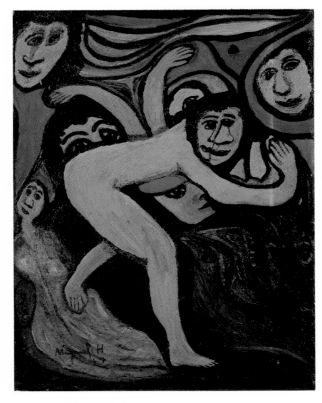

Miguel Hernandez (1893-1957):
Women and Birds, 1947. Oil on canvas.

Georges Demkin (born about 1929):
Composition with Eyes and Masks,
9 November 1961. Gouache.

78

Charles Jaufret: The Red Heart of the Managing Director Adrien Bouteille
("C'est le cœur rouge du Directeur Adrien Bouteille"), about 1900. Pencil drawings and numerals on a page of an exercise book.

of the body, of sexuality, of sleep, of depersonalization or other practices too little known in the West to be subject to cultural investment. We are apt to make similar mistakes in dealing with Art Brut. Think, for example, of the priority which, for economic and cultural reasons, we give objects over more ephemeral forms of expression. Well, we shall see that a creative outsider like Wölfli is capable of ranging over many registers of expression and drawing on many faculties of the mind and senses. It is a mistake to give priority to his pictorial production, as habit leads us to do.

To the extent, however small, that we can grasp Art Brut for what it is (and not as an inarticulate quirk, an aberration or a set of symptoms), we are naturally led to relativize our views and shift the center of our attention away from the cultural arts. Thus, to continue the comparison made above, a musical composition ranging beyond the scope of our acoustic receptivity would soon lead us, by the implications of its internal logic, to suspect the existence of these ultrasonic resources and might in the end attune our ear to them. Art Brut, in the same way, may awaken faculties within us which education has put to sleep. When that happens, the chances are that we will start looking at things with different eyes and that this enlargement of our experience will not be confined to Art Brut.

The distinction I have drawn with respect to primitive, naïve and child art may be felt to have cast doubt on the relevance of these categories and names—and, a fortiori, on that of "psychopathological art" (of which more will be said later). Art Brut is not a new discovery needing to be fitted into these other categories of art by reshuffling them a little. Art Brut subverts these categories, not to take their place, but perhaps to question the very idea of pigeon-holing art. Art Brut was born an outsider and persists in remaining one, for it has never been invited in. It does not really lend itself to the contrast between cultural art and Art Brut to which I myself have referred. There is not really any gap between the two. Dubuffet has acknowledged as much: "It is well to regard Art Brut rather as a pole, or as a wind that blows more or less hard but is usually not the only wind to blow" [11]. After all, an art

totally estranged from culture would scarcely be perceptible as such; conversely, in any given culture, as soon as an artist begins inventing, he begins moving away from accepted norms of expression. For this reason, Art Brut should not be envisaged only as a discovery of works that had passed unnoticed, but as a branch-line of a current that by degrees can act even on works endorsed by tradition and reactivate an energy pent up within them whose very existence had gone unsuspected.

Charles Jaufret: "80 conportes," about 1900.
Pencil drawings and nonsense writing on a page of an exercise book.

ORPHANED WORKS

The consequence of a serious illness contracted when I was eight years old was that, from that moment, I directly and radically forgot EVERYTHING.
 Adolf Wölfli

Guillaume Pujolle

The case of Guillaume Pujolle is remarkable in several respects: first, for a power of invention that can be seen unfolding through all its phases; also for the fact that it has been searchingly analysed by a psychiatrist, Dr Jean Dequeker, who, while keeping to psychopathological assumptions to which I personally cannot subscribe, proved capable nevertheless of rising above them and considering the man and his work with an open mind and real sympathy [25].

Guillaume Pujolle was born in 1893 at Saint-Gaudens (Gard) in southern France. His father was a cabinet-maker and taught him the same trade, which he worked at until he was eighteen. He was then caught up in emotional conflicts whose root cause was commonplace enough: an over-protective mother, a self-effacing father, a tense family atmosphere. Marrying at thirty-one, he proved to be morbidly jealous and over-particular about trifles, which would send him into a paroxysm of rage. Sinking into a state of suicidal melancholia, nagged by the idea that his wife and her supposed lover were persecuting him, he was interned in the psychiatric hospital of Toulouse in 1926.

Internment appears to have coincided with a withdrawal from reality, or encouraged that withdrawal. It looks as if Pujolle, once safely in the asylum and free of the social and emotional ties that had bound him outside, became aware of his creative potentialities. In some cases, the functions of real life having lapsed, a man makes up for them by a surprising development of what the French philosopher Gaston Bachelard has called the "function of unreality." So it was with Pujolle: his delirium was shifted away from its initial object and, free now from marital or family connections, launched in a different direction.

It needs to be emphasized that Pujolle's drawings, like those of so many other men and women dealt with here, did not originate from any aesthetic idea or purpose. According to Dr Dequeker, "Guillaume, after quarrelling with an attendant, made a comical caricature of him with makeshift colors taken from a laboratory to which he had access. This caricature was displayed and others followed it. They raised so much laughter that they easily gave him his revenge and compensated for his inferior status as a patient with respect to the attendants." His first works, then, answered to an aggressive and humorous purpose. Magic, too, was involved, for he went on to make dummy revolvers and daggers out of waste materials, also miniature airplanes and boats—typical prison-made objects embodying ideas of violence and escape (cf. page 33).

With reference to these assemblages, Dr Dequeker draws attention to the imagination and brashness which Pujolle brought to bear on everyday objects, deflecting them from their usual purposes and investing them with a new and disconcerting meaning: "So he appears, mixing up various materials, perpetually altering the intentions of nature and man, always guided by an ideal of decoration or an idealization of objects, endlessly reshaping forms which do not belong to him and will never be given to him—except to keep him under control—into the traditional forms he loves, like boats and airplanes, with which he achieves the great destiny of escape through art and the private destiny of his own ways."

The Sexual Question

Apart from caricatures, Pujolle's initial drawings deal with erotic themes. There is nothing surprising in that. Statistics show that sexuality bulks large in prison art, since art offers an obvious outlet for it. As Pujolle developed his work, however, explicitly erotic subjects disappeared. In this, he is not alone. The same phenomenon has been found to occur in every case where the artist's production proves to be really inventive. The fact is that expressly sexual themes are surprisingly rare in Art Brut. Is one to conclude with Dr Dequeker that a "desexualization" takes place in the drawings of Pujolle and other makers of Art Brut? Is it a matter of "sublimation" in the repressive sense that this term has assumed in psychoanalysis, meaning that the work of art is a substitute for the repressed sexual impulse?

The very opposite would seem to be true. In pornographic drawings, sexuality is as a rule reduced to a limited range of stereotyped themes; and, above all, it intervenes only in the subject matter. The drawing simply provides a rough and ready medium to which the maker resorts with more or less skill in order to record a scene already pictured in his imagination. The erotic imagery always keeps to the principles of representation, even, or above all, when the maker breaks down in his attempts to apply them. On the other hand, a really inventive drawing is no longer merely a means of conveying an imagined scene: it is itself invested with a sexuality released from its usual objects. Then the sheet of paper is no longer a protective screen decently projecting the erotic scene into illusionist space: it becomes as it were an extension of the body, a libidinal surface, a place of finger-felt enjoyment.

Dr Dequeker's comments on the genesis of the figures in Pujolle's drawings are very revealing in this respect. For they denote a physical participation which moreover one feels immediately. As a rule, the subject is not premeditated. It takes shape in the course of the work as its outcome rather than its aim. In other words, the drawing does not record forms pre-existing in the maker's mind. It plays rather the part of promp-

Guillaume Pujolle (1893-?):
Eagles and Quill ("Les aigles, la plume d'oie"), I2 November I940. Chemical fluids, colored crayons and ink on drawing paper.

ter or pump-primer for the imagination: "His hallucinations usually have to find a point of support in order to develop." What comes first is a kind of graphic gymnastics, proceeding by purely gestural impulses which are recorded on the paper by a multiplicity of wavy lines. As these curves crisscross and combine, they conjure up unexpected forms. This is what accounts for Pujolle's very peculiar style, all in flame shapes and undulating, jagged, tormented contours. The initiative for his forms is left to his own physical impulses which are not determined by any preconceived purpose. As Dr Dequeker aptly remarks, "In these snake-like undulations there is an initial power of contained daydreaming, the initial improvisation of an automatic motricity which relaxes and becomes slack, the better to receive the internal visionary impulse. For he only uses the ruler to lay in the lines of the rigid decorative framework, to which his dream has nothing to add and which is meant rather to contain it and dam it up. Elsewhere, in the reproduction of elementary forces, like wind, water or fire, which are open to make-believe, the dream feels its way into this rounded motility and into its flow."

Without knowing anything about Pujolle's creative process, one immediately feels the metabolism of the composition, the torsion of the axes, the innervation of the lines, the fluidity of the ink, the impregnation of the paper. One is made to feel all that by a kind of physiological

sympathy. Nowhere else can one grasp so well the bodily and libidinal genealogy of the visible forms, their tactile, gestural, dynamic premises. This is what leads me to think that in this case sexuality has detached itself from the objects commonly assigned it, and that it rediscovers and develops that wealth of investments, that nomadic and polymorphous character which it had in a merely embryonic form in early childhood. The fact is that with Pujolle, as with most makers of Art Brut, as with children's drawings too, the jubilant gesturing, the manipulation of the materials and the aggressive pleasure of inscribing or incising prevail over the figurative result. In none of the forms of cultural art does one feel so keenly the physical enjoyment of the creative act. One can therefore understand why erotic *subjects* disappear. Desire ceases to let itself be taken in by a recognized erotic theme. It acts directly, in and through the physical substance of the medium.

This makes nonsense of the interpretations given by some psychiatrists, who imagine they are demonstrating their perspicacity and accounting for the erotic character of a drawing when they detect a vulva or a phallus in certain suggestive forms—and in the final analysis all forms suggest something—as if one were dealing with those picture riddles in which the hunter's cap has to be detected in the outlines of the leafage! Such interpretations, applied to the "polymorphous perverse" sexuality of the drawings that concern us here, are indeed symptomatic of an inhibition, but not in the maker of the drawing. They betray in the interpreter an uneasy reflex which causes him to drive sexuality back at any price into its "erogenous zones" (their ghetto) and place it again under phallocratic control.

Guillaume Pujolle (1893-?): The Broken Violin.
Watercolor, ink and colored crayons on drawing paper.

84

The Ideology of Representation

Art Brut is generally found to challenge the very principle of representation, which always presupposes the existence of an object (real or mental) antecedent to the pictorial realization [45]. With Pujolle, as with many makers of Art Brut, the figures are not predetermined. They arise out of the haphazard interplay of the pictorial elements, and they impose themselves on their maker much as dream figures do on the dreamer. They are as elusive as gleams of sunlight on rippling water and would be carried away by the flow of forms and colors, were it not that Pujolle contrives to catch and hold them in a kind of graphic snapshot—for which he uses the ruler.

The color handling in equally remarkable. Pujolle's method is this: he waits until he has a series of drawings ready, then sets them up side by side and goes down the line coloring them one after another. He lays in areas of flat color as the fancy takes him, guided by this or that line or pattern of lines. In doing so, he may be led to recast this or that form. When a blot or smudge occurs, he integrates it forthwith into the composition and works it up like any other picture element. Will it be said that, by this assembly-line method, Pujolle is simply out to increase his production and rationalize his efforts, like a commercial artist intent on mass production? Even if this were true, what matters is the result, and this serial method helps him to stand back from the subjects already crystallized in each picture and see them with a fresh eye; it helps him to apply his colors more freely, with an eye for something more than the mere hand-coloring of silhouettes, prompting him on the contrary to rethink and rework his forms.

Need it be said that Pujolle does not trouble himself about the rules of conventional representation? Working freely, he makes the most of all the figurative resources which are ruled out by the conventional approach: he combines different points of view, he varies the scale of his objects, he resorts to overlapping and juxtaposition, he allows one form to show through another, he passes without a break from figuration to abstraction. A steady process of anamorphosis is at work, depriving men and things of any permanence and continually reshaping them in unexpected ways.

This instability comes as a more radical challenge to the principle of objectivity than abstraction or non-figuration have proved to be. For the cultural art of the West may be said to have stabilized pictorial representation by a system of set rules, and it may be said by the same token to have fixed the status of objects, in the manner of a tautology, laying it down once and for all that an apple is an apple and a violin a violin even when seen through a painter's temperament. In addition, the subject of the picture, however little anecdotal it may be, further contributes to rivet each object to its function within the context of the scene in which it figures: the subject consequently acts as a reducer of meaning. In the hands of the angel, the concert performer or the street musician, the violin remains the prisoner of its univocal instrumental meaning. The psychoanalyst has to be called in to detect in it a woman's body or a sexual organ—and these are hypothetical at best. The mirage of realism holds our attention so entirely that the metaphorical overtones are driven back into a latency area.

In Art Brut, on the contrary, and in Pujolle in this particular instance, the subject explodes and in doing so releases all the suggestive overtones of objects. In his *Broken Violin* the undulating shape of the instrument is amplified and reverberated throughout the picture, in cosmic proportions, as in mescaline visions. Its bowings resound through the picture space, the lines vibrate like tremolos and form sharp angles, giving the composition both an acoustical and optical stridency. In a word, the violin is no longer the *object* of the representation but its principle, as the rhinoceros was with Gaston Duf and the tree with Zivkovic. Instead of an objective view of a violin, we are given a subjective vision of it which dislodges us from our position as an observer and sweeps us into its own space.

The Mythology of the Visible

What is being challenged, in addition to representation, is the primacy of the eye, which may probably be taken as the essential characteristic of the figurative arts in the West. Painting, sculpture and decoration have of course to be perceived in the first place by the eye. But in cultures alien or anterior to ours they often merely pass through the eye in order to refer back to beings or meanings which do not belong to the visible world. Such is the case with all art works invested with a religious, magic or mystical purpose. Historians of civilization have often pointed out that acoustic, tactile and olfactory sensations had in the Middle Ages an importance scarcely imaginable today. Generally speaking, without there being any need to go into the physiology of vision and all the photochemical processes that serve to produce an optical image, each of us is well aware of all that the image owes to the participation of the body. Countless phenomenological and psychoanalytical analyses have laid bare the proprioceptive, motor, gestural and tactile determinants underlying visual perception. Representation in its purely optical form is never any more than the final stabilization of a perceptual meaning to which all the senses have contributed in an initial undifferentiation. This is realized when the visual function comes into action without any objective point of support for it; that is, in a febrile, hallucinatory or "psychedelic" state. Then the most lavish pictures can be conjured up by a noise, a smell, a physical sensation.

It is in child art that the bodily origin of figuration can be felt most strongly. Gestural impulses, tactile and dynamic sensations, delight in the manipulation of materials, and the emotional values attached to the objects pictured, all this enters into the expression at least as much as, if not more than, the perception of visual forms. It is an aberration to evaluate such work according to the criteria of optical representation, these criteria only being applicable to the work of Western adults.

The fact remains that the educational training peculiar to our culture gradually teaches children

to separate the visual function from those of the other senses and to treat optical elements as signs which are assumed to refer to "reality." The visual image is thus presented as a semblance, or anyhow as a derivative expression, of what it represents. As a corollary, the "thing" to which it refers is construed as a primary substantial entity coinciding with itself. The object and its image form a system. Yet one may question whether reality thus conceived is not a projection or fiction, and whether, in spite of the ontological privilege of antecedence attributed to it, that reality does not derive from the system of representation which it appears to establish. If this were so, reality would owe its status to the representation of it, the latter designating it retroactively as such by investing it with naturalness and subsequently conferring a primary essence on it. The image as conceived in our culture postulates an initial presence which, however, receives its pattern from that image, so that we are left to refer back from one to the other as if caught between two mirrors.

This "ontologizing" function of representation would explain the primacy of vision, equal to that of the logos, in our society. While the senses of smell, touch and taste call for physical contact or proximity, seeing, like hearing, allows and even requires a certain spatial distance from its stimuli; consequently, it provides for the possibility of a symbolic substitute. The operation whereby the outlines and colors of an object are detached and treated as its equivalents in a system of representation is in some ways analogous to the operation whereby gold is distinguished from other matter and used as the sole monetary standard. Perhaps in our culture there is a fetishism of the visible just as there is a fetishism of money. It is from its optical image that an object receives its status of reality, just as it is evaluated according to the gold standard. The visible is to the real what exchange value is to usage value: a system of signs designed to create a mirage of reality or give credibility to an object [37].

This comparison could be continued by considering the phenomenon of the occultation of production, or call it eclipse or concealment, which is common to both visual and monetary representation. It was shown by Marx that, in their *value* form, commodities retain no trace of the labor that brought them into existence. Likewise, the pictorial illusion requires that the material medium and the painter's labor shall cease to be perceived as such and shall be reabsorbed into the imaginary display which they go to create. The subject stands in painting as being or essence in metaphysics and value in economics; the dualism here is that of a solid signification and a transparent significans.

But there is no point here in developing this idea, except to say that in this context Art Brut gives rise to what might be called a *mythology of the visible*. Because, on the one hand, it leaves the work with its non-optical components and connotations intact; and because, on the other, it plainly records its own genesis in all its phases and steps up its power of expression by the very fact of leaving an open record of its material creation. By reversing the relation between reality and image, it challenges the prevailing system of representation.

Emile Ratier

If Ratier's work also gets away from the ideology of the visible as described above, the reason lies in a fateful circumstance: Ratier, by the time he came to produce his work, was blind. His infirmity appears to have acted as a spur to his inventiveness, as is often the case with creative individuals [9].

Emile Ratier was born in 1894 at Soturac (Lot) in southern France, where he worked as a small farmer until 1960, when failing eyesight condemned him to inactivity. He reacted against dejection and listlessness by occupying himself with manual work, having always been clever with his hands, with a quick grasp of mechanical principles. He took to devising large contrivances made from pieces of wood roughly shaped and nailed together. They always included a moving part, set in motion by one or two cranks and involving an intricate and noisy mechanism.

Ratier followed his hobby not only to occupy himself but to entertain others. Among his contrivances are the following: an Eiffel Tower over six feet high, with an elevator inside that runs up and down and a merry-go-round at the top that can be set spinning; a "clock that tells the time," with the mechanical figures of a monk and nun which "according to the weather report go in or out" (his own words); and an "elephant carrying a cannon that comes from Dahomey."

But the striking thing is not so much the subject, the fairground figure or the edifice that offered the pretext for his contrivances, as the formidable machinery that sets them moving. It is obvious that Ratier was much more interested in all the materials and devising that went to provide the show than the show itself. He takes a sly pleasure in emphasizing the heaviness and inertia factor of his materials. He refrains from using metal wheelwork and even from oiling his mechanisms. On the contrary, he loses no opportunity of increasing the weight, friction and rattling that hinder the transmission of power and cause a wasteful expenditure of it.

This feature makes it unadvisable to consider Ratier's constructions merely as toys, unless the meaning of the word is extended, for these constructions were not intended for children. What they are apparently meant to do is to exalt man's relation to the machines in a holiday atmosphere attended by a euphoric dissipation of energy. They stand in obvious contrast to utilitarian machines, which tie individuals to the high output system and cause alienation. They stand

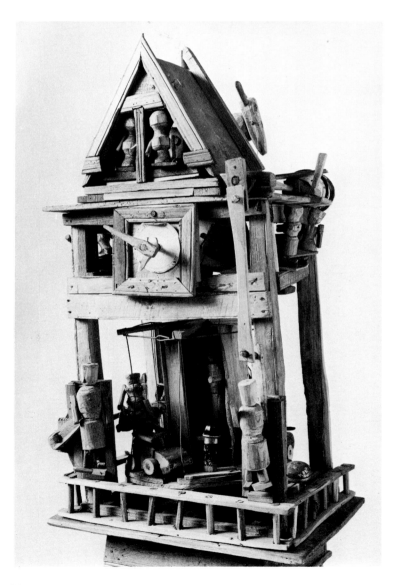

Emile Ratier (1894-?): Clock with Merry-Go-Round, from 20 October 1966 to 3 March 1967.
Construction of elm wood and other materials, with moving parts.

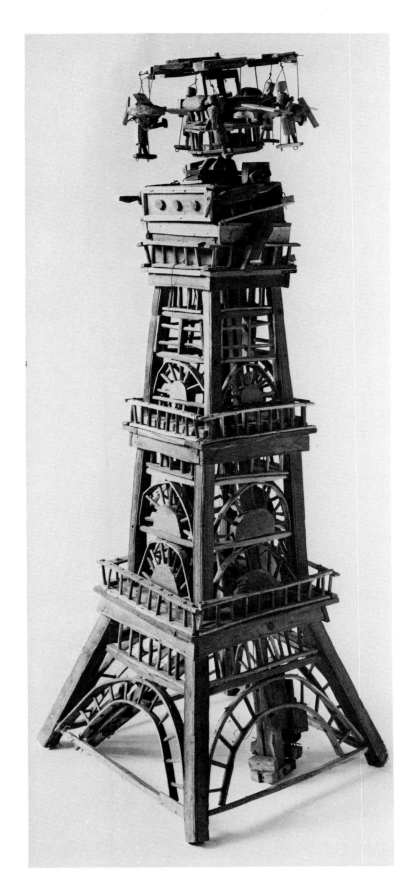

apart from such neurotic devices as all the gadgetry that surrounds us today and all the symbolic substitutes for our repressed drives (which is just what most of our children's toys are). They also stand apart from the fanciful machines that bring phantasms into play without departing from the stock system of representation. They may be likened rather to the "desire machines" of Deleuze and Guattari [24], which are defined by their power of connecting and extending forces and inducing intensive states.

Cut off from the world by blindness, Ratier in effect established new lines of connection with it by means of his constructions and their transmission devices which have nothing in common with the wheelwork of the world's social machinery. To turn the cranks is to integrate oneself into the mechanism and join in with the drums, hammers, valves and rods, to set oneself to their rhythm and feel their jolts and heaviness, to experience them bodily, by hearing, touch and gestures. "A picture...," muses Deleuze sadly, "all you can do is see it." Escaping to a large extent from the merely visible, Ratier's machines awaken echoes on deeper levels of intensity. You may think them attractive, endearing, lovable. But beware: start turning the crank and you lay yourself open to a backfire kick which may dislodge you from your comfortable position as an onlooker and catch you up in its workings.

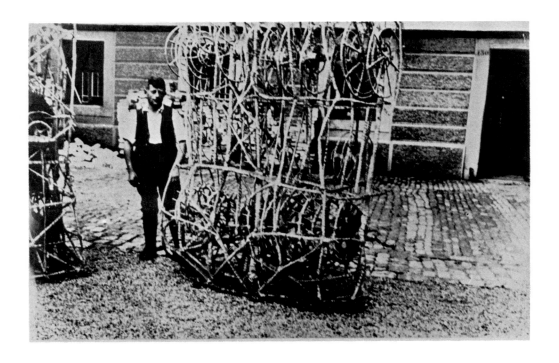

Photograph of Heinrich Anton Müller (1865-1930),
with machines of his invention in the courtyard of the Münsingen Asylum (Bern).

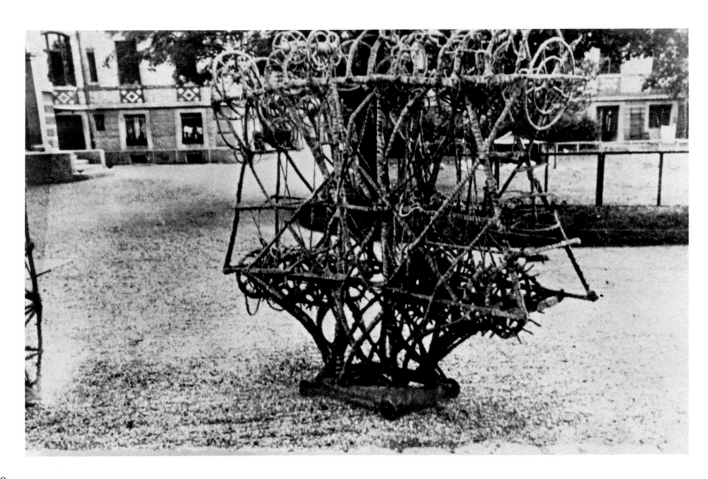

Heinrich Anton Müller

Müller also had a mechanical turn of mind. A Swiss, born in 1865 at Boltigen, near Bern, he moved as a young man to the canton of Vaud where he went to work in the hillside vineyards there, above the Lake of Geneva, and became a vine grower [1]. About 1903 he invented a device for trimming the vines, which is said to have been highly ingenious. But the idea was taken over and exploited by others. This mishap and his broodings over it triggered off a mental disorder which in the end led to confinement for the rest of his life in the psychiatric hospital at Münsingen in the canton of Bern.

According to the psychiatrists who treated him, Müller was subject to ideas of grandeur and persecution. He occupied himself with drawings and inventions, the latter with a view to achieving perpetual movement. In the hospital garden he constructed a large telescope and would spend day after day gazing through it at a curious object of his own devising, made from nondescript materials, which the psychiatrists did not fail to interpret as a female sex symbol. Müller devised other contrivances of considerable size which apparently had no other purpose but to be geared up and down, and expend energy in a ceaseless whirl and, of course, to no purpose.

This concern with machines is the thread, real and allegorical, on which all else hangs. Before his internment Müller was a cog in the social machine, subjected like everybody else to the law of output. His state of dispossession or, properly

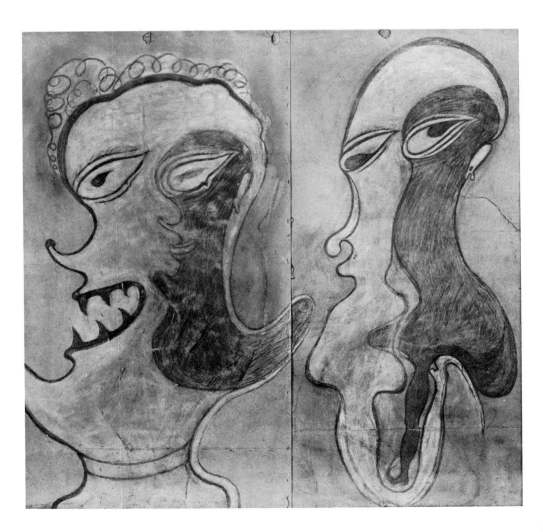

Heinrich Anton Müller (1865-1930):
Two Faces, between 1917 and 1922.
Black crayon and chalk on two sheets
of colored wrapping paper sewn together.

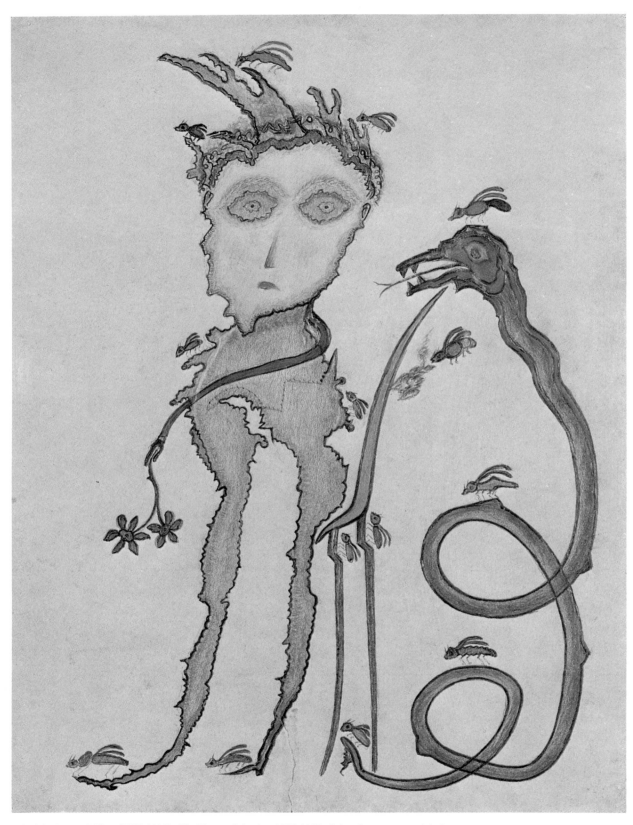

Heinrich Anton Müller (1865-1930): Fly Man and Snake, 1925-1927. Colored crayons on drawing paper.

speaking, his *alienation* from it reached its culmination when he was robbed of his invention. But internment removed him from the workings of the economic and social machine, and this put him in a position to devise a machinery of his own exempted from the necessity of serving any particular purpose. Exchange, no longer dependent on value and efficiency, then became purely a matter of symbolic expenditure. (Unfortunately, all the machines he built were destroyed by order of the hospital management.)

Between 1917 and 1927 Müller turned sporadically to drawing. To begin with, he used sheets of wrapping paper, which he sometimes sewed together in order to obtain a surface of larger size. His usual medium was the big black or blue pencil used by carpenters, with highlights added in white chalk. He would sometimes moisten his drawings, which gives them the toned-down, washed-out look that frescoes have.

His way of handling figures is disconcerting. He combines highly realistic elements with bold schematic patterns. He is continually changing scale. He will suddenly move from one viewpoint to another, drawing for example two eyes in front view in a face seen in profile; the outlines of the figures, however, retain a gestural dynamism in their upstrokes and downstrokes, and their momentum sometimes carries them away into purely decorative arabesques. So one goes without transition from perspective to hieraticism, from figuration to abstraction, from sensory responses to mental constructs. Modern movements like Cubism, Futurism and Orphism have of course accustomed us to such discontinuities. Müller, however, is not trying to work out some clever reorganization of the system of figuration. He seems intent on emphatically maintaining the character of his figures as effigies or semblances, like those that enter into magic practices. Yet he persistently manhandles them, playing with the likeness, approximating to the model and suddenly moving away from it, as if putting the power of the image to the test. He mischievously makes use of our sensing and scanning reflexes to lure us unawares into aberrations and ambiguities which challenge the principles of representation, beginning with our presumption of the object's reality.

His faces are extremely suggestive in this respect. Sometimes they are repeated and varied from the same model, as if the subject were broken down into a many-sided individuality; at others, they are redoubled internally by a reiteration of the outline within the figure. This challenge to the individual person, and more generally to the mirror representation from which it results, can be traced back I think to the same rebellious violence that appears in its primary state in the dummy weapons made by the inmates of the Waldau asylum; but a violence which here subtly pervades both the pictorial and philosophical registers. In this respect the case of Heinrich Anton Müller is representative of Art Brut in general.

Jules Doudin

It is known from an article by Dr Alfred Bader [14] that Jules Doudin was born in 1884 in the Swiss canton of Vaud, into a family of ten children. His father, a shoemaker and a heavy drinker, hanged himself when the boy was eleven years old. After a few years of primary schooling, Jules worked as a laborer, then as a railway switchman and finally as a farmhand. He too became an alcoholic. He became convinced that he was constantly being spied on and whispered about behind his back, and he would give way to fits of anger and violence. This led in the end to his internment in 1910 in the Lausanne Psychiatric Clinic. He was diagnosed as a schizophrenic.

For some years he proved to be a restless patient, difficult to control, with peculiar oddities of his own. He would make and unmake his bed

Jules Doudin (1884-1946):
Virginia ("Virginnies"), between 1927 and 1937. Pencil on gray paper.

Jules Doudin (1884-1946):
Wild Cat ("Chactz Sauvatges"), between 1927 and 1937. Pencil on gray paper.

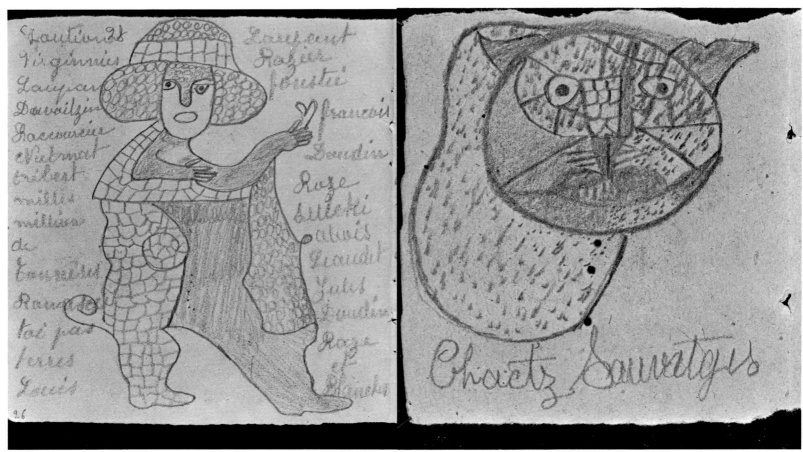

all day long, day after day. Above all, he would keep scratching his head until the blood flowed, because, he claimed, he could hear his doctor's shoes scraping over his head. He imagined that eyes and teeth would grow from the places where he scratched and drew blood. By 1925, when he was forty-one, he became quiet enough to be employed in making paper bags. In 1927 he suddenly took to drawing with a pencil in small notebooks which he made up himself from wrapping paper. He drew intermittently over a period of ten years. He died in 1946 of tuberculosis.

In addition to drawings, Doudin's notebooks contain some curious pages of writing. Although the present work is expressly limited to raw creation in its pictorial form (I hope to deal with *raw writing* in another book), it is worth pausing over one of these scraps of writing (originally published by Dr Bader in the article referred to above), for it sheds some light on the creative process in Doudin and perhaps in other makers of Art Brut (the translation retains, so far as possible, the erratic spelling of the original text):

Gentlemen

Ihm saddizfyd with yoo ih gest want to tell yoo wun thing Reezentment mayd me suffer in the gardn? The Catss wont keep kwiyit in Yoor Howss. Frum The dayy I cam heer ihuv not binn kwiyet til now. My yi meenz lidle to me Ihm braking down. Ihm sikkaza dogg. A liddel fresh Errr woud do me Good.

The writing is more or less phonetic, but its oddities are such that they cannot really be explained as the spelling mistakes of an uneducated man. One feels that the writer is lingering over the words and cunningly distorting them. His distortions are calculated to hold up the reader and make him fall back on the phonetic structure in order to grasp the meaning. The resentment Doudin mentions seems to have been carried over into the writing and directed against the words themselves.

According to Luce Irigaray [42], word distortion by schizophrenics, or presumed schizophrenics, is apparently caused by an intolerable sense of subjection to the mother tongue, ruling out a straightforward or "normal" use of it. "In so far as he is willing to try to speak, instead of merely being spoken to, the schizophrenic will prove *to be a linguist... A linguist in quest of the lost object of his search: language.* And one who tries to

Jules Doudin (1884-1946):
Louise Fauttiez in her Swaddling Clothes ("Louizze Fauttiez Dant ses Lange"), between 1927 and 1937. Pencil on gray paper.

recast it by loosening up the grammatical machinery at every turn and getting away from its frozen and freezing mechanisms. Hence his apparently ludic behavior with syntax... To say that he 'speaks' is to use the word improperly. He *unspeaks*, he talks incoherently, *reversing the process by which statements are formed.* Attempting to break down the fence of cramping speech to rediscover the laws of its creation..., he repeatedly disintegrates a prescribed word, violent in its allegedly 'proper,' exclusive, totalitarian meaning... He shatters its meaning—but, for him, it had never been anything but meaningless—in order to go back to its categorical and lexical components, its underlying articulations, and play with them."

This explanation seems very much to the point—so long as it is not made to bear any pathological connotations. The fact is that poetic creation, whether "schizophrenic" or not, always in some way, in variable degrees, does violence to the mother tongue (the very notion implied by

95

Jules Doudin (1884-1946): Two-Headed Animal, between 1927 and 1937. Pencil on gray paper.

the remarks of Francis Ponge previously quoted: "Words are ready made and express themselves: they do not express me... So let us hold words up to ridicule by doing our worst with them—by the simple misuse of words"). Presumably his family and social circumstances led Doudin to feel a painful sense of linguistic oppression and react against it with corresponding violence. Possibly, in his case, one should distinguish a symptomatic level, where he compulsively scratches his head from an urge to escape the ascendancy of his doctors (representatives of the Law), and an inventive or poetic level where he shakes off the shackles of the established language.

It is in this sense too that I would interpret his drawings, and more particularly the treatment he inflicts on his figures. The only instrument he uses is the ordinary lead pencil. He proceeds in the classic manner by first outlining his figure, then filling it in with flat shading, hatching, checkering, circling and dotting. Delimit the silhouette, enclose its identity, differentiate its surfaces and characterize these by their texture: this is the conventional function of line. Doudin keeps to it, but goes one better, in an insidious way of his own, by turning the means of figuration against the representation itself. For example, the outline may suddenly be shifted *into* the figure, setting up a division there, in defiance of the body's unity, and creating strange anatomical cleavages; or, conversely, he merges two figures into one. Disintegration of the individuality is further emphasized by the discontinuous treatment of internal surfaces, which may involve either a blending of forms or a further disassociation of them. In the result, then, as we look from drawing to drawing, we find that the man on horseback becomes a centaur, the crucified figure merges into the wooden planks of the cross, and William Tell's son is first agglutinated to his father's body, then absorbed into it.

For the psychiatrist, a tempting opportunity for bold diagnosis! And here, after all, he may be justified in interpreting the cleavage line as schizophrenia, the agglutination and absorption of forms as psychic regression, the anatomical aberrations as a loss of the body schema. All the evidence suggests, moreover, that Doudin felt

himself particularly threatened in his physical and psychic integrity. But in his drawings he himself takes the initiative of splitting up bodies or joining them together; he takes it upon himself to regulate the breakdown of forms; the discretionary power over the linear rearrangement is in his own hands. Paradoxically, in the face of his own vulnerability to enforced limitations, he acts the part of the demiurge, as if he had resolved to gain control, on the imaginary plane, of the aggressions to which he felt himself a victim in reality. Instead of clinging to a personal identity forced upon him, as social norms called for him to do, he makes himself the devil's advocate. He opts for depersonalization, for a merging or a cleavage of bodies, for a generalized subversion of identities. Out of his madness he makes a language which challenges that of medical knowledge.

The "Exemption from Meaning"

The reader will no doubt have noticed my reluctance to infer from the works analysed any psychic condition or private secret which could be regarded as explaining them. It is my intention in any case to refrain from slanting my comments in this regressive direction, which would mean shifting the focus from the work to the person of its maker. The work should be envisaged in its productive effects rather than its causes, as a breaking of new ground rather than a probing of the unconscious mind. As I see it, an art work deserves its name only to the extent that it is, psychologically and culturally, an *orphaned work*; only to the extent that it stands on its own and cannot be reduced to the motivations that fathered it. This does not mean rejecting biographical and psychological evidence *en bloc*. But there are times when the only course to follow is the one laid down by R.D. Laing when he writes: "The tendency now among psychoanalysts and psychotherapists is to focus... not only on what has happened before, but on what has never happened before, on what is new" [50]. It is true that this describes a desirable objective rather than an actual fact, and the latest psychiatric or psychoanalytical monographs continue to depend largely on pathological and determinist conceptions. Although the most enlightened psychiatrists now refrain from basing a diagnosis on drawings and are showing a more sensitive response to their artistic aspect, they continue to postulate the existence of an original meaning or a psychological essence, even if obliged to give up for good the idea of bringing it to light.

Against this primacy accorded to the *meaning* or the *origin*, I maintain that the value of Art Brut lies in the fact that it gives us nothing to exhume. It has no hidden compartments, nor even any depths or arcana. It evades that relation of cultural complicity between artist and art lover which always ends up by effacing the significans (the productive movement, the body, the gesture, the material) and raising up the phantasm of a hidden truth that has to be decoded. This is not to say that we should approach Art Brut without any idea of attaching a meaning to it, or that it

should be put in brackets, like a digression in a foreign language. For even then the vocables would remain haunted by a potential communication, imminent or lost. Whereas in Art Brut there is nothing to put in brackets. Its makers seem to have taken care precisely to protect us against any risk of *communication*. Art Brut has to be envisaged as a practice or a production in which no question of any message can ever arise. True, the effects produced by these works reverberate on mental or philosophical levels, and always in a subversive sense. But while they may yield certain revelations, these never carry us back to an antecedent reality or a psychic prehistory. Those revelations, such as they are, proceed from pure fabrication. They come as the by-products of a "seeing experiment" (Claude Bernard), or the incidents of an adventure, or the outcome of a gamble. What is happening here is essentially a generative and centrifugal process,

Juliette Elisa Bataille (1896-?):
"Eden Casino at Berck-Plage," 1949. Woolen embroidery on cardboard.

Henri Salingardes (1872-1947):
Figure with Goatee and Hat, between 1936 and 1943. Cement.

Rose Aubert (1901-?): "Head with Braids," 1954. Gouache.

in which the maker of it takes as much delight as we do, and which, mentally, involves us as much as it does him.

This "exemption from meaning," to use an expression coined by Roland Barthes [15], can be seen most plainly in those makers who choose to remain on the threshold of form, without venturing to leave the realms of the elementary and embryonic; in those who deliberately hold their ground in an area of indecision or excessive generality; in those who like to put obstacles in the way of one's efforts to see what they are about, or rather in the way of the hallucinatory projections which those efforts may give rise to. The colored cement of Salingardes, the embroideries of Elisa, the gouaches and oils of Rose Aubert are all striking illustrations of this fondness for the rudimentary, this indulgence in what runs counter to their own intentions. If there is such a thing as *poor art*, in rebellion against the cardinal values of our culture, then this is it.

Imagination is generally considered as an addition, an extra over and above reality. It is associated with the idea of proliferation, a peopling of empty spaces, an interpolation of reality. But it might equally well be regarded as proceeding in the opposite way as a subtraction, a dwindling of reality, a generalization. This in fact is a predominant tendency in Art Brut, a tendency which consists in announcing an immediately recognizable figure, by way of a pregnant silhouette, then cutting short the process of figuration, leaving the form in abeyance, resisting its solicitation. The result is to set up a tension between the flow of intentional meaning and the material support on which it moves—linguists would say: between the *form* and the *substance* of the signifier. We are suddenly checked in our reading of the work by a failure in the materials. One is never more aware of the movement one makes to climb stairs than when in the dark one misses a step. Likewise, the insidious falling away of the figurative support breaks off the impetus of our imagination and makes us aware of the complicities on which meaning is based. The artist has craftily led us pretty far along in the game, then has suddenly broken the rules, leaving us immobilized in a mental posture which now fails to make sense. The stereotypes of representation are thus baffled and set at naught. But this stratagem of figurative *deception* is not merely negative. For a reversal occurs in the reception and reading of the work. The substance of the signifier, being no longer governed by the meaning, breaks up the system in which it was contained, battering it down as it were. That substance bursts out on its own, as pure energy without any semantic purpose—raw matter if ever there was any, because released from its representational or descriptive subservience, and matter prodigiously rich, because arousing all the potentialities of its original savagery.

Of course this "exemption from meaning" is not there to begin with; it is not the result of a state of grace or a miraculous preservation, like the "ingenuousness" or "authenticity" with which naïve art is credited. It has to be arrived at. It is the end-result of a process or *work of exemption* which may sometimes proceed by unexpected byways. Creation can never be completely pure or completely raw. It often has to free itself from strong psychic determinants, through stubborn efforts. There are even times when, initially, it makes a pretext of delivering a message, only to move away from it imperceptibly. This, I think, may be said to be the case with Palanc and Emmanuel.

Francis Palanc (1928): The Isolated Lover ("L'amoureux isolé"), about 1954. Crushed eggshells on hardboard.

Palanc and Emmanuel

Francis Palanque, who took the name Palanc, was born in 1928 at Vence in the south of France [1]. The son of a pastry-cook, he learned the same trade after leaving school early. Moody and impulsive, he was subject to violent fits of temper. From the talks which Jean Dubuffet had with him, it is clear that his art work acted as a vent for these outbursts. He took it into his head to invent a new kind of writing, made up from a private alphabet of letters of his own devising. But he never worked it out once and for all, being continually impelled to review the results, adapting and perfecting them and also complicating them.

This has led him to experiment in endlessly different ways with the expressive energy of his graphic elements and to speculate on the subtle

relationships between their meaning and shape. It was not long before he took up painting, which fell in with the same line of research, for he used it to develop the same esoteric signs, and as a means of emphasizing their material side. Palanc has made the most of his talents as a pastry-cook, even exploiting some of the materials and techniques of his trade. Spreading a gum mixture over his hardboard panel, he applies to it a preparation of crushed egg-shells, pressing them down with a rolling pin or sprinkling them with a sifter. To his way of thinking, these are not works of art. They are, so to speak, unedible variants of his pastry, designed to set off his inscribed shapes and words in an unusual way—which, after all, is not unlike the written words on a birthday cake.

This does not prevent Palanc from dealing in his own way with grammatological problems corresponding to those which, in the cultural field, have been raised by artists and philosophers like Klee, Kandinsky, Jakobson and Derrida. But he obviously takes good care not to approach them in philosophical or artistic terms. He prefers to take his stand on the familiar ground of his own trade, where he is free to move and act as he pleases, owing accounts to no one, and where above all he feels that he is not open to aesthetic judgments. But we are not obliged to accept his self-justifying attitudes at face value. Moreover, what would be the point of inquiring into the unconscious mechanisms behind his temperamental outbursts, his exercises with writing and his experiments with a private alphabet? Let it be stressed again that, in the case of Art Brut in general, personal determinants and expressed intentions need to be interpreted, not in terms of psychic causality, but as a *strategy*, as the preliminaries or pretexts of novel and as yet unassignable experiences.

Alphabetic writing also inspired the most inventive works of Emmanuel. Born in Brittany in 1908, he was interned in 1958 in the psychiatric hospital at Quimper, remaining there until his death in 1965 [4]. A letter or a number, chosen at random and drawn large on the sheet of paper,

Francis Palanc (1928):
My eyes burst with joy
seeing you for the first time
("Mes yeux ont eclataient de joie
vous voyant pour la premiere fois"),
between 1955 and 1960.
Crushed eggshells on hardboard.

Emmanuel (1908-1965): ▶
16 Letters from "Alphabet No. 36,"
12 February 1964.
Watercolor and Indian ink on drawing paper.

103

provides him with a basic pattern for the composition and suggests the figures which Emmanuel proceeds to develop with no preconceived idea. As he explained to Dr Pierre Maunoury, "I choose certain letters. I say to myself: well, today I'll take this one here. One letter will give me a pigeon (often the S, as I know now) or a duck, another a fish, another a parrot. I add on a head, a tail and so on if I feel the need for it. With me the subject comes out as I go along with the drawing, and depending on what I use. At first, I don't know where I'm going or what the result will be. I decorate my letters with faces or figures to make a whole."

This ideo-graphic genesis of the drawing results in discoveries that are not only pictorial but philosophical. While varying a great deal in the iconographic interpretations he gave of his work, Emmanuel considered that he had gone back to the pictographic origin of words and given an account of their morphological development in the course of the centuries. This development could be explained, he thought, as arising out of the creative energy originally materialized in the dot and the dash, and from there engendering language in all its forms.

Writing and Picturing

While one must treat with caution and skepticism the explanatory theories and special pleadings sometimes invoked by the makers themselves, here it would be a mistake to minimize the role of alphabetic signs in the work of Palanc and Emmanuel. The fact is that in Art Brut generally one often meets with written elements integrated into the forms. This would not be surprising, were it not that centuries of Western culture have accustomed us to a strict segregation of writing from pictures. Such apparent exceptions as ornamental letters and inscribed phylacteries are actually a confirmation, since these devices serve to regroup within the page and the picture the foreign elements which in each case have to be expelled from it. In earlier and in non-Western cultures, and even in the work of badly acculturated individuals of our own society, this segregation is unknown. As Leroi-Gourhan has pointed out, figurative art in its beginnings was inseparable from language and closer to writing than to the work of art. The earlier styles of writing should be interpreted in their verbal context as

Constance Schwarzlin (1845-1911):
Two Pages from a Notebook, 1897.
Pen and brownish black ink on paper.

"mythograms" rather than pictograms [53]. It is symptomatic moreover that children spontaneously integrate would-be texts into their drawings, and that "mental patients" in general (both those who may be considered as makers of Art Brut and the others) move without a break from picturing to writing—a characteristic, be it added, to which psychiatrists attach a pathological significance. However that may be, both children and deviants are there to remind us that writing and drawing are done with the same instrument and spring from the same impulse.

It is interesting to see how close a bearing some of Paul Klee's reflections have on this matter. A cultured artist if ever there was one, he nevertheless carried his experiments to the limits of the cultural spectrum. In his view, "The act of writing and the act of representing are at bottom one and the same thing" [47]. At the Bauhaus Klee set his pupils graphic exercises based on a combination of capital letters. He himself devised some imaginary alphabets [39]. He also practised drawing with his left hand, the uncultivated hand, no doubt with the idea of reactivating the written origin of figures.

But perhaps Klee's exercises and, more generally, the modern attempts made to reintegrate writing into the picture (by way of the collage, for example) are to be interpreted as the nostalgic repudiation of a centuries-long discontinuity—a repudiation, however, which can do little more than sharpen our sense of that discontinuity. In any case, the makers of Art Brut go much further in this direction. I have tried to show the extent to which they bypass the ideology of representation. It is true that most of them can be consid-

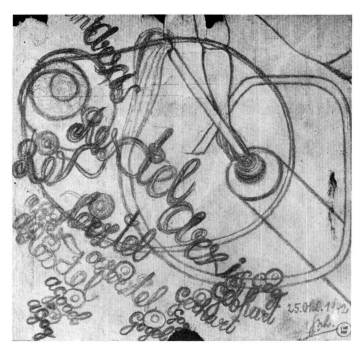

Gustav (1885-?): Drawing and Inscriptions, 25 October 1942.
Pencil on wrapping paper.

◄ Teresa Ottalo (about 1800-about 1870): Embroidered Letter, 1860.
Text embroidered with blue, yellow and red thread on linen cloth.

ered as "figurative artists." But the fact remains that they never aim at the fiction of a presence. On the contrary, they drive back the symbolic movement of the figuration into the object itself, in such a way as to put that object in turn in the position of a signifier, and so on. Objects are successively seized on by this interpretative frenzy which never resolves itself into a settled meaning. The figure is presented in such a way as to unmask its latent character as *writing*.

Conversely, whenever they take to writing, makers of Art Brut are inclined to emphasize the actual letters of words and disrupt their linear arrangement, as if by such distortions they were confusedly trying to work their way back to the original continuity between picturing and writing. Or are these irregularities to be attributed to a simple inability to withdraw from the body space and enter into the logical and atopical relations which govern alphabetic writing? For the typographical system is based essentially on the standardization and ordered sequence of the signs, leaving out of account their position on the field of the sheet. In a page of writing, the position of a word at the beginning or end of a page or line is a matter of chance, independent of the meaning and immaterial to it. Now in the writings of Constance Schwarzlin, Palanc, Gustav or Teresa Ottalo, one is made keenly aware of the

Sylvain (1900-1950): "Cock-a-doodle chicken there's joy for you passing away we'll manage" ("Co Coco Cocoo Poulette en voilà la joie s'en va ça ira"), about 1949. Black crayon on paper.

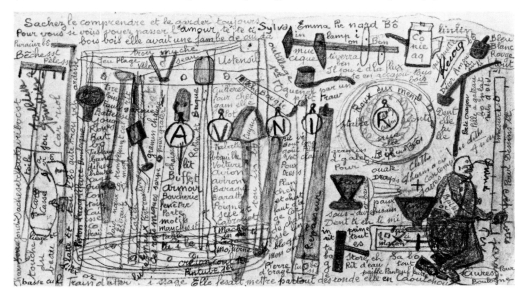

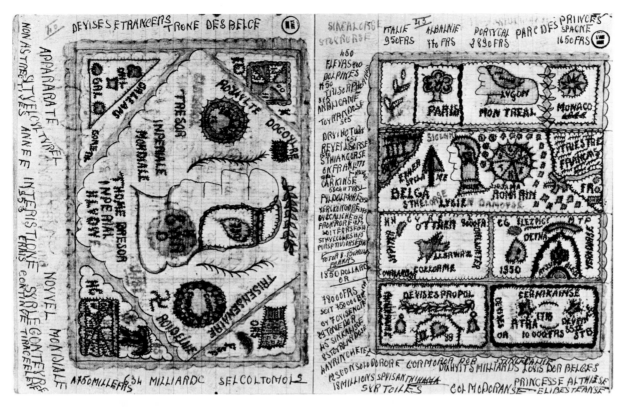

The Philatelist (Emile N., 1920-1956):
Two Pages from a Green Notebook of 92 Pages: "634 MILLIARDE" (left) and "COLMODORANSE" (right), April 1953.

distortion of the letters, the fluctuation of the lines, the general respiration of the spaces, the pause of the blanks, the erection of the text—in short, a perverse eroticization of what should be considered as the signs constituting a purely logical relation. Alphabetical writing, which appeared to have accomplished the desexualization of words, thus becomes paradoxically the object of a libidinal reinvestment, and what was bodily suppressed reappears in the very signs of its obliteration.

So we might apply to the makers of Art Brut in general what was said in connection with Jules Doudin: their disregard of spelling and lettering involves too many disruptions on the level of meaning for it to be considered a simple matter of mental inability. The very reverse is true: in their handling of the different languages (oral, written, figurative) they reveal a crafty deliberation, slyly inverting their terms and wilfully throwing their mechanisms of communication out of gear. Jacques Derrida has pointed out the affinity of Western metaphysics with the voice,

the *phone*, envisaged not in its material manifestation as a speech sound but in the spiritual quality of its breathing as pure immediacy [26]. In the logocentric system, phonetic writing professes to be the graphic representation of actual speech, but in the standard spelling of ordinary writing speech recurrently finds the formal guarantee of its ideality. Thus graphic signs and phonic signs are interdependent: they refer to each other for mutual support, in order to transcend their own substance of expression and to fade away in the presence of the referent. But the irregularities I have noted disrupt the system of meaning and its metaphysical postulates. This is a further reason for regarding Art Brut, not only because of its intrinsic creativity but because of its anti-cultural effects, as a kind of experimental disorder which breaks up the system of meaning and representation in order to bring out its internal logic.

Adolf Wölfli

The erosion of meaning, the reactivation of writing, the subversion of categories, the interaction of different idioms, all the tendencies I have noted in the course of discussion so far are combined in their most radical forms in an œuvre of encyclopaedic scope: that of Wölfli.

From earliest childhood Adolf Wölfli found the world to be a place of trouble, social injustice, exploitation and harsh treatment. Born in 1864 in Bern, Switzerland, he grew up there until 1872, when his mother, a laundress and occasional prostitute, fell ill and died. His father, a

Adolf Wölfli (1864-1930): "St. Adolf wearing glasses, between the two giant cities of Niess and Mia," 1924. Colored crayons.

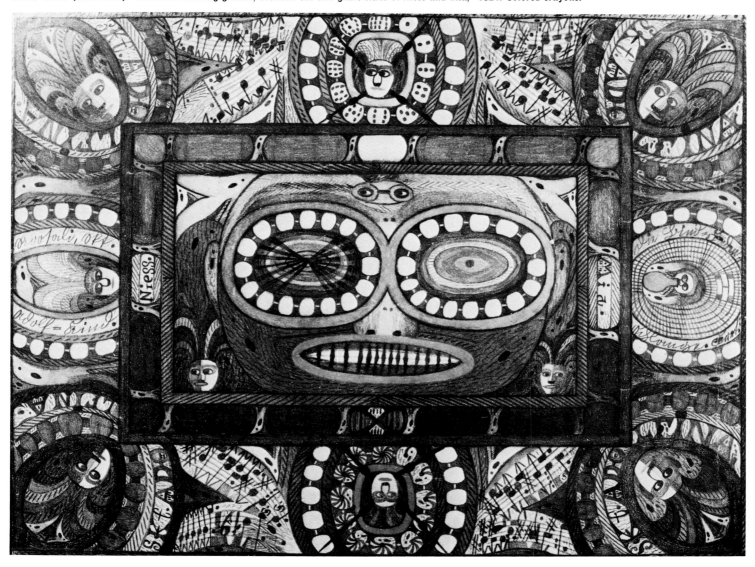

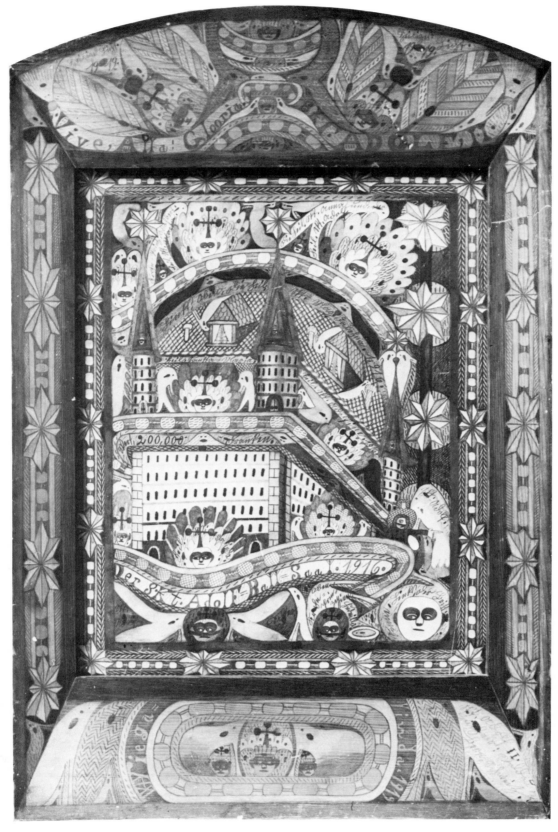

Adolf Wölfli (1864-1930): "St. Adolf's Ball-Room," 1916.
Colored crayons. Set by Wölfli in a wooden frame adorned with drawings.

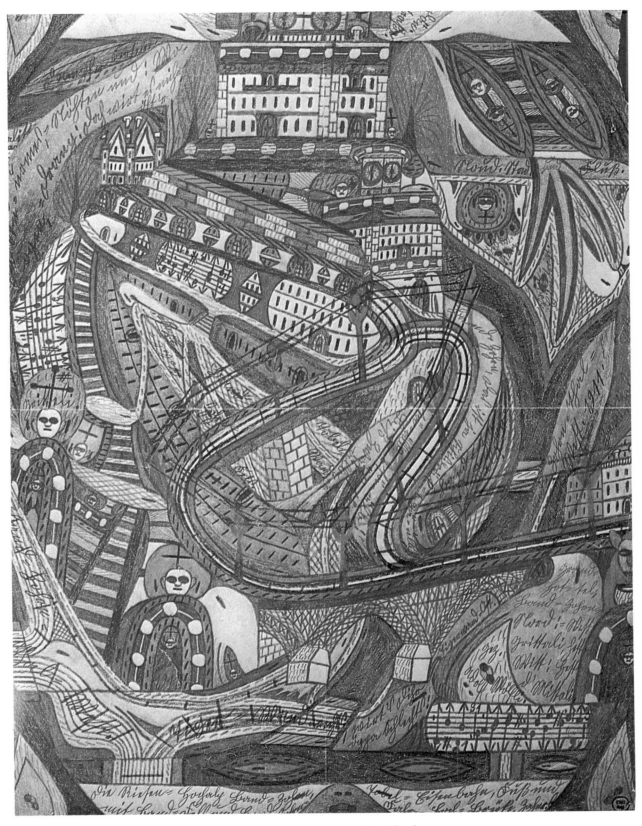

Adolf Wölfli (1864-1930): "The Great Railroad of the Canyon of Anger," 1911. Colored crayons.

stonecutter and an alcoholic who could never keep on the right side of the law, was then in prison; he died a few years later of delirium tremens. At the age of eight Adolf Wölfli was thus left alone and penniless. The cantonal authorities saw to it that he was placed as a farmhand in the Bernese countryside. He experienced a succession of farming families and hard-drinking farm foremen who overworked him, kept him from school most of the time, and beat and bullied him. While still a youngster, he was involved in carousals among the peasants and forced to drink brandy to the amusement of the company. He often went hungry. At eighteen he fell in love with the daughter of a neighboring farmer. But the affair was brutally put a stop to by the girl's parents, who refused to allow her to have anything to do with a mere farmhand. Wölfli was deeply marked by this experience. He became restless and irritable. He began to commit petty thefts. His interest in women became concentrated on teenage girls, and he was taken into custody several times for indecent assault, though this appears to have been limited to touching them. Even so, he was given a prison sentence and finally committed to a psychiatric hospital. In 1895, at the age of thirty-one, he was interned for good in the Waldau Psychiatric Clinic in Bern. Pursued by ideas of persecution (which the psychiatrists considered hallucinatory!), he proved to be so quarrelsome and violent that he had to be transferred to an isolation cell, which of course only made his condition worse. "He makes such a row that he has to be locked up in his cell for weeks, stark naked," reported one of the psychiatrists. Beginning in 1897, he spent twenty years alone in his cell! One night, in 1899, he broke up his bedside table and with the pieces demolished first his cell door, then the window in the corridor outside. But he went no further: he made no attempt to escape and was found there in the morning, in front of the broken window, stock still, ghastly pale and covered with sweat.

That same year, 1899, he began to draw and write, and also to compose music and play it on wind instruments of his own making. At first, drawing materials were given to him sparingly, and he was continually forced to beg for scraps of paper and bits of pencil. But as soon as the doctors noticed his work, they saw to it that he was liberally supplied with the necessary materials and in the end Wölfli devoted all his time to it. In the course of the years he accumulated sheaves of manuscripts and drawings sprinkled with musical scores. His autobiography, written out in a calligraphic hand and ornamented with drawings on large sheets twenty inches high, makes a pile nearly six feet in height. He wrote and drew uninterruptedly until his death in 1930.

This information comes from the monograph on Wölfli by Dr Walter Morgenthaler [2], whose indications regarding his creative process are highly instructive. As a rule, Wölfli had no idea beforehand as to the conception or even the subject of his drawings; the subject emerges from the pattern of the lines. "Wölfli," writes Dr Morgenthaler, "is the very type of the kinaesthetic person. He *thinks with his pencil*. With him it is often the gesture that gives rise to the thought." Wölfli himself would sometimes attribute the invention of the drawing to a divine source, of which he was only the interpreter: "Do you think that I could find that in my own head?" He drew without any preliminary plan or design, and without any hesitation, usually beginning on the edge of the sheet and moving inwards to the center, but sometimes also working from the center outwards.

From the first, one is struck by the tectonic rigor of the drawings. They are generally built up on the basis of orthogonal frame lines, which are repeated internally right up to the center of the composition. This partitioning of the surface is designed not for a proportionate but for a disproportionate development of the forms, these being worked up in accordance with a principle of indefinite extension, as if they had the power of being unfolded and spun out interminably. Wölfli is never more expansive than when he can let himself go on a decoration of some size—a large folding screen, a cupboard door, or the walls of his cell (his cell at the Waldau asylum still exists as he left it, with its decorations intact). Then one realizes that the cosmic scale comes naturally to him, that the overflow of his inspiration, as it comes pouring out, needs more and more room to accommodate it. But as Wölfli

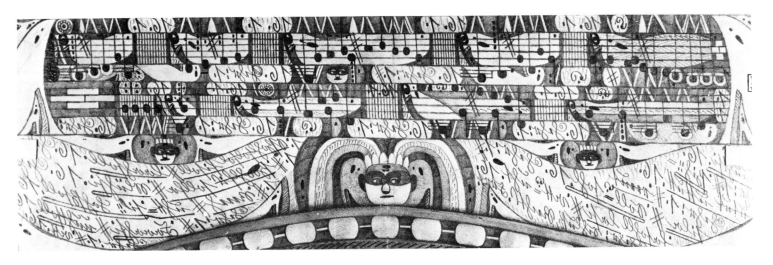

Adolf Wölfli (1864-1930):
"The Canary March," 1918, on the back of "St. Adolf's Ball-Room." Upper part of a large medallion decorated with music noted alphabetically.

is usually restricted to the rectangular sheet of paper, he reverses the genetic process and pursues the work of expansion from the periphery inwards to the center. He encompasses the territory of the sheet as if it were a planetary space. In filling up the surface he freely combines writing, drawing and musical notation. He establishes a free-flowing current of sensations between the sentient and the geometric, between the physiological and the mental, which is emblematically manifested in the ornamented staves of music. In the same way, the calligraphed text and repeated figures move together in easy continuity. When one sheet is full, Wölfli immediately passes on to the next without interrupting the flow of his invention, just as if they were successive written pages, and this gives his sets of drawings a serial character.

His scores remain enigmatic. Is this a secret notation which Wölfli invented for his own use? In any case, it has not been possible to read his music. He himself seemed to understand it. When he had finished a musical composition, he would sometimes roll up the sheet of thick paper and blowing into it like a trumpet he would interpret with amazing virtuosity the notes he had set down on it. This speaks for the ease with which he moved from one form of expression to another, overstepping the well-defined limits of our "disciplines." His scores show a quality of writing analogous to that of the alphabets of Palanc and Emmanuel. It would probably be a mistake

to consider them as graphic transcriptions of heard or remembered music, that is as derivative expressions. The fact is that they possess a melodic and rhythmic value of their own. They have an intrinsic power of musical production— and not reproduction.

In his texts Wölfli takes similar liberties with the spelling code. Writing in German, he will change his letters in the middle of a sentence or a word, passing from Roman handwriting to Gothic script or to letters of his own invention, as if he wished to cut the signs off from their connection with the alphabet and restore their diagrammatic power. So that the letters (like the notes of his scores) bypass the verbal (or melodic) signification which they are supposed to spell out and act directly in terms of their visible shape. This effect of expression conveyed by the substance of the sign rather than its meaning is to be found again in the spelling. Words are subject to strange manipulations. Wölfli makes lavish use of capitals, doubles certain consonants and commits deliberate errors which cloud the meaning. He is fond of bringing in foreign terms, he coins new words of his own, and he intersperses his discourse with long onomatopoeic passages, which need to be read aloud, since it is the sound that suggests the sense. It is as if the ideas originated from the phonetic interplay, from the effects of consonance and rhythm.

Wölfli shows himself equally inventive and exuberant in his handling of mathematical

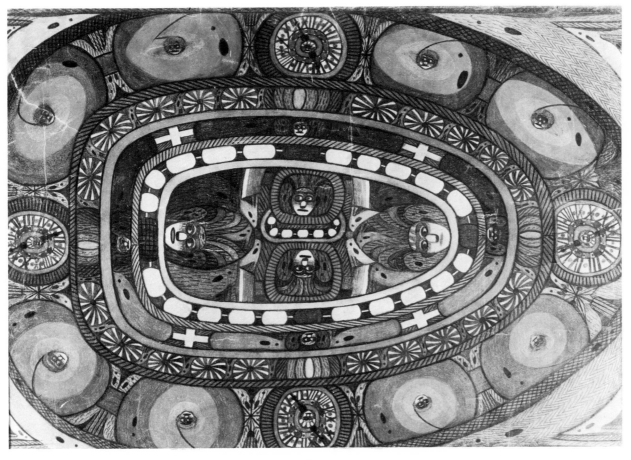

Adolf Wölfli (1864-1930): "District of Biela Villa, City of the Indies," about 1924. Colored crayons.

figures. In his autobiography he fills whole pages with figures, indefatigably working out the sum of his riches. As might be expected, they prove to be incalculable. They bear such colossal interest that he sets to work at once to compute the interest on the interest, and so on indefinitely. Ordinary figures being inadequate, he invents a numerical system of his own, for which he devises new signs and names, and these carry him into the quadrillions and beyond.

To come back to the drawings and their subjects, Dr Morgenthaler commented very pertinently: "As regards the *content*, one may say that everything is represented, not only what can be shown directly but generally speaking everything that can be thought and felt." In other words, with Wölfli as with the makers previously dealt with, visible things are not given primacy over the other sensory responses. The fact that the drawings are necessarily addressed to the eye by no means ties Wölfli to the illusionist conven-

tion traditional in the West, which would restrict the visual arts to the field of the visible. Graphic elements can have a direct effect on our tactile, rhythmic, kinaesthetic and other sensibilities without necessarily referring to visible forms. Thus by a sort of immediate physical empathy we experience the effects of symmetry and organic unity in the composition, the circulatory network that quickens it, the interwoven pattern of lines and their elastic movements of torsion, contraction or expansion, without it being necessary for there to be any figurative reference to anatomical forms as visually identified.

True, Wölfli integrates into his composition a number of motifs that belong to optical representation. But it might be said of these motifs that they reveal their structural function even before they represent something. Like drugs such as mescaline, they convey a tangible sense of that underlying algebra, so to speak, on which every sense impression hinges. An oval form will be

repeated within itself until it closes round a central face, as if to represent ovalness in general before coming to its objective avatars. Wölfli, as noted above, is as fond of playing with words as with things; conversely, he likes to treat forms as if they were concepts, making play with their different degrees of generality, over a scale that ranges from total abstraction to the most concrete shape. His favorite themes owe their symbolic potency to their knack of throwing into relief the geometric figures from which they stem: cross, circle, spiral, mandala, etc. We are thus brought back to what might be termed a pre-objective stage in which things have not yet taken form. Or, if they have, they remain unstable, labile; they may be condensed, reversed or transformed according to a system of generalized equivalence which hinges precisely on these

Adolf Wölfli (1864-1930):
"Karo the Whale and the Devil Sarton I," 1922. Colored crayons.

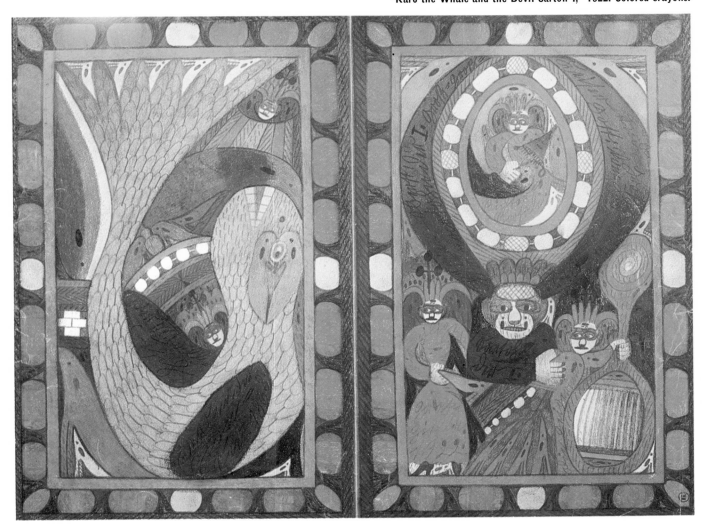

115

generic figures. So it would be pointless to assign a fixed meaning to this or that object, for every object here is always subject to an unforeseeable transformation.

To take an example. Wölfli very often represents a snake whose coiling shape and scales provide a pretext for all kinds of ornamental patterns. This animal has always aroused the interest of commentators because of its sexual, Biblical and cosmic symbolism. One might even say that the mine of its meanings has been worked out: having been pressed into service to symbolize everything, the snake has ceased to mean anything. In Wölfli, in any case, it would be quite gratuitous to attribute any definite meaning to it. For properly speaking it is not a figure in his imaginary space; rather, in the manner of Gaston Duf's rhinoceros or the violin in Pujolle's painting, it constitutes the principle on which the composition hinges, so much so that the picture space is pervaded with a generalized sense of creeping. Its gyratory movement prevails over its objective identity. In other words, Wölfli's pictorial syntax subordinates substantive terms to verbal and conjunctive forms. On occasion, moreover, his coiled snake is transformed into a massive tower; or its coils are superimposed like the lines of a musical stave, which Wölfli accordingly proceeds to fill with notes; or again it is folded over itself in circles which go to form a wall clock. In other drawings the same all-pervading sinuous movement occurs in the form of a street or a railway line, which sweeps up the whole composition into a frenzied play of curves.

The clock plays a similar part in the space-time articulation. It is not the object but the subject of the figuration; it regulates the latter by acting as the principle of design by which the picture space is divided up. But this pictorial function of the wall dial can also be assigned to a star or sun motif, which organizes space in terms of the same radiating pattern. In his hands, all objects are treated metaphorically in a way that makes them endlessly convertible.

There is something peculiar in Wölfli's manner of representing faces. Although they are always shown frontally, in compositions which themselves have a frontal and hieratic character, the eyes look sideways and are outlined in black.

The head does not follow the eyes, and this gives the face the uneasy, watchful expression of a prisoner or sentinel. Sometimes the faces are arranged symmetrically in the corners, like watchtowers. One cannot help seeing a connection between the searching, sidelong glances of his figures and the *concentration camp situation* in which he found himself from early childhood. Bruno Bettelheim has pointed out the analogy between the averted eyes of autistic children and those of concentration camp inmates (having been one himself). The prisoner, he tells us, had explicit orders not to observe, not to see, not to notice what was going on around him and above all what the S.S. were doing; at the same time the prisoner was afraid of *not* seeing, of *not* knowing, since his life depended on rightly assessing the danger [16]. Wölfli was caught on the horns of the same dilemma: he was not supposed to see (the foreman, the farmer's daughter, the little girls), but he had to be watchful (in order to avoid punishment). To account for this peculiar play of the eyes in Wölfli's pictures, there is no need to evoke the sempiternal "primitive scene" of parental copulation, as Morgenthaler does; here, as always, it is a mere assumption.

In the same book Bettelheim gives us what is perhaps the key to one characteristic feature of Wölfli's drawings which I have already noted: the tendency to frame the composition and to repeat the frame inside it, sometimes right up to the center. The parts of the drawing thus fit together in an interminable sequence, like a nest of frames that can be removed one by one like onion skins without in the end finding anything inside. The fact that these "ramparts" are often provided in the corners with sentinel faces, such as I have referred to above, makes it clear that they are a system of defense also related to Wölfli's existential situation. In this connection, Bettelheim refutes the over-simple view which would have it that withdrawal from the outside world necessarily develops an inner richness, in accordance with a principle of energy compensation. As he sees it, personality develops only in relation with its environment, through uninterrupted dealings and interaction with it. If it withdraws, it consumes itself in its own defense. It builds a fortress, yes, but an *empty fortress*.

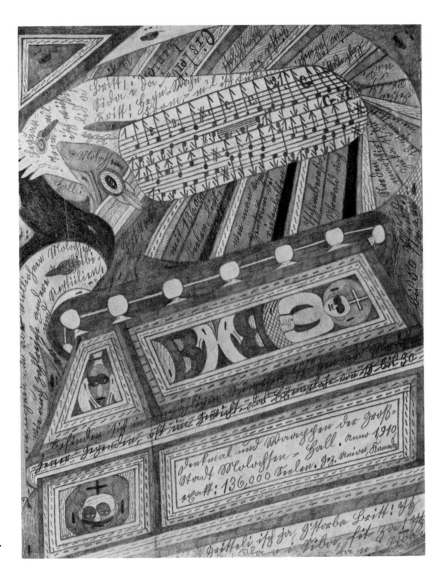

Adolf Wölfli (1864-1930):
"Necropolis, Amphibians and Reptiles," 1911.
Colored crayons.

Such is the impression conveyed by Wölfli's successive fencings, which in the end enclose nothing, except the enclosure itself. One may, however, question the therapeutic ideal of personal fulfillment proposed by Bettelheim. May not identity, as apparently achieved in individuals considered normal and integrated, amount in the last resort to identification with a social role, with a mirror self? Is this not, in other words, a matter of alienation, the more misleading for being socially recognized and honored? The productions of cultural art are always evaluated on the basis of a subjective treasury which they are supposed to express, as if a gold coverage was necessary to guarantee their financial standing. Art historians are apt to convert themselves into hagiographers in order to build up the myth, the highly profitable myth, of the inspired genius. In view of this *fiduciary* wealth, which like stocks and shares varies with the mood of the public (Van Gogh goes up, Bernard Buffet goes down, etc.), it may be that Bettelheim's "empty fortress" should be regarded as a *monument of truth*. This is what leads me to say that, psychologically and culturally, works of Art Brut are orphans. So it is that in Wölfli's work there is a well-marked intention to forestall any personal link-up; a deliberate attempt to counter the limitation actually imposed on him by a strategic retreat, a redoubling of the limit within itself, if only to gain the initiative. Wölfli plays with the enclosure as he does with the calculation of his

riches: initially, perhaps, there is an attempt to escape from nothingness and to exist in the accepted sense in a society where *being* means essentially *having* (had he not been made to feel this again and again?); but beyond that one senses the malicious pleasure he takes in carrying those riches to the height of absurdity and discrediting wealth by a frenzied abuse of it. Likewise, the impulse to delimit, to localize, to territorialize, is carried off into a *hyper-territorialization* which foils the limitation imposed on him by endlessly redoubling it. In the end, the reference to wealth and the reference to identity cancel each other out in a dizzy spiral of inflation.

It will be noticed once again that my interpretation *skirts* that of the psychiatrists. One would only have to transpose it into the nosological terms of a diagnosis in order to attribute, for example, the sidelong glance of the sentinels to paranoia, or the system of ramparts to autism, or the obsessional partition of the picture surface to schizophrenia. I freely admit, moreover, that Wölfli's life and work give room for a *pathological* commentary, provided that one can precisely determine the object on which that commentary should turn. Something abnormal certainly occurred when at the age of eight Wölfli was suddenly cut off from his childhood and condemned to forced labor and harsh treatment. From that time, he was forced into a situation that can only be described as *schizoid*, so strongly is it marked by *cleavages*: those that separate social classes, those that delimit wealth and property, those that determine sexual taboos, those that cut off the prison and the asylum. It would be equally legitimate to speak of *autism*, of absorption, that is, in a private and imaginary world, provided it is realized that Wölfli was forced to become autistic.

The schizophrenic is said to "refuse reality." Let it be admitted, with this qualification: Wölfli refused *this* reality because it was intolerable. Nor would it be quite correct to say that, in his work, he set up against it a world of his own imagining. On the contrary, he reflected it back and amplified it with insensate emphasis and re-emphasis. How strong and secure his psychic resources, his love of life, his creative energy, his *sanity*, to put it plainly, had to be for him not to sink irretrievably into taciturnity and catatonia, like so many human wrecks who have been reduced to a similar state. This is true, incidentally, in some degree, of the other interned makers of Art Brut who are dealt with here: nearly all of them came from the most uncouth and underprivileged walks of life; from childhood they were familiar with poverty, solitude, brutality or illness, all at the same time in many cases! It is no exaggeration to say that they number among the damned of the earth, and that they were literally *driven to breaking point*. As a rule, they went directly from prison to asylum. In their case the purpose of the psychiatric diagnosis and internment appears very clearly: to suppress the scandal, to seclude the person causing it, to deprive him of the ultimate faculty which a human being is acknowledged to possess, responsibility; and thereby to annul the legal contract that sets a time limit to the incarceration of common law prisoners. Here the psychiatric institution clearly shows its political role, which is to *medicalize* the conflict, to confine it to the individual unit declared to be diseased, in order to avoid envisaging its social implications. Consequently, if one is justified in adopting a pathological point of view, if one can *rightly* speak of autism or schizophrenia, it is with the proviso that these terms shall be applied to the pathogenic social group. Wölfli would then have to be regarded as a kind of inspired resonator, taking upon himself the general schizophrenia and reflecting it back to the limits of expression. Wölfli invented a language of his own to express a latent situation in which all of us are more or less consciously involved. It is not by chance that, more than any other maker of Art Brut, he came up against the police in general and the psychiatrists and psychopathologists in particular: apart from its prodigious inventiveness, his work represents the most virulent affirmation of *anti-psychiatry*.

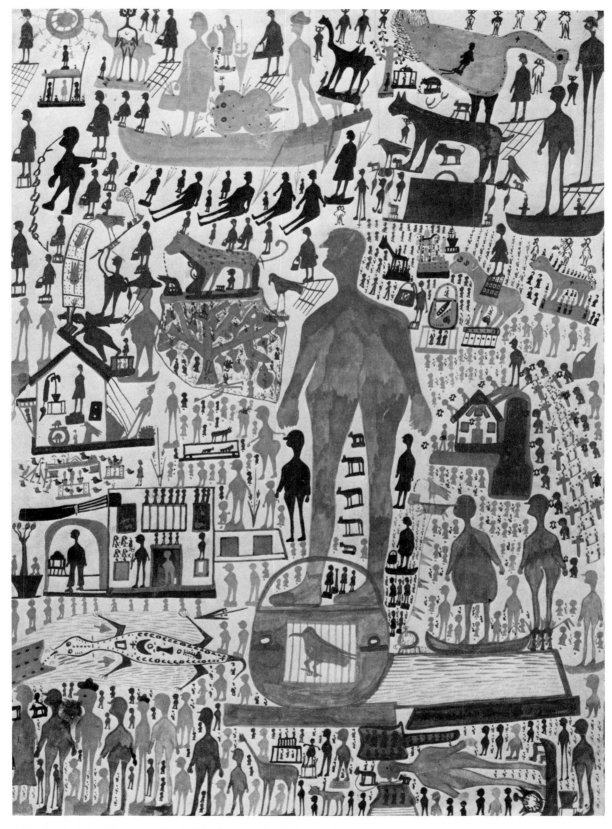

Carlo (1916): Men, Women and Birds (The Green Man), 1960. Gouache on paper.

Carlo

Carlo was born in 1916 at San Giovanni Lupatoto, a village in the province of Verona in northern Italy, where his father was a carpenter. He had to leave school at the age of nine and go to work as a farm laborer. Those who knew him at that time have gone on record as saying that, without exactly disliking people, he seemed to prefer being alone, the only company he sought being that of his dog, from whom he was inseparable. During the Second World War he was conscripted into the Italian army and sent to the front. The shocks of battle left their mark on him and later took a turn for the worse. Becoming a prey to visionary terrors and persecution mania, he was interned for good in 1947 in the psychiatric hospital of Verona.

The authors of the monograph devoted to Carlo [6] lay stress on the conditions of internment at that time. Eighty men had to live together by day in a room measuring 65 by 32 feet; at night they slept together in a dormitory with two rows of superimposed bunks. There was never a moment of silence among them, there was no possibility of being alone; nothing but groans

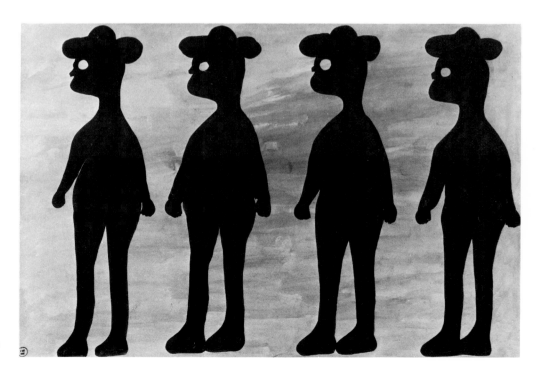

Carlo (1916):
Four Silhouettes on a Yellow Ground,
1960. Gouache on paper.

scription, prognosis. In fact, in legal cases, he is asked to examine the disturbing individuals and designate the ones whom it is advisable to exclude from the social contract and who can then be locked up and drugged uncontrollably—for this is what *really happens* once a diagnosis of mental illness is handed down. (It may be objected that cases involving criminal law are in the minority, and this is true; more often the psychiatrist is committed to the repression of non-criminal deviance.)

It is not for me to judge the validity of the nosological (i.e. disease-classificatory) categories on which this repression is based. The point I wish to make is that, where Art Brut is concerned, the concept of mental illness is irrelevant. It is easy enough to assure oneself of that by asking any unprejudiced persons, including if possible some psychiatrists, to examine the works reproduced in this book and to designate the ones they think were executed by "madmen." It will be found that the choice is always fanciful, that it varies from one person to the next, as well it may, since there simply does not exist any discernible connection between the character of a work and the fact that its maker was or was not interned. In this connection, I have referred to the nosological tables used by early twentieth-century psychiatrists, which, so they supposed, enabled them to diagnose this or that mental illness from the stylistic features of a drawing. There is surely no need to demonstrate the worthlessness of this method; with such criteria, Picasso, Ernst or Klee could be found to combine all forms of insanity! This is why most psychiatrists have discarded it and now no longer regard an art work as having any diagnostic value. They nevertheless continue to take a medical interest in it, and in reading their studies of such works one realizes that, however much they may appreciate the aesthetic aspects of them, they still rely on pathognomonic references that remain more or less unavowed. Without those references, moreover, would there still be any sense in putting art into relation with mental illness? For myself, I agree with Jean Dubuffet that "there is no more an art of madmen than there is an art of dyspeptics or of people with knee trouble" [11].

But while the notion of mental illness is hazy and questionable, the internment for which it gives a pretext is all too real, and it would be surprising if it did not lead to certain consequences in the field that concerns us here. One scarcely dares to imagine what would have happened if a man as independent and creative, as enamored of solitude and freedom as Ferdinand Cheval had been interned. There can be no doubt that the concentration camp existence in an asylum of that day would have brought him from deviance to catatonia, from creativity to sterility; that is, it would have reduced him to such a state as to confirm the doctor's diagnosis retrospectively! Thus the chain of causality has to be reversed: whatever the reasons for psychiatric internment, it is that internment, through the changes it brings about in the destiny of the individual, which determines his status as a mental patient. Yet, however paradoxical and inhuman it may seem, internment can sometimes have a positive effect on the creative faculties of the individual; it can sometimes stimulate them in a way that would probably never have happened in a situation of social integration.

THE POINT OF NO RETURN

Xbdqgxatuvwaytiviskitos, alsaqualificatifsogo bibiscoloyatel domiconilosiskibitos; alleuiyabisloyosicos ürwisky yoyodelsicomatociscoyatismoyos; Jagocesissa Jgdcovryiscovoyaviscotismayomatissistos; viviscos J. d'Arc! pipisiscotoyomaticcosyovadismoloyadelmos prépare, de très grandes surprises, à tous les peuples nomades...

Jeanne Tripier

The Medicalization of Deviance

I have quoted the comments of Ferdinand Cheval on the reaction of his neighbors to the construction of his Ideal Palace (see page 25). Being well aware of the danger, Cheval evokes with great discernment the threat of internment that hung over him, as it hangs over all individuals of his kind. He only owed his freedom to the comparative tolerance to be found in country districts, where solitude and space are not rationed and where, consequently, manifestations of originality are felt to be less disturbing and less contagious. In a more thickly populated and more conventional-minded milieu, he would probably have been interned, after a few psychiatric formalities which would have been got over without much difficulty. The American psychiatrist Thomas Szasz has bluntly declared that psychiatric diagnostics are stigmatizing labels applied to individuals whose behavior disturbs or offends other people [68].

Without wishing to enter into the anti-psychiatry debate, I start from the view that the notion of mental illness is relative to the conventions of a man's surroundings. Michel Foucault, in his *Histoire de la folie à l'âge classique* [30], has shown that madness is not a phenomenon of nature, but an entity that varies in its definition and extent with history and civilization. The same psychic states which, in India or New Guinea, are valued for their magic power, are declared to be diseased in our society and penalized by exclusion or confinement. Ideologically, the psychiatrist claims to take his authority from science and therapeutics, and he apes the procedures of his medical colleagues: diagnosis, pre-

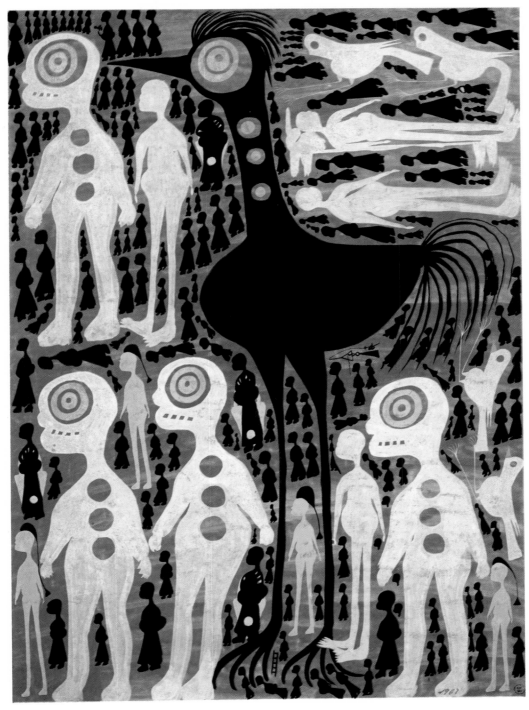

Carlo (1916): Long-Legged Bird, 1964. Gouache on drawing paper.

and wailing, continual disputes, and the brutal irruptions of the attendants! Their one distraction: the courtyard of the asylum, where the inmates were sometimes taken out in a group, and where Carlo persisted in drawing graffiti on the walls with a pointed stone.

Things changed for the better thanks to the good offices of an outsider, the Scottish sculptor Michael Noble, who in 1957 prevailed on the Verona psychiatrists to provide the facilities of an artist's studio. From the start Carlo made full use of them, and since then his life has been al-

most entirely devoted to artistic expression. (I see no reason here, however, to reconsider the doubts which I have expressed, not about art workshops of course, but about the views underlying ergotherapy, i.e. the notion of treating mental illness by means of artistic activity or craft work. Maud Mannoni has recorded a revealing remark by one of her patients: "Ergotherapy is a foolish invention. If I wanted to work I would be outside. My *option* is for the life of a victim" [57]. It is obvious that Carlo seized on the chance of "ergotherapy" not to neutralize but on the contrary to heighten his madness.)

What is striking about Carlo's drawings, at first glance, is the alternation of congestion and emptiness, a feature that one cannot help putting into relation with the concentration camp situation in which he found himself at the asylum (psychiatrists and jailers are the only people left to regard such "crowding" as a psychotic symptom!). In the most crowded compositions, one gets the impression that the treatment of space has not proceeded from an overall design, but from a gradual and continuous filling of every available gap. As the gaps were gradually reduced, the figures became smaller, which no doubt accounts for the curious variations of scale and positioning. This packing in of figure after figure at every point prevents the composition from forming an organic, articulated whole. The concentrated overcrowding is made still more haunting by the effect of multiplication: single, unrepeated motifs are rare in Carlo's work. Most of the time they are reiterated, like endless replicas without any original. Man, above all, appears essentially as *one of a series*. One notices the repetition of motifs even before the eye is able to focus on any one of them in particular, the more so since the silhouettes seem to have been deliberately schematized or standardized. Thus one's attention is continually adrift, carried this way or that by the attraction of the duplicate; it shifts from one register or scale to another, it is dispersed without ever being able to settle on one element or embrace a whole. It is no doubt this obsession with dissolution that leads Carlo to multiply figures by four, a number essentially divisible, symmetrical and inorganic, well calculated to frustrate any possibility of totalization.

His collages, dating from 1962, only went to reinforce this obsessive tendency. They consist of a series of labels from matchboxes or cigarette packets covering the entire sheet of paper. Contrary to what is sometimes supposed, the collage is not the ultimate form of *trompe l'œil*. On the contrary, it is a technique that by visual means suspends one's belief in the antecedence of the imitated object or original over the imitation. It is, furthermore, a way of emphasizing the serial essence of the object. For my part, I would be tempted to describe it as a new kind of anti-humanist allegory. After experiencing life as a farmhand, a soldier, then a prisoner, Carlo, from within his asylum, working with such means as he can get, signifies in his own way a certain state of civilization.

The Secondary Gain from Internment

It has often been thought surprising that so many inmates of psychiatric hospitals should suddenly begin to draw, usually without having had any artistic training, and sometimes reveal unsuspected gifts. To be accurate, one would have to say that they begin to draw *again*, since they are only taking up anew an activity which all of us have practised in childhood. What has actually happened, in every case, is that there has been an *interruption* in the practice of drawing. But then the real matter for surprise is rather that this interruption should prove to be final in "normal" individuals. Has there ever been an attempt to explain why it is that in Western societies children generally cease to draw at about the age of twelve? May it not be that artistic activity represents a "libidinal discharge" incompatible with our way of life, and that it calls either for a cultural framework (supplied by the "fine arts system") or for pure and simple repression. Such is the price we have to pay to acquire the knack of abstract thought, the technical mastery and the material output which are the cardinal values of our civilization.

If this is so, it will seem less surprising that a faculty of invention sacrificed by our culture should be perpetuated or rediscovered by these marginal individuals, the dropouts of our educational system or the outsiders who, by temperament, have rebelled against the social norms. Detention is particularly propitious to imaginative creation. It may be likened to a state of drowsiness. It involves a social estrangement and a decline of the "reality principle." The surrounding world ceases to be envisaged in an instrumental sense, and the emotional investments, on the basis of which it was originally built, stand revealed for what they are.

Of course, in the best integrated social life, any work that is not simply mechanical, any intellectual effort, belongs to what Freud called the "libidinal economy." Movements and gestures, the handling of a tool, the tackling of a material, the strain of an exertion, all bring sexual impulses into play more or less consciously. But they are sublimated in the purpose to be

achieved. Objectivity is the control and rationalization of those impulses, which are channelled into constructive and socially sanctioned activities.

What detention does is to remove the individual from the system of ends and means and put him in a position of contemplative passivity. Seen in the light of that hebetude, the most ordinary things lose their practical and social meaning and betray their innate symbolism. The act of drawing or assembling materials here plays a revelatory role, rather like a manipulation of objects which is not oriented towards their instrumental purpose and is thus able to release all the phantasmagoria underlying their familiar aspect. The works of Gaston Duf, André Robillard, Auguste Forestier and Guillaume Pujolle are highly significant in this respect. Among the characteristic features of the work of their patients, psychiatrists themselves have noted the "physiognomization" of objects and the emotional tonality of nature. But they put this tendency into relation with mental illness, whereas I would attribute it to the mere fact of detention.

It is true that the works of inmates of psychiatric hospitals are much more numerous and creative than those produced by prisoners under common law. Can this be explained otherwise than by mental illness? It must be noted first of all that imprisonment is meant as a punishment; it is, if you like, a debt to be paid to society. The terms of that payment are fixed by law, which the judicial authorities are bound to respect as much as the prisoner is. The latter knows that his stay in prison is temporary: he looks forward to his release, whose date is guaranteed by law, and he sees everything in terms of that longed-for release. So that whatever the strain he may be under he continues to refer mentally to the "normal" life outside, from which he is temporarily excluded. His imagination remains polarized by objectives related to social reintegration.

While prison aims essentially at impressing his *responsibility* on the inmate, the psychiatric institution does everything to exempt him from it. The mental patient, as soon as he is designated as such, ceases to be listened to—except with a view to diagnosis or in a climate of therapeutic solicitude that rules out any reciprocity. Since he is now deprived of any interlocutor, his utterance,

his power of expression, no longer has to be regulated in terms of a desired result: it becomes an end in itself. Disinterested, having no direct object, it can play freely with itself. Usually it will regress towards stereotypy. But it may also develop and open out, without regard to any standard of communication. The psychiatric inmate, having nothing to look forward to, having no idea when he may be released, if ever, is in a position to prefer the shadow to the prey, as André Breton put it. The advantage he reaps from his dereliction is that he is free to express himself *gratuitously*, and he is exonerated from the anxiety of human relationships and social responsibilities. No longer having to use language as an instrument, since his faculty of so using it is challenged, he can make play with it for its own sake, he can let himself be lured away by the plastic density of the signs and their intrinsic symbolic energy. Having nothing more to lose, he can indulge in the intoxication of self-surrender and untrammelled freedom which is so favorable to imaginative creation. This is what led Heinrich Anton Müller, the victimized inventor, to construct machines exempt from the laws of production and thus to pass on from the realm of value to the realm of expenditure.

It seems probable that the most creative inmates deliberately turned their situation to account, with a duplicity that was perceived even by the psychiatrists: the latter have noted in some of their patients a state of indecision between simulation and real disorder. It may be assumed that the creators of Art Brut reacted to social exclusion by going one better: pushed out of the communication circuit, they took the initiative of creating a secret language of their own, rather as the underworld coins its slang by taking over accepted terms, but they did so more boldly, radically, violently. Their only resource lay precisely in "re-sourcing" signs which for them had no further use, in detaching them from their usual meaning and forcing a new one upon them—in a way that I have likened to the methods of the handyman tinkering with makeshift materials.

The French Traveller: ▶
Flower Composition, between 1902 and 1905.
Watercolor on drawing paper.

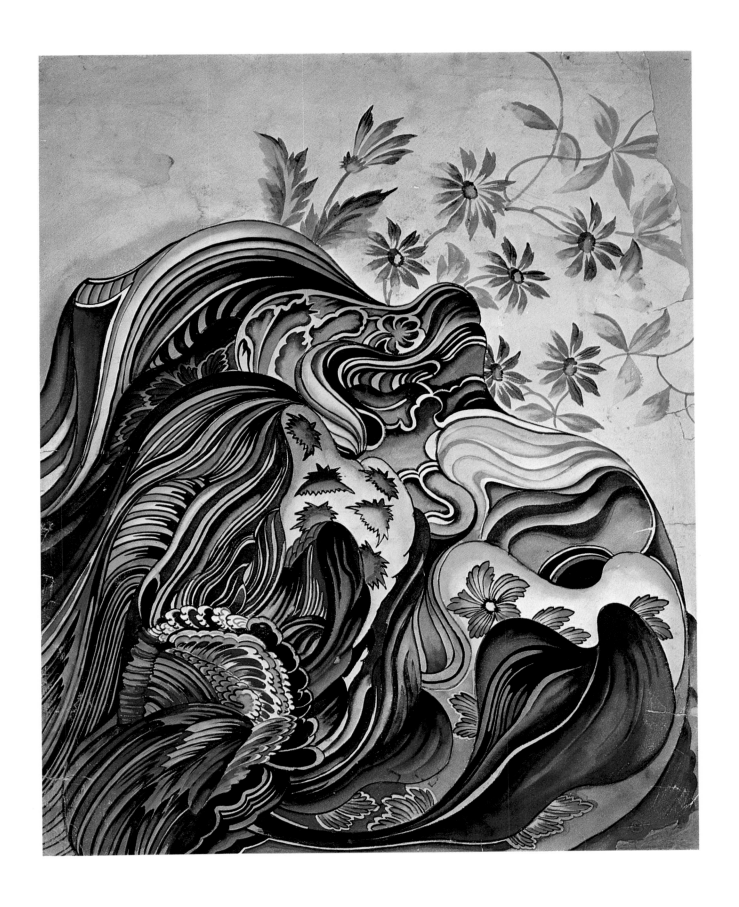

This duplicity comes out emblematically in the drawings of the "Voyageur français," the French Traveller, whose real name has not been recorded [9]. We only know that, before his internment for schizophrenia at the Villejuif Asylum near Paris, he was a decorative artist. The surviving drawings probably date from around 1900. One of them is entitled *The Land of Meteors*, and psychiatrists are fond of citing it as a particularly striking and overt symbol of schizophrenia, playing on the etymological sense of the word. For in fact the composition is *split* in spectacular fashion: on one side is a quite conventional landscape; on the other, abruptly abutting against it, is a hard mineral world, wrought out of strange jagged shapes and crystallizations. But to my mind it is a mistake to invoke here the notion of *Stilwandlung*, that is a change of style determined by psychosis. For the artist could hardly give a clearer demonstration of his ability to express himself in two languages, that of normality and that of deviance; he displays in graphic terms his power of passing from one register to another and keeping control over this alternative; he plays at going from one to the other, he is not acting under compulsion. It is misleading and mistaken to reduce to the level of a symptom a power of expression which forestalls the obvious psychological interpretation.

While firmly rejecting the notion of mental illness as irrelevant to the creation of art, and while trying at the same time to evaluate the part played in it by detention, I do not by any means claim that detention in itself is apt to arouse a man's faculties of invention. It would be preposterous to credit the psychiatric institution with the works that see the light there. The "secondary gain from internment" to which I have referred—rare at the best of times and now largely eliminated by the advent of chemotherapy—can in no way compensate for the essential inhumanity of the mental patient's position in our society. The fact remains that in a very small number of cases, and these are the ones that concern us here, institutional care has happened to have a positive effect, in so far as it represented an alternative to a social existence in the outside world which was felt to be still more intolerable. One of these exceptional cases is Aloïse.

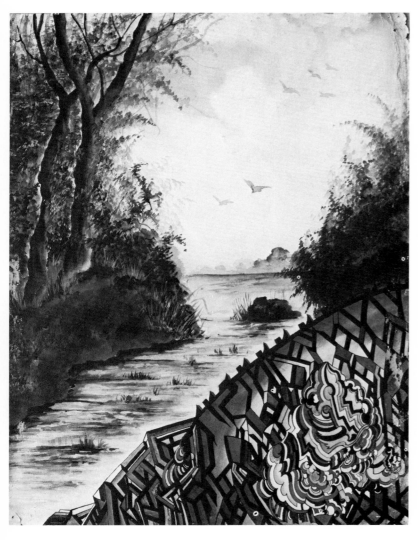

The French Traveller:
"The Land of Meteors," July 1902.
Watercolor on drawing paper.

Aloïse photographed in 1963 with one of her paintings, in the Rosière Asylum near Lausanne.

Aloïse

Like all the makers of Art Brut who went through psychiatric institutions, Aloïse was dispossessed of her surname (cf. page 37). Although in her case there is no mystery about it (her full name was Aloïse Corbaz), I shall keep to the practice of referring to her only by her Christian name, since her work, much better known that that of the others, has gained recognition under that name. The biographical facts that follow are taken from the remarkable monograph on her by Dr Jacqueline Porret-Forel [7], who as a general practitioner looked after Aloïse for many years and succeeded in establishing ties of friendship with her.

Aloïse was born in Lausanne in 1886. Her father, a post office employee, is said to have been a coarse and brutal drunkard, but this did not prevent Aloïse from displaying great affection for him. Endowed with a fine voice, she had some hopes of becoming an opera singer; they were thwarted and she felt the disappointment keenly. But she did well at school and got her high school diploma in 1906. She does not appear to have been happy at home, nor was she

able to adjust to the families and boarding schools where she worked episodically as governess and teacher. In 1911 she left Switzerland for Germany, working as a private teacher in Leipzig, Berlin and finally Potsdam. There she had the opportunity of meeting or seeing the Kaiser, Wilhelm II, in circumstances that remain obscure, and she fell passionately in love with him. Her religious scruples and sense of inferiority inclined her to turn her feelings inward and she lived out her love in a dream-world of her own, all the more ardently.

Returning to her people in Lausanne in 1913, she went through a period of increasing mental disorder, marked by fits of agitation and inordinate religious and pacifist zeal. In 1918 she had to be interned in the Cery Psychiatric Hospital near Lausanne. The diagnosis was dementia praecox; her intelligence and retentive memory were duly noted, as were her wandering mind and a tendency to dissociate language and make use of neologisms. She lapsed into a state of autism, broken by outbursts of violence and eroticism towards the doctors.

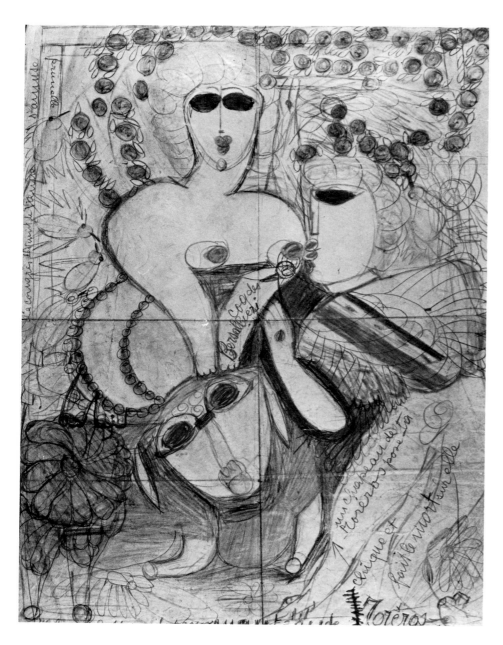

Aloïse (Aloïse Corbaz, 1886-1964):
Cock of the Sharpshooters -
He wraps her in his torero's cloak
("Coq des Bersallieri - Il l'enveloppe
dans son manteau de toréros"), 1942.
Pencil and colored crayons on paper.

130

Gradually, however, Aloïse settled down to asylum life. She was soon transferred from Cery to the Clinique de la Rosière at Gimel, in the Vaudois countryside not far from Lausanne, an annex reserved for quiet and incurable patients. Although for most of the time she remained engrossed in her private dream-world, muttering unintelligible phrases, she gradually arrived at a relatively harmonious routine of life, and one highly creative on the artistic plane. She began to write and draw, probably about 1920, and she also helped with the mending and ironing of the household linen at the asylum, carrying out these tasks with exemplary care and efficiency: no doubt these activities contributed to soothe her mind. Until 1936 no notice was taken of her pencillings, and almost everything she wrote and drew up to that time was destroyed. Then Dr Hans Steck became director of the Cery Hospital and its annex, La Rosière. Together with several other people, including Dr Jacqueline Porret-Forel, he took care to preserve her drawings and saw to it that she was supplied with the materials she needed.

Jacqueline Porret-Forel, who won her confidence and succeeded in establishing an emotional contact with her, has recorded some of her talk, which impresses one as being perfectly lucid. Aloïse considered herself to be one of "those old maids who were afraid, those women who dare not say either yes or no... they are kept under lock and key, they are not supposed to leave the convent... she stayed there thirty years... she settled down there." Unable to muster the strength, or having no desire, to cope with the secular world, Aloïse entered into madness as one enters into religion, and she adjusted herself to asylum life as a nun does to the convent. Her peace of mind was disturbed only once more, when she was taken for a few days from La Rosière back to the Cery Hospital during the congress of the Swiss Psychiatric Society in 1948, which apparently wished to have some human material on hand in order to illustrate certain arguments; but it may be that Aloïse did no more than obligingly play her part as a mental patient, as Charcot's guinea pigs played theirs. On another occasion, out of friendship for her, Jacqueline Porret-Forel prevailed on her to leave La Rosière and come out for a drive in the car; but as they drew away from the asylum her anxiety became so evident that she had to be taken back at once. As for her alleged verbal confusion, it would seem to have been practised more or less deliberately, as a means of defense against strangers and nosey outsiders, for she was capable of conversing easily and vivaciously with people she knew.

The position of Dr R.D. Laing is well known: he has challenged the underlying assumptions behind the notion of schizophrenia. In describing his encounters with his patients, he has spoken of "his or her deliberate use of obscurity and complexity as a smoke-screen to hide behind. This creates the ironical situation that the schizophrenic is often playing at being psychotic, or pretending to be so... A good deal of schizophrenia is simply nonsense, red-herring speech, prolonged filibustering to throw dangerous people off the scent, to create boredom and futility in others. The schizophrenic is often making a fool of himself and the doctor. He is playing at being mad to avoid at all costs the possibility of being held *responsible* for a single coherent idea, or intention" [51].

Emphasis needs to be laid on this crucial factor of responsibility. I have already touched on the barbarity of the psychiatric expert's report, which doubles the delinquent's punishment by condemning him to be deprived not only of freedom, but of responsibility for his acts. There are, however, I repeat, exceptional instances in which the individual is able to turn this situation of irresponsibility to account, because it enables him to go ahead and express anything and everything, without having to justify himself in the eyes of anyone, not even himself. For such an individual, this is tantamount to the removal of any moral or critical jurisdiction; he need feel no qualms of conscience and he knows it. With reference to this very situation, Maud Mannoni has cited Pirandello's play *The Fool's Cap* (*Il berretto a sonagli*, 1918) [57]. The plot may be roughly summarized as follows. Beatrice, in her jealousy, makes a great fuss by accusing her husband of being the lover of Ciampa's wife. In such circumstances, denial is useless; it only lends color to the accusation. There is only one solution, and

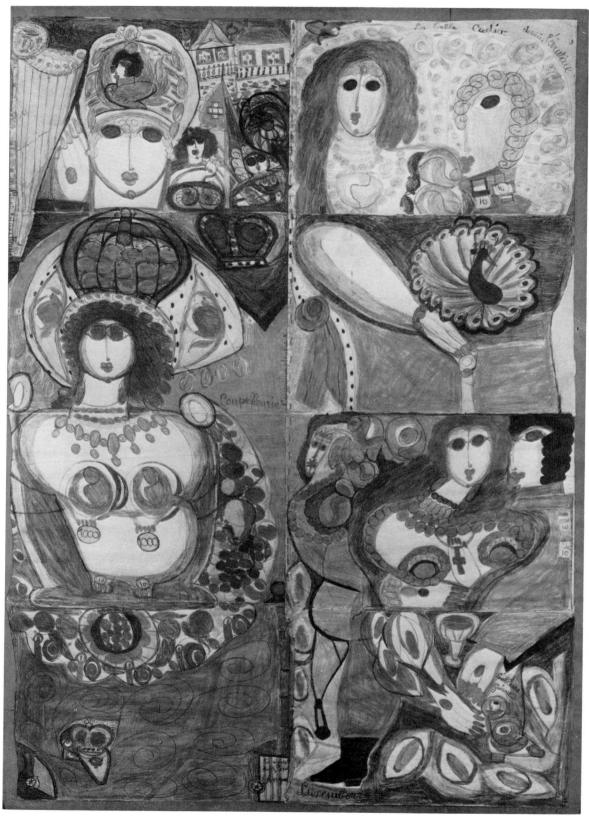

Aloïse (Aloïse Corbaz, 1886-1964):
Luxembourg - The Beautiful Cadix behind her Fan ("Luxembourg - La belle Cadix derrière l'éventail"), 1952-1954.
Colored crayons on eight sheets sewn together.

132

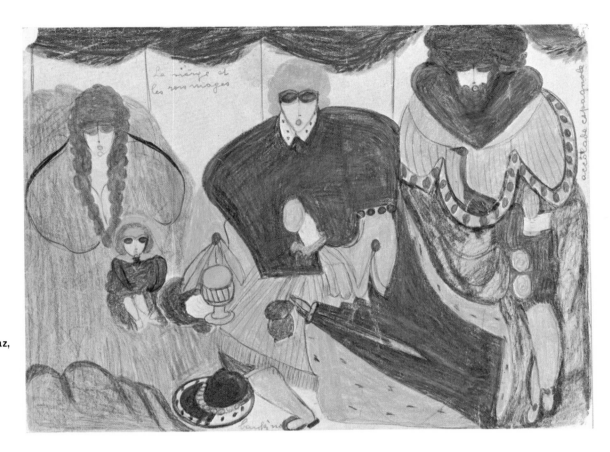

Aloïse (Aloïse Corbaz,
1886-1964):
Virgin and Child
with the Magi
("La vierge
et les rois mages").
Colored crayons
on drawing paper.

that is for Beatrice to make believe she is going crazy, which she should be able to do easily enough: after all, when you tell people the truth, unreservedly, they think you have gone mad. This is what Ciampa tries to make Beatrice understand: "Come on, give yourself the pleasure of being crazy for three months. Ah, if I could, if only I could!... Ah, to pull a fool's cap down over your ears and run through the streets and houses and spit the truth in people's faces... You can do it—what a piece of luck! It's like living a hundred years longer! Start now, start shouting the truth..."

Aloïse may be supposed to have adopted a similar strategy, to have found in madness a peculiar status which enabled her to devote herself to her private imaginings, without having to account for them to anyone. This is the view of Jean Dubuffet, who wrote in a letter to Jacqueline Porret-Forel in 1964, at the time of Aloïse's death: "She was not mad at all, much less in any case than everyone supposed. She made believe. She had been cured for a long

time. She cured herself by the process which consists in ceasing to fight against the illness and undertaking on the contrary to cultivate it, to make use of it, to wonder at it, to turn it into an exciting reason for living. The wonderful theater she was always putting on—that incessant talk, incoherent and hardly intelligible (she made it unintelligible on purpose)—was for her an unattackable place of refuge, a stage no one else could get on to, where no one could reach her. It could not have been more ingenious, nor more convenient. And with her great talent, her great inventive intelligence, she smoothed and perfected this theater, to astounding effect. She loved to astound. She had worked out little by little a technique which enabled her to do it with great ease, sparing herself trouble (thanks to her unintelligible elocution which dispensed her from always having to hit on new finds). She had discovered the realm of the incoherent, she had come to realize the profusion of fruits that it can yield, the ways it opens up, the lights it turns on; she was enamored of it and thrilled by it, never

Aloïse (Aloïse Corbaz, 1886-1964):
Woman in an Evening Gown with her Partner, 1941.
Pencil and colored crayons.

ceasing to wonder at it. But mad, certainly not. Quite lucid, I am convinced, withdrawn into the so very ingenious shell which she had devised for herself..."

Her way of representing bodies conveys Aloïse's determination to withdraw from the world and above all to hold herself aloof from any relation with others. It is by way of the body that one fits into reality, that one becomes a focus of attention, that one puts oneself at the mercy of others. So it becomes a matter of removing it from the objective world, refining it into pure appearance, distilling it into the picture alone, which is materially assimilated to the surface of the paper. One can understand her fondness for figures that are all façade, like those in the glossy magazines, existing only as representation. The fact that Aloïse would sometimes paste into her drawing a picture of some famous actor

or public figure from whom she had taken inspiration, shows clearly enough that what interested her was not Pius XII or General de Gaulle or Paderewski in the flesh, but their sublimated image as displayed in the illustrated magazines. She presents them "in majesty," like the sacred figures in Christian iconography; that is, as absolute and disembodied presences, transcending the material world.

The best way of eluding a scrutinizing gaze is precisely to deny it any depth in which to probe, to offer it no more than a deployment of surfaces devoid of any recesses or inwardness; this is to defeat scrutiny by an integral translucidity. So if Aloïse paints in flat tints, it is from a necessity which she feels to be not only pictorial but metaphysical (or rather anti-metaphysical): if being and seeming are to coincide exactly, they require a flawless surface, with figures and motifs packed

so closely that nothing can slip through. She is therefore intent, as she executes her drawing, on filling up any gaps which might afford a glimpse beyond or let in a sense of change or becoming. To paint or draw is, in the first place, tantamount to living in a two-dimensional world. It is a test for many artists to find themselves called upon to convey the missing dimensions in terms of the flat surface. But for Aloïse it is a solace and a refuge: here she has permission to withdraw from the shifting levels of reality where one is required to cope with adverse circumstances and otherness. Yet, with Aloïse, the surface appearance is exhaustive: it drains the figure and therefore cannot admit of volume, of the density and secrecy of bodies.

Nor can it admit of perspective. For perspective is as much a conjuring trick as a reproduction of the visible. More exactly, the two go together and form a system, so that the partial and contingent object brought before us is articulated in terms of an overall visibility which as a matter of principle transcends any actual representation. Any object represented in perspective recession suggests to us, from the position where it stands, the possibility of another viewpoint which makes our own merely relative. Those different viewpoints are like so many reverse shots which a single eye is unable to follow. In the last resort, the emblematic object of perspective is the eye of the figure represented in the scene: we see it seeing, and it sees us seeing; the keynote then is otherness and this very reciprocity engages us physically.

Understandably, Aloïse's world of *pure appearance* excludes as a matter of principle this seeing eye, which would look out from a physiological organ localized within the imaginary picture space. But there cannot be any figure here endowed with a distinct and separate vision, since there is in fact neither seer nor seen, because the dialectical relation between subject and object is magically resolved in an absolute visibility. So one has about as much chance of discovering a real eye in Aloïse's drawings as of detecting a ghost in a photograph. This is why the eye sockets are always painted over in blue, the color of absence, cancelling out any perspective in a mutual transparency.

Knowing the existential attitude of Aloïse, one would be tempted to interpret this blue screen over the eyes of her figures as a defense against outside aggression, or more precisely against the psychic wounds inflicted by others, and at the same time as a kind of mask enabling the wearer to observe without being implicated. It would thus be a device for neutralizing that undefined gleam in the middle of other people's faces, that image of ourselves which remains unknown to us, that unendurable reflection of our own gaze. It would be interesting moreover to analyse the paradigm of the "evil eye" in Art Brut in general (I have already referred to the shifty, sidelong glance of Wölfli's sentinels). In the case of Aloïse, however, one would simply be adopting the assumptions of naïve realism if one supposed that eyes are implied by these apparent masks and exist behind them. For this being a world as yet alien to dissimulation, anterior to it, one must rather assume that the gazing eye and its innuendoes have not yet materialized and that their place is merely designated by a blank space as clear as the blue sky abiding forever overhead.

Another characteristic aspect of Aloïse's world, and one that contributes even more to the disembodiment of the figures, is the tendency towards symbolism and metamorphosis, a tendency which has been frequently pointed out in her work and into which sexual implications have predictably been read, the foot being equated with the phallus, the rose with the breast, the basket of fruit with the womb, etc. There is no denying the part played by the organs of the body in the cycle of associations here, nor the pervading eroticism of her compositions. But I don't see why, in point of fact, a breast or a penis should, in the pictorial context, be any more sexual than a flower and its stalk. What eroticizes are the fluidity of the images, the metaphorical shifts, the interplay of associations, and not the coded meaning attached in passing to this or that anatomical organ. This one-way symbolism, which might equally well be termed repression, gives the perspicacious psychiatrist a further opportunity of tracing the genealogy of forms back to the inevitable phallic or uterine referent. But Aloïse's work does not function in these terms. It functions in terms of *generalized metaphors*, in

terms of theater, play acting and masquerade kept up endlessly. To suppose that all this can be interpreted objectively is a complete mistake. Being is continually announced, but continually held back, never attained: it is kept in receding perspective, in symbolical posture. The art of Aloïse keeps us moving from image to image, as a dictionary keeps referring us from one definition to another: we glide over the surface of being without ever getting a firm footing. It is precisely this metaphorical movement which exempts figures from making their presence felt and refines away anything that shows a tendency to take shape.

As in a dream, a figure has only to be evoked in order to come into existence, but only long enough to hover there a moment and then melt into some new transfiguration. Anachronisms and contradictions matter little: this fabulous world knows nothing of the opposition between actual and potential, present and past, here and elsewhere. Jacqueline Porret-Forel has described the execution of a drawing made in her presence (although as a rule Aloïse insisted on working in absolute seclusion): "In 1962, when I asked her if she would draw an animal for me, Aloïse answered: I'll make a darling little crocodile. And she began to draw a sort of lock of red hair adorned with two small blue dots (the crocodile, about half an inch long, being continued by further loops), the whole forming a head of hair, beneath which the large blue screen of the eye suggested a face. She quickly completed the outline, added two more blue dots on the brow, firmly drew in two flower-bud breasts with the dark head of a reclining man beside them, and so in a few minutes evoked Cleopatra, her lover and her scorpions, the latter so well concealed that one might well have taken them for locks of hair." From this I infer that the drawing is not a graphic transcription of an inner vision or a hallucination, but rather that the act of drawing creates the vision. The subject takes form in the very course of the execution; it is absolutely contemporaneous with it. It therefore seems to me that Dr Alfred Bader is mistaken when he writes: "The line is generally laid in straightaway, without being repeated or corrected. One gets the impression that the picture is so precisely imag-

ined in the patient's mind that she has only to copy it down on the paper at one go" [14]. It is true that Aloïse never did any altering or retouching, but that is because the line did not need to be adjusted to a pre-existing vision. It is the line that takes the initiative in creating the figures.

This is curiously brought out in the short film which Dr Bader made on Aloïse, showing her drawing with feverish intensity, oblivious of all else. In her left hand she keeps in readiness a bunch of crayons of different colors. As soon as one is broken or blunted (and this happens frequently), instead of pausing to sharpen it, she casts it aside and takes another, of no matter what color; she takes what comes. And not only does she adjust at once to the change of color, she seems to turn it to account. My impression is, in seeing the film, that she resorts to the handful of assorted crayons held in readiness as to a cast of the dice, expectantly prepared for any surprise that may turn up. Each color, by virtue of its intrinsic energy, and even before representing or suggesting something, produces in her an emotional shock as it comes to hand, and this shock is followed at once by a fallout of images, as one can see from a stenographic report of her muttered talk taken down as she worked over her drawing:

"Yes, that's Napoleon and the cafés. They go well with Aubonne [a country town near the asylum], the cafés do. Red, you know, is fine for schizophrenics. These crowds in blossom look just fine. A Greek nose, Mary Queen of Scots.

"Yes, that's the nose. I'll have to put some roses on the brow, then I won't do it any more because I'm disgusted with them. I've got the wrong green, I thought it was darker. Green doesn't scare me the way black does. The generals of green armies go out into the country. When these old uniforms are black, or they go to the theater, these old uniforms do.

"Magnificent, these superb lights, this is regal beauty, the red I must obey, it's small, after all, it's too red, a half-tone is better..."

Aloïse (Aloïse Corbaz, 1886-1964): ►
The Lovers ("Couple with Three Medallions"), 1948-1950.
Reverse side of "Samaritaine." Gouache and colored crayons.

136

Aloïse, then, "obeys" her colors: it is these that decide whether the figure will be a king or a general, whether he will go into the country or to the theater. In examining her drawings, moreover, one notices that the areas of flat color are independent of the linear design (when there is a design). The color areas are apt to shift about; they often overlap their outlines and overrun other surfaces, giving rise to new figures. The technique employed by Aloïse is like a game of ducking and dodging, calculated to check any tendency towards physical embodiment or weight.

Nor can I follow Dr Bader when he writes: "From the delirious, ill-starred passion at the beginning of her illness arose her fondness for representing the great female figures of history who experienced tragic love and with whom she identified herself: Cleopatra, Mary Queen of Scots, Josephine, etc. Their voluptuous forms, with their breasts often metamorphosed into flowers (a symbol of fecundity), enable her to fulfill, at least on paper, her instinctive, unappeased desires. Here we have a compensation for her suppressed love." This notion of a hallucinatory and compensatory identification with queens or princesses has all too much in common with the popular, over-simple conception of madmen as people who take themselves for Julius Caesar or Napoleon! I contend, on the contrary, that in Aloïse's delirium there is a strong element of duplicity and, above all, a stubborn refusal of *any identification*. The drawing, for her, is a way out of herself and the world: it offers her a means, not of taking on any assumed personalities, but on the contrary of refusing them, declining to meet them on their own ground and deferring indefinitely any personal relationship with them. There comes to mind what Marcel Griaule has said about the mask wearer in Dogon rituals: he arouses no curiosity as an individual, and even if he did such curiosity would be taboo. The person of the mask wearer is absorbed in the person represented by the mask, an accessory which was called *persona* by the ancient Romans [38]. Likewise, Aloïse dreamed of a nomadization and dissemination of self, a fantastic migration of it into various personalities, devoid, however, of any corporeal or mental consistency. The fact of the matter is that she carefully refrained from characterizing her figures by any individual feature. When she represents Andromache, Esmeralda or La Belle Otéro, she does not refer to real persons, but to the pictures of stars in the papers and on the screen, to theatrical and operatic personalities; in other words, she is referring to images at a second remove, which rule out direct reference. This explains why the figures are frequently repeated in a small medallion within the composition. This removal to a distance, into the depths, is essential to the world of Aloïse; it represents an indefinite transfer and re-transfer of identity; she *re-marks* herself, so to speak, by this internal miniaturization.

Her historical and legendary evocations are designed to achieve the same effect of abstraction or remoteness. There is no question of a reference to the present of a definite period. What she does is to set things back into an absolute past, a realm of pastness conceived as an essential quality and by definition ruling out any presence. This being so, there is not much sense in speaking of *identification*. Or if one must entertain the idea that Aloïse really identified herself with Cleopatra, Ophelia or Josephine during the time it took her to make the drawing, it must be admitted that she did so with much more aloofness, mobility, playfulness, humor, imagination and creativity than such and such an individual who takes himself definitively and incurably for a psychiatrist or an art historian. It may be worthwhile at this point to pause for a moment over the notion of *alienation* and the type of people to whom, in the last resort, it may fairly be applied.

The "Inner Voyage"

While, as I have made clear, I reject the notion of illness as applied to the makers of Art Brut, I am on the other hand quite prepared to accept on their behalf the notion of madness (but a non-pathological madness) in contradistinction to normality. Normality, to state the matter roughly, is a matter of adaptation to things as they are; it amounts in effect to a capitulation. As R.D. Laing tellingly puts it, "What we call 'normal' is a product of repression, denial, splitting, projection, introjection and other forms of destructive action on experience" [50]. Freud, in touching on this, speaks of the triumph of the "reality principle" over impulses which continue to act, but in a roundabout way, in the average man; or which may intermittently burst to the surface, as in the case of psychosis. In the conflict opposing these psychic impulses to the outside world and social norms in general, Freud always advocated capitulation. It is well known that, as regards political and social issues, his attitude was one of crusty liberalism and resigned pessimism, of skepticism towards all aspirations to change; it was, in other words, an attitude of metaphysical faith in an intangible Reality. He was accordingly led to characterize madness as a failure of the faculty of adaptation; that is, as an illness amenable to medical treatment.

This is a view which one is not obliged to share. One might well take the contrary view that the alienating factor is the social order and that it should therefore be changed. If one reverses the terms in this way, as R.D. Laing does, one will assign a positive value to madness as a successful attempt not to adapt oneself to social pseudo-realities. The madman, then, may be seen as a man who has not been able to repress his normal instincts and conform to an abnormal society. He has embarked on an "inner voyage" which needs to be furthered: "Can we not see that this voyage is not what we need to be cured of, but that it is itself a natural way of healing our own appalling state of alienation called normality?" [50] But as things are the psychiatric hospital does everything in its power to put a stop to this voyage by means of nerve sedatives, electro-shocks

or psychotherapy. And this counter-attack is effective in most cases, since it succeeds in stupefying the patient and wearing down his strength. It needs to be added, however, that the notion of madness, in this sense of the word, by no means covers all the cases referred to the psychiatric institution. When one comes down to it, these cases actually have but one feature in common: all of them concern individuals who in one way or another disturb their entourage and are for that reason interned. On the basis of a single criterium, that of social importunity, we have come to lump them all together under the same name and status—the congenitally and incurably feeble-minded and the deviants, even the creative deviants. The psychiatrists, who in general refrain from raising the issue of euthanasia as regards the former and the political and social issues connected with the latter, are at once the victims and accomplices of this indiscriminate lumping together. It is to this latter category, that of the deviants (to use a rough general term), that Laing refers.

Seen from this angle, the works of men and women like Wölfli, Aloïse, Müller and Carlo will appear as the outcome of an "inner voyage" carried out successfully, in the face of all attempts at psychiatric normalization. The origin of such works, it may be freely admitted, lies in a certain madness, but madness in a positive and not a diseased sense, as it is understood by Dubuffet, whose views tie in with those of Laing:

"Art creation is something that one expects, that everyone expects, to be strongly marked by the influx of an unusual personal secretion. Such a characteristic obviously implies in the maker a mental standpoint different from that of other people; it presupposes that questioning of norms and usages, that spirit of non-alignment, that withdrawal into oneself which—to continue to use the term in its moderate sense—are on the way to *alienation*. To what extent, whether greater or lesser, matters little. Should art creations be expected—and, if we look closely, most people do expect them—to be personal, unusual and novel *only slightly*, and in such a way that, if they go beyond a certain point (what point exactly would have to be marked), they are too much of a good thing and thereby cease to pertain to art,

taking their place among prohibited aberrations? Such a view is indefensible.

"I am convinced that art creation, wherever it comes forth, calls for the aptitudes stated above, and that it is of value only where there occurs a breaking away from the common way of looking at things, from accepted opinions, from custom in every domain; where there occurs, then, to repeat the word, an alienation of the eye and the psychic movements. In this matter I fully subscribe to the opinion that art creation always and in every case has an asocial and therefore, in the eyes of the public health officer, a pathological character. Where that character is lacking, one may be entitled to speak of art (it is a matter of agreeing on the sense of words), but certainly not of art creation. Creation implies that one is not satisfied with what already is and what others are satisfied with; it calls for a position of rebellion and conflict. The work, it seems to me, will be all the more creative as that position grows worse" [5].

It must be acknowledged, then, that in this sense madness, in varying degrees, lies at the origin of all art creation; and it is seen at its highest degree in Art Brut, in what may be called art in the raw. The idea of *normal* art is evidently contradictory. Creativity in this sphere can be understood only as deviance, as a transgression of norms. As for the verdict of mental illness and the internment it can lead to, they are based on the very criteria which creativity challenges, since it brings to the surface everything that has been kept down by social and cultural norms.

Dr David Cooper [22], an associate of R. D. Laing, has tried to shed some light on these muddled notions of normality, sanity and madness by means of a diagram which, with a few additions of my own, will serve to pinpoint the position of the most asocial makers of Art Brut with respect to cultural artists.

The development of the average individual is indicated by the arc which starts at point alpha (α), designating birth, and progresses to the top of the circle, the stage of normality. In this case, which is the most frequent, one may consider that the role-learning inculcated by family and school has been assimilated and that the social apprenticeship is "correct." The dotted arc,

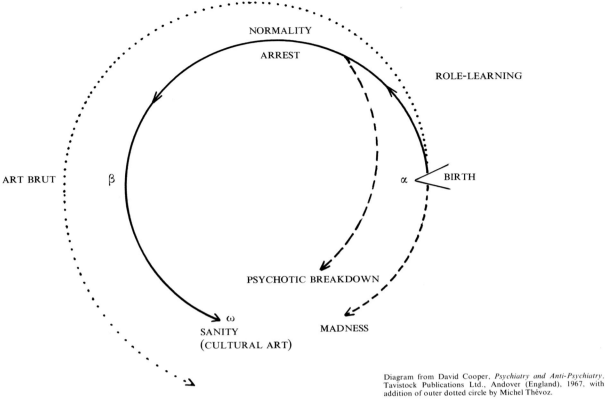

NORMALITY

ARREST

ROLE-LEARNING

ART BRUT β

α BIRTH

PSYCHOTIC BREAKDOWN

ω
SANITY
(CULTURAL ART)

MADNESS

Diagram from David Cooper, *Psychiatry and Anti-Psychiatry*, Tavistock Publications Ltd., Andover (England), 1967, with addition of outer dotted circle by Michel Thévoz.

beginning at point alpha and descending in the opposite direction, indicates that the individual did not go through this apprenticeship, for one reason or another, and has regressed towards madness. It may also happen that somewhere along the way towards normality a lapse or reversal occurs, designated as a psychotic breakdown. In view of the status of exclusion assigned to madness in our society and the treatments applied to it, anyone diagnosed as mad has a very good chance of seeing his life wrecked.

To come back to the diagram and move in the opposite direction. Some individuals succeed in progressing beyond the stage of normality and arrest, achieving an exceptional development of their mental faculties. This can take them to some extent on the way to point omega (ω), representing genuine sanity. The latter, it will be noticed, is much closer to madness than to normality. "Sanity," says Cooper, "approaches madness but an all-important gap, a difference, always remains." What distinguishes these exceptionally sane individuals from madmen is that they have gone through the social apprenticeship,

the process of role-learning; from it they retain an awareness of the criteria of social normality, and so they can avoid being considered mentally ill (though, as Cooper puts it, "this is always a dicey game"). To take an example. Paul Klee developed certain psychic resources which remain inhibited in the normal man, and which can only be found similarly developed in certain madmen. But while the latter, socially speaking, are irretrievable misfits, Klee is capable at any time of exerting his mastery over the whole compass of social conventions. It was always possible for him to return from point omega (ω) to normality.

It is to be noted, however, that in his schematic representation Cooper keeps strictly to the institutional circle which assigns each individual his place or range of action (which comes to this: the madmen in the asylum, the normals in front of their TV set or at the match or ball game, the scientists and geniuses in their laboratory or workroom). The circle of social and cultural functions is only diversified, the better to keep people within its orbit. Some individuals nevertheless escape this field of gravitation, either by

141

having in some way avoided the social apprenticeship or by reacting with sufficient energy and duplicity against psychiatric normalization. They veer away for good from the cultural orbit, without concerning themselves with role-learning or the rules of social communication, and even, if need be, putting up with the label of psychotic that has been stuck to them, but without renouncing the use of their mental faculties, on the contrary. Such is the "far out" trajectory followed by the makers of Art Brut, indicated by the outer dotted circle, which for my present purposes needs to be added to Dr Cooper's diagram.

A distinction is thus called for: while the cultural artist addresses himself to a public to whom he considers himself accountable, responding to it by an exhausting give-and-take that carries him from the top to the bottom of the circle, like an army that has to keep moving while maintaining logistic contact with the rear areas, the maker of Art Brut simply ignores the whole question of communication, with the result that he is able to concentrate his energies and pursue his trajectory to the utmost without any thought for a return to normal.

This *irreversibility* needs to be emphasized, for to my mind it is the principal characteristic of Art Brut, the one that gives it all its virulence; whereas in cultural art the boldest strokes always remain mere hyperbole and in the end relapse into the institutional field of attraction. Let me make a philosophical comparison. Descartes, trying to put truth to the test by doubting everything, assumes the worst: he imagines that there might be an evil demon which has taken possession of him mentally and which is cunningly misleading him, so that all the things he sees and all his convictions are only illusions. But even assuming this, he goes on, at the bottom of this abyss of diabolical illusions there is one piece of solid ground. Where all else may be illusion, the fact of thought remains: *cogito, ergo sum*—I think, therefore I am. And on this basis he can rebuild all his certainties without having to change them. Knowing Descartes, one can imagine the *paranoiac* enjoyment, in the proper sense of the term, with which he surrendered to this inner demon for the sake of his demonstration. This assumption of an evil demon implies a dizzy

height of complete alienation which temporarily makes of Descartes a *man possessed*, a maniac, even though this possession is complete only in the fiction of the philosophical account. In the philosopher's mind, doubt always remains pure *hyperbole*, and he is only able to give himself over to the demon because he is sure of his final release from its clutches. Descartes never really cast off the moorings of reason. So that his strategy is comparable to that of cultural artists, whose aims always remain within the reversible trajectory of communication.

The psychoanalyst Ernst Kris gives a lucid account of the orthopedic purpose of cultural art in his book *Psychoanalytic Explorations in Art* [49]. For he presents artistic creation as a "controlled madness," a momentary delirium which is finally resolved by a recentering and reinforcement of the ego: "We may speak here," he writes, "of a *shift in psychic level*, consisting in the fluctuation of functional regression and control." This corresponds to a certain American ideology. The artist is sent out to reconnoitre the "inner distance," rather as a CIA agent is dispatched into the outer distance, for the ultimate purpose of gaining control over it. While normal individuals react to madness by resistance and segregation, the cultural artist proceeds by homoeopathy, so to speak. He inoculates himself with the disease the better to neutralize it. His ventures outside the conscious sphere, however bold, are in the end profitable to mental hygiene and social integration. This view is quite adequate to cultural art, but it tells us nothing about Art Brut except by contrast.

Another psychoanalyst of art, Anton Ehrenzweig, accounts for this inner voyage in a much less hygienic manner [27]. Moreover, so far as I know, he is the only one who has made use of psychoanalytic concepts in order to throw light on the process of artistic creation in the sense desired by Laing; that is, as production rather than expression, laying stress on innovations rather than antecedents. He divides the creative process into three stages, in a way that will help us to determine more exactly the specific strategy adopted by makers of Art Brut.

The initial stage is described by Ehrenzweig as *paranoid-schizoid*. As the name indicates, it

brings into play the same psychic dispositions which occur in permanent fashion in madness. The temporary breakdown of the inhibiting ego permits the projection of erratic impulses which are ordinarily repressed, because they are felt as unwanted and persecutory. Western culture, being based on values of conceptual and technical control, dissociates the activity of symbolization from its somatic, libidinal and phantasmic sources. As already pointed out, detention, social exclusion or solitude can have the effect of partially breaking down these mechanisms of inhibition. And I have noted the importance of corporeal, gestural, motorial and material determinants in relation to conscious initiative in the makers of Art Brut. Moreover, in many of them, it is significant that art creation originated in so-called "paranoiac" feelings of persecution; this denotes the irruption of the hidden mental forces which concern us here.

The second stage sees the integration of these fragmented elements in the work of art. This integration is possible only if the critical judgment of the ego remains suspended. What is required now is for conscious attention to give way to what Ehrenzweig calls "unconscious scanning," a comprehensive, polyphonic and multidimensional inattention which extends the spectrum of the sensibility well beyond its ordinary limits. To illustrate the operation of unconscious scanning in Art Brut, one could hardly do better than quote Dr Dequeker's comments on Guillaume Pujolle. Dequeker singles out Pujolle's "ability to bring an ever increasing number of objects into relation, thanks to an increasingly indistinct idea of what he is about and an increasingly dominant and forceful complex. What is thereby extended is his apprehension of the world: it is widened thanks to a greater indistinctness and a growing maladjustment. Curiously enough, these drawings combined and regained a greater overall unity, they fitted into a synthetic pattern which was all the broader because the maladjustment with the outside world made the relations of the ego with objects increasingly vague and hazy" [25]. In my opinion, these comments apply equally well to all the other makers of Art Brut.

As for the third phase of creativity, which Ehrenzweig describes as *depressive*, let it be said

at once that the makers of Art Brut contrive to evade it. This phase is characterized by the conscious "re-introjection" and "socialization" of all that came to light in the two previous stages. The surface ego is called upon to take charge of the other self which erupted in psychotic guise; it is compelled to reorganize itself in terms of this revelation. In other words, the artist has to *sign* what has come forth under his hand; and this may be attended with severe anxiety.

It needs to be added that these three phases, discussed one by one, do not in reality form a time sequence: they come into play simultaneously, they interact. So that the third phase functions almost always in an obstructive and dissuasive sense: the artist is reluctant to let things emerge in his work which he may have to account for personally. All the more reluctant since the procedure of cultural solemnization (exhibition, art criticism, publicity campaign, museum, etc.) heightens and amplifies the seriousness of the self-revelation. Here all the privileges which artists have claimed since the Renaissance to set themselves apart from craftsmen backfire and turn against them. The personal style of expression, the signature, the public recognition, the sovereignty over the work: these are so many intimidating imputations, predisposing them to conform to social expectations or, at least, to come to terms with them.

The case of Picasso is a good illustration of this "double bind"—the contradictory demands of the creative impulse and its social justification. It can be felt already in the evolution of his work, punctuated as it is by outbreaks of savagery and relapses into "neoclassicism." There is undeniably a gust of Art Brut blowing through the *Demoiselles d'Avignon* and other paintings of that period. It is for this reason that art historians, being allergic to such works, which challenge the principles of artistic affiliation on which their knowledge and methods rest, at once set to work to provide them with an ancestry—doubtful at best—in Black Africa or Phoenicia. Picasso himself appears to have felt a similar alarm at his own audacities, which again and again were followed by a "return to the sources." It is as if, in the absence of any established cultural ancestry, he were intent on forcing his way back in time

and rejoining Cranach or Velazquez or Delacroix—like that character in a Malraux novel who with a razor traces out a life line for himself in the palm of his hand. Picasso of course is a special case. The dramatic change-overs from a "paranoid-schizoid" outburst to a depressive classicizing episode or vice versa were spectacularly heightened by the fact of his exceptional resources of vitality. It is otherwise with the common run of artists. With them, the depressive stage of cultural art very soon prevails over all other impulses and keeps their work on an unvarying level of *communication*; that is, a level of mediocrity.

The fine arts system, which works as much by a focusing and refocusing of the limelight as by intimidation, can only discourage such individuals as the makers of Art Brut, who already have little gift for social life. But even more discouraging for them is the machinery of education, whose effect is such that each individual, even the born outsider, interiorizes his self-critical judgments and doubles their severity. From that point on, there is no longer any need to refer to the art critic or the cultivated public for an opinion: the young man or woman who feels any impulse to produce art, even in secret, is prompted immediately to laugh at his efforts even more cruelly than would the fine arts experts. What happens is that the conscious self, which in Ehrenzweig's "depressive" phase has to take charge of the products of creativity, is in fact the deputy of the social superego, the personal representative of the cultural authority. It is precisely this conscious self which the makers of Art Brut contrive to neutralize. If necessary, they will refrain from considering their creations as works of art, so as not to have to justify them as such before the tribunals of taste which they have been taught to respect. It has been seen that, in most cases, they invoke a pretext quite alien to the sphere of art in order to justify their work (at least at the beginning; later, when their imagination has caught fire, they no longer bother about inventing an alibi). Thus Maisonneuve and Guillaume Pujolle began by practising caricature in a spirit of raillery; Ratier set out to make toys, not sculptures; Clément indulged in a pastime that had no artistic pretensions; Palanc

and Emmanuel were engrossed in problems of writing and coded messages. The work of interned makers often has a magic or maleficent purpose. It has also been noted that the psychiatric institution has produced a model of madness with which some makers have been tempted to identify themselves, thus siding with those who denied them all responsibility. Generally speaking, one may say that the makers of Art Brut reverse the findings of Descartes: with them, it is the *cogito* that is mere hyperbole. They provisionally invoke the hypothesis of an aggressive, sarcastic, ludic or psychotic self in order to excuse and finally sanction the power of the creative demon lurking within them. We may now have a look at another device for evading the artist's social role: spiritualism or mediumism.

Augustin Lesage

Augustin Lesage was born in 1876 at Saint-Pierre-les-Auchel (Pas-de-Calais) in the great mining region of northern France [3]. The Lesages had been miners for generations; he became one himself as soon as he left primary school, and he married a miner's daughter. He had never shown any aptitude for drawing. The farthest he had ever gone in the world of art was a brief visit to the Lille museum with some army chums during his military service, and the pictures he saw there made no particular impression on him.

In 1911, when he was thirty-five, while working as usual one day in the coal mine, he heard a voice distinctly saying to him: "Some day you will be a painter." A few months later he was initiated into spiritualism by some fellow miners, and he soon showed unusual gifts as a medium. After a number of séances the spirit guides urged him to draw, and then to paint. One of the messages they dictated to him ran as follows: "Yes, some day you will be a painter and your works will be studied by science. At first you will feel it to be ridiculous. But we will draw and paint through your hand." Lesage accordingly went to Lille and purchased the necessary materials at a stationer's. As he had never seen or handled a tube of color, it was under the guidance of the spirits that he chose the brushes and tubes he needed. He wished to begin with small-sized pictures, but an unaccountable misunderstanding occurred in connection with his order and when he received his first canvas by train from Lille it turned out to be ten feet square! He was about to cut it up into smaller pieces when again he received a spirit message: "Do not cut the canvas. It will do. All will be fulfilled. Follow our instructions and we will fill it up to perfection. Set to work on the painting." Reassured, Lesage fastened the canvas to a wall in the front room of his house in the little mining town, mixed his paints and began gingerly in the upper right corner, working his way down and across from there, inch by inch, without any idea of what he would paint, relying entirely on the spirits who were guiding his hand. It took him over a year to

complete the picture, on which he spent all his evenings and Sundays, while the neighbors frowned and looked askance at him.

Lesage tackled this canvas of nearly a hundred square feet in the spirit of a miniaturist, focusing his attention on the small area immediately in front of him, without worrying about what was to come next. In other words, he carefully refrained from mortgaging the still unpainted surface by any overall program by which he would have felt himself bound. He chose to proceed in such a way that it was always open to him to make whatever move he pleased. This means that the composition has no *unity* in the usual sense of the term: one feels that it was created piecemeal, by fits and starts, that there was no shaping plan behind it. Yet it does not have the balanced disorder that one finds for example in action painting or in works built up by an accumulation of micro-elements. The fact is that the composition falls into a coherent pattern if one refrains from taking an overall view of it, if on the contrary one ranges over it slowly with the eye, for the reading of it needs to be geared to the slow rhythm of its making. Thus, from the upper righthand corner, where Lesage began, the eye moves into a curvilinear system where forms are reproduced freely, spreading outwards over the surface, rather like the growth of a plant. Then it would seem as if a fortuitous arrangement of elements went to form the nucleus of another process of growth, based now on symmetry and crystallization. If an organism so constituted does not allow itself to be overrun and prematurely absorbed by the neighboring plant life, it develops to the latter's detriment until it imposes its pattern over a broad area, forming as it were a picture within the picture. But sooner or later it uses up its own resources, and then a new system of development emerges. This, then, is an unstable and dynamic world, one in which antagonistic forces are at work, and one which might fairly be interpreted as a kind of model or allegory of the life process, or even as a figuration of mental or cerebral mechanisms.

How is one to explain the mastery displayed by Lesage in this baffling venture of his? Would he have dared to embark on it, had he not been certain that he could rely on his "spirit guides"?

Augustin Lesage (1876-1954):
Composition signed Medium Lesage, 1923. Oil on canvas.

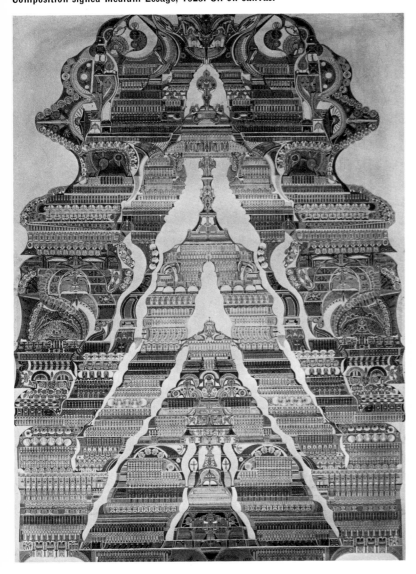

146

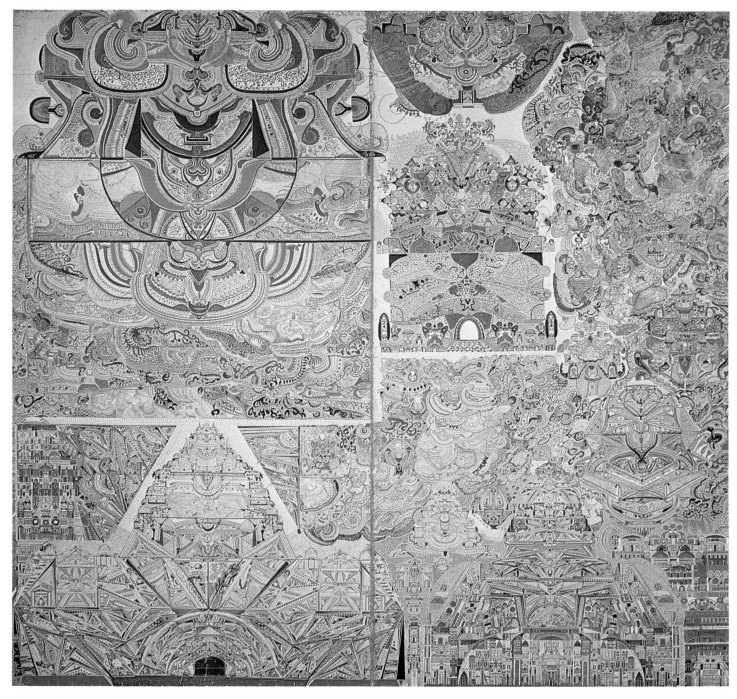

Augustin Lesage (1876-1954): First Painting, 1912-1913. Oil on canvas.

These guides he subsequently identified, first as Leonardo da Vinci, then as a personage whom he called Marius de Tyane (a name possibly suggested by Apollonius of Tyana, a thaumaturge of the first century A.D.): they, he claimed, inspired him throughout his work. His case was investi-

gated by Dr Eugène Osty, to whom Lesage made the following statement [3]:

"Never, before painting a canvas, have I had any idea what it would be like. Never have I had an overall vision of a picture at any point in the course of its execution. A picture comes into exis-

tence detail by detail, and nothing about it enters my mind beforehand. My guides have told me: 'Do not try to find out what you are doing.' I surrender to their prompting. I lay in the figures they make me lay in. I take up the color tubes they make me take and I mix them as they prompt me to, without knowing what tone will come out. I take up the brushes as if at random. Even my eyes go where they have to, independently of me. I know it sounds unbelievable, but that's the way it is. I follow my guides like a child."

The theories of Anton Ehrenzweig could hardly be better exemplified, with the reservation that I have noted. Lesage leaves the initiative to forces which do not belong to the sphere of the conscious mind. But even when these forces have been materialized in the painting, he persists in considering them alien to his own personality, so that he does not have to assume any artistic responsibility. He never ceased to claim the powers of a medium.

Lesage also practised healing. After the First World War (in which he served in the French Army), he began to attract the attention of spiritualist circles, with a degree of success that enabled him to give up his work in the mines and devote himself entirely to painting. In 1925 the Spiritualist Congress sponsored an exhibition of his work in Paris. From 1927 on, his pictures were increasingly influenced by the doctrines of the Institut Métapsychique in Paris, with which he became closely connected, gaining some measure of recognition as a medium and an artist. This no doubt explains why he no longer displayed quite the same freedom and inventiveness as in his earlier work. Augustin Lesage died in 1954, after having painted nearly 800 canvases.

The Spiritualist Alibi

Cases of *mediumism* are frequent in Art Brut. A well-known case is that of Raphaël Lonné. A postman in a small town in the Landes, in southwestern France, a simple and emotive person who had never shown any taste for art, he began to draw in 1950, at the age of forty, after having been initiated into spiritualism [1]. He claimed that his drawings were made at the prompting of spirits and that he executed them automatically, without any preconceived idea. He was at a loss to give any explanation of them.

Joseph-Albert-Alfred Moindre (1888-1965) was a property agent in Paris who, on being introduced into spiritualist circles, discovered a new vocation for himself as an Egyptologist [4]. At the age of fifty-two he began painting small pictures in gouache, whose content stemmed from his newly acquired beliefs. In one of his writings he refers to a message he conveyed to Moses, whom he had invoked as an intercessor: "I ask you to be kind enough to set Amenophis II on my road to guide me along the divine paths of the Sphinx and the Pyramids which, together with yourself, will give me the guidance I need to complete my present mission." (See plate, page 61).

Joseph Crépin (1875-1948), a disciple of the miner Lesage, had a small business as a plumber and driller of wells in the Pas-de-Calais [5]. At the age of fifty-six he became aware of his powers as a water diviner and healer. In 1930 he joined the Circle of Psychic and Spiritualist Studies in Arras. At sixty-three he tried his hand at painting, as his friend Lesage had done. The keynote of his pictures is symmetry, so strict as to produce a disturbing or intriguing effect. While he did not actually paint them in a state of mediumism, he claimed that they emanated from the supernatural powers with which he was invested. In 1939 Crépin declared that mysterious voices had set him the task of painting three hundred pictures, after which the war would end and peace would reign in the world. (See plate, page 43).

Madge Gill (1882-1961) was born in London and spent most of her life there in the East End;

she was an illegitimate child whose mother succeeded in concealing her existence for a long time [9]. She began to draw at thirty-seven, without ever having had any lessons: "I felt I was definitely guided by an unseen force, though I could not say what its actual nature was." That was in 1919. A year later it appeared that Madge was a true medium under the influence of a spirit guide named Myrninerest. She has described the kind of work she began to do: "First of all, knitting—even doing pieces of knitting on one knitting needle without any pattern. Then came a flow of all kinds of inspirational writing, mostly Biblical. Then I felt impelled to execute drawings on a

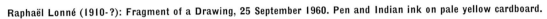

Raphaël Lonné (1910-?): Fragment of a Drawing, 25 September 1960. Pen and Indian ink on pale yellow cardboard.

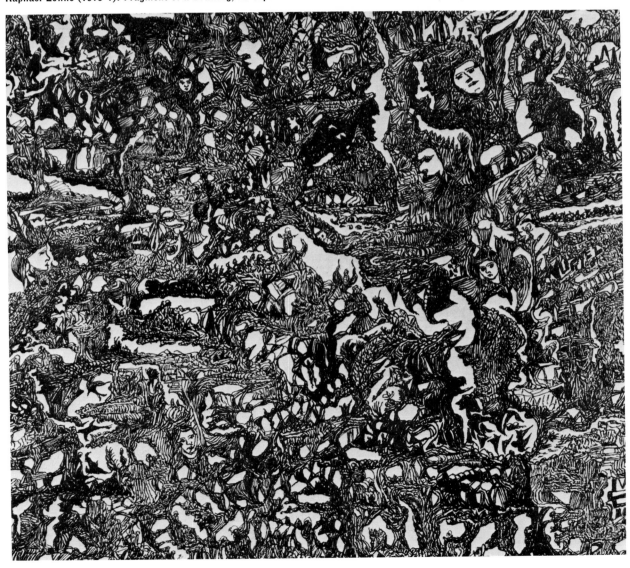

large scale on calico." Working in black and also colored inks, she would draw standing up in front of a large roll of calico which her son Laurie arranged for her on a bobbin, from which it could be unwound little by little as she drew; so that in this medium she never had an overall view of her work. There were times when she also drew in semi-darkness. (See plates, pages 167 and 169).

The presence of a considerable number of spiritists among the makers of Art Brut calls for a few general remarks. Spiritualism, it will be remembered, is the belief that the spirits of the dead can hold communication with the living through a medium. This belief became widespread in Europe (and also in the United States) in the mid-nineteenth century and soon enjoyed an extraordinary vogue, especially in the commoner walks of life, among workers and peasants. Specialized periodicals devoted to spiritualism had a wide circulation in Europe; at one time there were about fifty of them. In the presence of adepts, at their séances, as they called them, tables would begin to turn or tilt and emit strange noises. Messages would be delivered and questions answered by means of table rapping, the number of raps corresponding to a given letter of the alphabet. Tables would even write and draw by means of a pencil tied to their leg. The most responsive or gifted adepts soon came to provide a direct channel of communication with the other world: lending their body, voice or movements to the spirits, they proceeded to speak, gesticulate, write or draw at their prompting. These were the mediums. They possessed the singular power of relinquishing all will of their own, of resigning all conscious thought, and responding with utter docility to a personality which they felt to be alien to this world, and which was assumed to be the spirit of the dead.

The phenomenon of mediumism has been analysed by Pierre Janet in his book *L'Automatisme psychologique* [43]. He explains it as a semi-somnambulistic state in which the subconscious receives perceptions and produces thoughts in which the conscious and voluntary self has no share and to which it consequently lends no sanction. The fact is that mediums who practice automatic writing *do not know* what their hand is noting down; they only find out when they look over what they have written, and sometimes they even have to call in other people in order to decipher it. Janet thus sees it as a phenomenon of mental disaggregation, and more precisely as a splitting of the personality. It is symptomatic that the most prudish mediums and the most virtuous young ladies will often transmit messages from the most ribald and libidinous spirits. This, in the eyes of spiritists, is ample confirmation that the mediums themselves have not made up the messages. As I see it, this tends rather to bear out Ehrenzweig's view: moral inhibitions, like cultural inhibitions, lead the subject to shift responsibility for the "message" to the spirits in question. In similar fashion, as I have pointed out, the maker of Art Brut evades the last, "depressive" phase of creativity, involving the assumption of personal responsibility.

Furthermore, every seer or medium is inclined towards ambiguity, imprecision, generality. He feels, without necessarily thinking about it, that it is to his advantage to be enigmatic: the vaguer the message or prediction, the more interpretations (i.e. the greater number of possible verifications) it will admit of. The oracle ingenious enough to throw out phrases which can be taken to mean anything is bound to see his predictions justified by events. Here we come back again to the maker of Art Brut: he too, more or less consciously, invokes this ruling principle of mediumism in order to free himself from the fetters of any set and single meaning and transfer his figures into a wider realm of symbolic generality. Creation then is no longer under the surveillance of an intended meaning: the ties of complicity between the sender and the recipient, which ordinarily restrict the message to a narrow code and set meanings, are here relaxed.

There is no overlooking the fact that Lesage, Crépin, Madge Gill, Jeanne Tripier and Lonné very soon aroused the interest and sympathy of those who shared their mediumistic beliefs. While it is true that they evaded the judgment of the critics and pundits of the professional art world, on the other hand they won support in more popular and even proletarian circles. Spiritualist groups as a rule know nothing of institutions, ministries or hierarchies. The most gifted

mediums come quite naturally to the fore, and they owe their powers more to sensitivity and knack than to acquired knowledge. Spiritualism, like magic in general, is opposed by religion because of its demon-haunted or maleficent propensity and because of its clandestine and sometimes illicit character. It answers to the aspirations of individuals who feel themselves to be barred from the cultural world. For this reason, it is practised in the first place by those whose status of exclusion is *re-marked*: for example, invalids, outsiders, misfits, eccentrics, those who have a somewhat mysterious profession, and also, in our male-dominated society, women (cf. page 161). The figure of the medium in spiritualist circles may be likened to that of the witch doctor in certain African societies: endowed with a magic power, he can put himself in communication with the dead. By virtue of a psychic predisposition which I would term "hysterical," he is able to focus and reveal irrational forces diffused through the group, by utterly surrendering himself in the effort.

There occurs, then, a kind of *communication between unconscious minds* both in spiritualism and in Art Brut, and this is what explains the connection between them. I have referred to the disquieting strangeness of the latter: while taking us out of ourselves and even bewildering us, at the same time Art Brut closely involves us. It neutralizes the surface ego and awakens that other self, common and anonymous, which the workings of the educational and social machine had put to sleep. This may seem to contradict the hyper-individualistic views of Jean Dubuffet. But we must try to be clear about this notion of individuality, which is all too specious in its commonly accepted meaning and which therefore needs to be handled with strategy or hyperbole: individualism, in the sense of resistance to conditioning, when carried to the limit gives us an inkling of an area outside culture which transcends individual purposes. This is what happens when the creation of Art Brut takes place in a spiritualist milieu: it outlines a form of collective participation and symbolic exchange which is the exact opposite of established culture, marked as the latter is by individual atomization and social cleavages. I would prefer to describe Art Brut,

not as *another culture*, but as *something other than culture*: an exchange which is free of institutional restraints (beginning with individualistic repartition) and therefore remains fundamentally asocial and anarchistic.

For this reason, the outlined participation referred to above tends to be fleeting and is always threatened. Take the case of Augustin Lesage. Once he was taken up in the micro-milieu of a spiritualist group, everything he had previously stood for was threatened, for even that micro-milieu tended to reproduce within itself the institutional pattern and to recreate its ideology, its hierarchy, its honorary titles. So it too can stifle art creation, just like the culture from which it had seemed to break away. Or, conversely, the conditions of true participation may be so uncertain that the spiritualist creator lets himself be taken over by the spirit of which he was the outlet, so far as to forget his mediating role and acquiesce euphorically in a state of total possession. Psychiatrists have noted this in their clinical terminology: "Spiritualism, and this is a serious matter, predisposes one to a certain mental automatism, to a dissociation of the psychic centers, as has been observed over a more or less short period in several mediums. This disaggregation has formidable consequences, for from the day when it has become *permanent*, when it occurs *in spite of* the medium, then hallucination, the source of delirium, has set in" [29]. In other words, one can surrender more or less to one's demons. It is this *more or less* which goes to define the poles of madness and mediumism respectively, and Art Brut in all its variants brings home to us the continuity between these two poles.

Jeanne Tripier

The daughter of a wine dealer, Jeanne Tripier was born in Paris in 1869 [8]. Her early childhood was spent with her grandmother in the Ile-de-France countryside. As a young woman she lived for some time with an American named Joseph Baum Miller, who already had a son, Gustav, whom Jeanne adopted. She worked for a while in a Paris department store, the Palais de la Nouveauté. She took an interest in occultism and divination and frequented spiritualist groups. At the age of fifty-eight, becoming aware of her powers as a medium, she began to devote herself seriously to writing, painting and embroidery, but none of this earlier work has been preserved. Here is what she wrote about it in 1936: "Madame Tripier will have to realize that her fluidic astral body goes wherever there is reason for it to go. You also have another fluidic body, a boreal astral body, which lives under the domination of all the stars and all the Planets, whatever they may be. Then you also have your fluidic carnal body, which is often in contradiction with all the celestial demoniac powers. You are not aware of it and yet we all of us informed you of it, during the time of your mediumism, from 1927 the 6th of May to the month of October 1934. Through the works of modern art and also through the holy writings which we reproduced for you daily. Unfortunately your writings and your works of art have been destroyed."

One can assume that her "fluidic astral body" finally prevailed over her "fluidic carnal body" and that Jeanne Tripier went so far in the game of spiritualist identifications as to pass for a lunatic. She was interned in 1934, at the age of sixty-five, and the diagnosis made then reads as follows: "Chronic hallucinatory psychosis. Psychic excitement. Logorrhea. Megalomania, probably initial state. In 1915, convinced she had inherited a large fortune, prone to litigation... Voices at first enigmatic, then informative. Redoubling of voices by means of writing; has only to start writing when her mind is inert to receive ideas and information. Many spirits housed in her brain, coming out and returning therein. Active and passive telepathy. She is the

Jeanne Tripier (1869-1944):
Page of Drawings, 1937. Purple ink on cross-ruled paper.

152

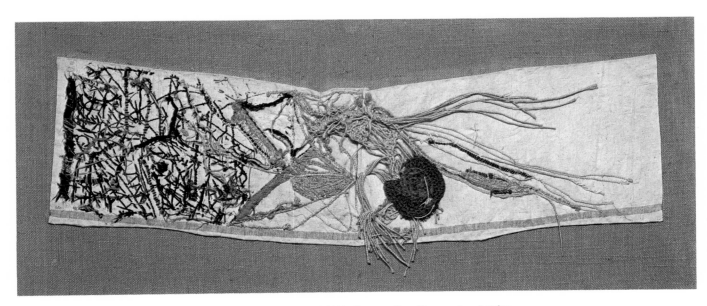

Jeanne Tripier (1869-1944): Large Rectangular Embroidery, 1935-1939. Green cotton, blue wool and string.

missionary of Joan of Arc... She is a medium of prime necessity, chief administrator of planetary justice, etc. Rough symbolic drawings with very varied and maladjusted captions—passive drawings, she calls them."

The surviving works of Jeanne Tripier date from the four years 1935 to 1939. They give one the impression that she must have devoted practically all her time to writing, drawing and embroidering, and in doing so she displayed an astounding mental agility in adapting herself to her supernatural inspirers. It is not a matter of play-acting or impersonation, for she shows a single-minded power of identification, a prodigious faculty of mental migration, which not only ranges beyond the level of representation (as already noted with reference to Art Brut in general) but transcends the very idea of directed time.

These two notions, moreover, are interdependent. The space of the representation has as its corollary a continuous duration of time, as defined by Bergson in particular: each moment retains what went before and announces what is to follow, like a melodic progression. There is a continuous interpenetration, a step by step determination which imparts to the duration the unity and purpose of a definite path or *meaning*. It is this character of continuity and orientation imparted to Time which guarantees the metaphysi-

cal unity of Being. This ideology of meaning even finds a somatic complicity, since the persistence of the retinal images re-establishes a continuity in the sequence of film images or in the luminous scanning of the TV screen.

On the other hand, the idea of a discontinuous time sequence, multiplying the pinpointed instants without itself being governed by a definite purpose, would be out of the question. It would mean a lapse into senselessness, a devaluation of the role of awareness and a loss of any ontological assurance. The stage of the representation would collapse. Words and things, sounds and ideas, signs and figures would interchange their roles and waste language in an insensate immediacy. Dreams, drugs and madness give us a glimpse of what the overthrow of the linear time sequence would mean.

Dubuffet has rightly drawn attention to the prodigious and fruitful "faculty of forgetfulness" displayed by Jeanne Tripier. It is this faculty that enables her to concentrate all her mental energies on the present, utterly ignoring what has gone before and what is to follow. It transmits, so to speak, on ultra-short waves, in non-Bergsonian frequencies. It cannot be said that the imagination takes this or that course or path. What we get, rather, is a burst of images following each other disconnectedly, each one stepping up our

153

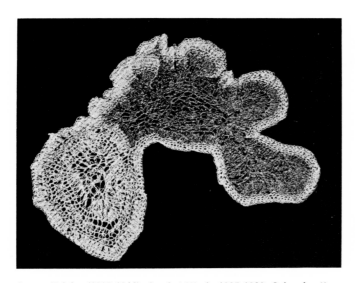

Jeanne Tripier (1869-1944): Crochet Work, 1935-1939. Colored cotton.

sense of bewilderment. This is felt most keenly in her mediumistic writings. Every day, writing as the spirit took her, without pause or erasure, Jeanne would note down communications from every conceivable source, without a thought for wording or phrasing, and yet in a well-ordered and readable style. This very fact throws into relief the discontinuity of the messages, which flash in and are broken off like calls in a telephone exchange. Oblivious of herself, Jeanne connects with the spirit world and, conjuring up one personage after another, she becomes Joan of Arc, Josephine de Beauharnais, Anatole France, Zibodandez I, Morin the One-Eyed Snail, Morpheus of the Catacombs and so on. As she proceeds, the process of spiritualist identification speeds up and the pace grows frenzied, rising to a pitch that rules out any identity.

Her mediumistic imagination veers off at times into drawings. The pages of her writings are strewn with them. Jeanne dashed them off at high speed, using various mixtures of water, ink, hair dyes and nail polish, which she spread over the sheet with a brush or her fingers. She makes the most, to fantastic effect, of all the properties of her medium, of all the accidents of its flow and spread, its transparency or opacity, its overlappings or blottings. She reads into them a confidential forecast of coming events, and taking up her pen at once she sets to commenting on them and elucidating them. Nothing could be further

from the cultural conception of drawings as the expression of a sensibility, a personality, a "temperament"; nothing could be further from the "Van Gogh effect." Art Brut as a whole stands outside the pale of the system defined by the notion of private property and its ideological correlate: the work of art as an emanation of the private person. Jeanne Tripier, moreover, as already noted, has no personal identity. And if she did have one, she would strive to the utmost to break free of it, through drawing and through spiritualism or madness—with her they amount to the same thing.

But it is in her embroidery and crochet work that Jeanne Tripier's imagination takes its most spectacular flight. Something has been said about the ordered linearity of her writing, maintained even under the crossfire of the mediumistic messages which it records. A similar paradox, but one carried now to an even higher pitch, appears in the adoption of the technique of needle and thread by a creator who set so much store by instantaneous effect. For if there is any symbol of permanence and continuity, it is the piece of woven material and everything connected with needlework. In our patriarchal ideology, the solidarity and orthogonality of warp and woof are naturally associated with maternal values in their domestic and tutelary aspect. But Jeanne Tripier uses needlecraft as a foil to intensify the effects of disruption. She makes a Machiavellian use of the emblematic signs of regularity and continuity in order to disorganize space, warping its axes, doing violence to forms and snapping off lines. Art Brut finds its most virulent embodiment in what might be called an *aesthetic of anarchy*.

The Negation of the Signature

The forger is often assumed to be an artist who only adopted that line of business because he failed to make a career under his own name. This is no doubt true with the majority of forgers. But the reverse may also happen: an artist may find it convenient not to feel himself personally implicated in what he has produced. As things are, the fine arts system functions in terms of intimidation and promotion, all too often self-promotion. The sensitive may well be deterred from having anything to do with it. Some of them—like the spiritualists, but more conscientiously and more cunningly—have hit on the idea of publicly declining the authorship of their works and attributing them to some unknown individual. Altogether, it would appear that madness, spiritualism and faking must be regarded as the varying lines of an anti-cultural strategy adopted by the makers of Art Brut, who apparently have neither the desire nor the courage to assume responsibility for that other self of theirs which society pompously dignifies with the name of artist. According as circumstances or their turn of mind may prompt them, they opt for disguise, a double life, or alienation from which there is no turning back.

Probably nothing will ever be known of the maker (or makers) of the "Müller Bearded Figures, " so called because most of them once belonged to a Swiss collector of that name [11]. Some are carved in granite, others in volcanic lava; they range in height from ten to forty inches. They are presumed to come from France, possibly from Vendée or from the region around Clermont-Ferrand. They appear to have been carved out of milestones stolen from the wayside. They were originally purchased from antique dealers, who provided no information about them. For all their apparent archaism, they are almost surely of recent making. One may be pretty sure too that their maker was not displeased at seeing them taken for folk art of some earlier century. In them he was able to give full and free expression to his taste for massive, timeless, generalized figures, without having to strike a pose somewhere between Maillol and Brancusi.

Anonymous: Head with a Wig. One of the so-called "Müller Bearded Figures." Date unknown.

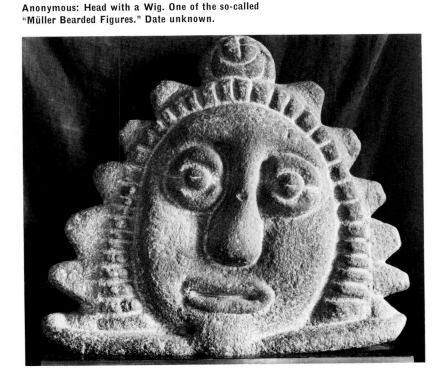

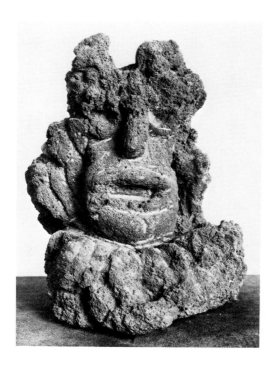

Anonymous: Woman's Head. One of the so-called "Müller Bearded Figures." Date unknown.

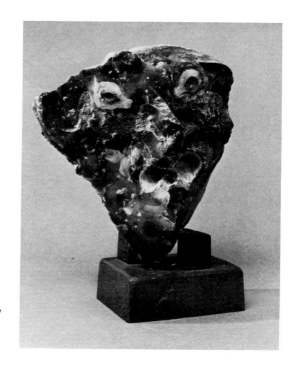

Juva (Prince Antonin Juritzky, 1887-1961): Man's Head, 1948-1949. Black flint.

The case of Juva is less enigmatic. Born in Austria in 1887, Prince Antonin Juritzky showed from boyhood an interest in fine stones [11]. He built up a collection of cameos and objects carved in porphyry, sardonyx and agate. He also became a keen amateur archaeologist. Then his interest shifted to the so-called semi-precious stones, and finally to flints. He found a peculiar fascination in their chipped and wayward forms. In the end he convinced himself that these flint nodules showed traces of human handiwork dating from prehistoric times—which did not prevent him from reworking and painting some of them himself. In 1948, at the International Congress of Anthropology and Ethnology in Brussels, he read a paper entitled "A Shrine of the Levalloisian Period." He claimed to have found in the neighborhood of Levallois, in the northwest suburbs of Paris, a palaeolithic shrine containing a hundred idols and amulets, some tools and also these flint nodules, whose android forms, according to him, attested the intervention of human hands. In his paper he stated: "The stalactites, like the flints, often have a grotesque shape which permits the imagination to see in them the forms of animals. The men of prehistoric times brought out these forms by further cut-

ting, adding color to them and completing them. The cave paintings are in many cases natural reliefs which were embellished." Prince Juritzky apparently succeeded for a time in deceiving even the best informed scientific circles. But of course it could not last. His passion for flint nodules, however, did not abate, and under the pseudonym of Juva he continued to rework them into shapes of his own devising. He died in 1961.

His hesitation about assuming responsibility for work that was actually his own and his more or less deliberate attempts at mystification evoke the doubts felt by Ferdinand de Saussure in working on the anagrams of the Latin poets [67]. The more he studied these saturnian poems, the more names Saussure came to detect, concealed in a single line. At that point arose the question of poetic responsibility. Were the anagrams deliberately devised by their Latin authors? Or were they produced by them unconsciously? Or did the anagrams stem from the imagination of Saussure himself, who projected them into the poems as in hallucination one projects a face into a cloud shape? Juva set himself the same problems of attribution with his flints; and in him there is a wavering between self-deception, mystification and pseudonymity which in any case

enabled him to evade the issue of artistic sovereignty.

But after all is there not something obsessional about our eagerness to ferret out a responsible signature? May it not be that that very eagerness goes to justify the strategy of evasion to which I have referred? If the real goal is to break free of one's specular ego and alienate oneself with the anonymous powers which put unconscious minds in communication with each other, then the chances are that a stone picked up by the wayside will be more likely to embody these impersonal forces than a framed Van Gogh.

This inevitably offends the conception we have of artistic creation and the sovereignty of the artist. True, modern painting has accustomed us to the idea that chance has its part to play in the creative process, that the materials themselves may take the initiative in that process. Even so, when they come into the artist's hands, those materials are on probation: they cannot impose their implied or inherent aspirations unless these coincide with the artist's guiding purpose. Thus, in the philosophical system of Leibnitz, God comes to favor the free will of his creatures because he knows that the latter will inevitably fulfill his own scheme of things. What is decided by the higher jurisdiction of the artist and what is decided by the materials follow a curve which in the last analysis answers to the intentions of the painter, who is therefore entitled to sign the work.

With the makers of Art Brut, on the other hand, no clear-cut dividing lines remain: they take up a wavering and undecided position somewhere between matter and mind, intention and chance, imagination and substance. When a stone from the wayside becomes capable of implementing the aesthetic scheme, then reality begins to topple over with it into the imaginary. But can one still speak of an image in the absence of any explicit artistic intention? And can one speak of art in the absence of any actual intervention on the object? Where is the work? Who is the maker? Who is the spectator? Who looks at it and who signs it? In the absence of any conniving over the roles to be played, does not the fine arts system run the risk of breaking down and leaving the field free to uncontrolled, anonymous, anti-humanist or even non-human forces? No doubt the signature is part and parcel of those fundamental conditions of culture which Michel Foucault had in mind when he wrote: "If those conditions were to vanish as they appeared, if through some event which at most we feel to be possible but whose shape and promise we as yet know nothing of, they were to give way, as the ground of classical thought gave way at the turn of the eighteenth century, then the odds are that man would be wiped out, like a face in the sand at the edge of the sea" [31].

Social Segregation and Creativity

Take the five leading representatives of cultural art in this century: Braque, Picasso, Klee, Ernst and de Staël (or others, it does not much matter): they all have this in common, that they came of well-to-do middle-class families, they were men, and they showed precocious gifts. Take by way of comparison the five makers of Art Brut who may be thought the most inventive (however arbitrary the choice must be in a field which by its very nature rules out schools and pacemakers)—say Wölfli, Aloïse, Jeanne Tripier, Heinrich Anton Müller and Laure Pigeon: they all came from poor working-class families; nearly all began their life work after they had turned fifty (they began at the age of 35, 55, 58, 52 and 52 respectively); and the women show at least as much creativity as the men. So as one goes from cultural art to Art Brut the nature of the facts is found to be the very opposite. Can this be a matter of chance?

The question of social background calls for little comment. If there is a sphere in which caste privilege has prevailed, it is that of artistic culture. It is only fair to add that in the age of mass media that culture is much more widespread. But one is almost tempted to regret it, so strongly elitist in character are the ideological models thus diffused. The middle-class minority came in the end to see that it was in its interest to democratize the access to ways of thought and feeling which contribute to strengthen its own power. So it is that, on the screen, in magazines, even in factories, missionaries of a new kind are cashing in on cultural values and winning devotees to them. Every possible means is used to make of art, not a vehicle of liberation, but an object of almost religious deference. One can understand why it is that the makers of Art Brut come, in their great majority, from an underprivileged class which the cultural contagion has so far largely spared. But not for much longer. Already, with the tentacular extension of the mass media into every home, the production of Art Brut is falling off.

Culture imposes its authority not only at the stage of schooling and the acquisition of knowledge. It acts even before that in the most elementary stages of language learning, structuring the child's individual expression and inculcating social norms. And this is true not only of verbal language but of figurative language. Is it a mere matter of chance that the advent of mercantile capitalism coincided with the development of the easel picture and oil painting, the most dematerialized of art techniques? We have seen that, in the case of commercial dealings and in the case of the image, the intent was the same: to draw a veil over the time and circumstances of production, to sanction the power of a monetary or figurative equivalent, and set up the reign of value (ontological, moral and commercial). The oil painting and its opposite number, the sculpture in marble, a hopelessly homogeneous and passive medium, are both in league with the ideology of representation. They confine the artist to a theatrical device, just as the piano confines the musician to the dodecaphonic system.

It so happens that most makers of Art Brut had no access to oil paints, marble and the conventional media of artistic creation. This was another secondary gain from poverty, which kept them free from a cramping art language and which also gave them a stimulating pretext. When an artist disposes freely of the most suitable means of execution, he is condemned to achieve nothing but what he already has in mind. The work of a demiurge is on principle uninteresting, because it holds no surprises either for him or for us. Whereas the maker of Art Brut draws a paradoxical advantage from his dependence on makeshift materials and techniques. He delights in letting his hand be forced and obtaining unforeseen results, circumventing or outstripping his intentions. He has the further advantage of being able to evade some share of his responsibility and attribute to his lack of means any singularities that may cause surprise.

Why is old age the golden age of Art Brut? Because it is a time of life which, psychologically, is synonymous with forgetfulness and obstinacy, which together mean immunity to conditioning: a state of mind highly propitious to non-imitative

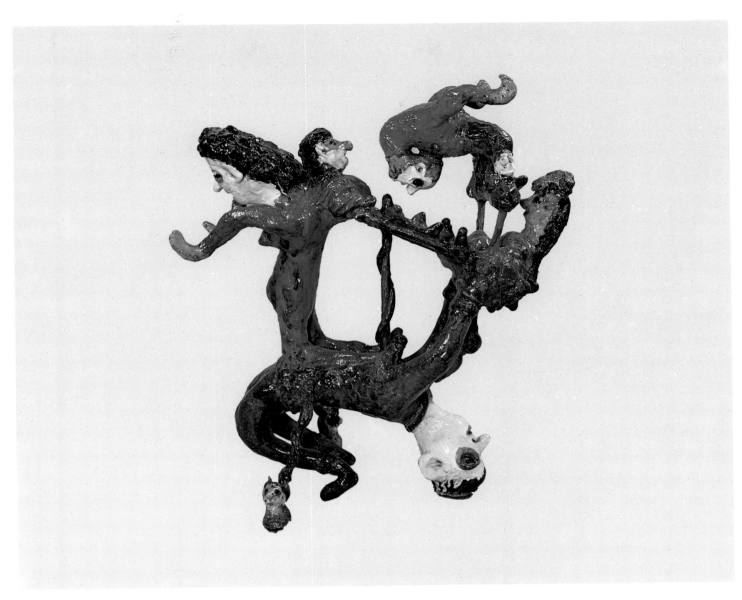

The Prisoner of Basel (Joseph G., 1877-1934):
Dance of Life, Group of Five Figures, between 1928 and 1934. Molded from bread-crumb, then painted and varnished.

work. It is only natural for cultural art, which owes so much to outside influences, to have its heyday early in the career of the individual concerned, youth being the most receptive time of life. In the same way, it is only natural for Art Brut to emerge at an age when the individual is closed to those influences. Dubuffet has made the same point in discussing the work of Heinrich Anton Müller: "It looks as if art creation is, with certain exceptions, a late fruit, one that begins to grow when the slant of a man's mind is reversed, at the time of life when he changes from a receiving station to a sending station, when he ceases

to expect wonders to be delivered to him and takes it upon him to make them himself; or, to put it better, at the time of life when all that is presented to him strikes him as inadequate and so he sets to work on his own. It must be borne in mind that old age is nearly always attended by *alienation* or anyhow by something very like alienation" [1].

To this may be added social factors peculiar to the status of old people in our modern society. As a group, old people have made a relatively recent appearance. In previous centuries, and especially in non-Western societies, they ensured

159

the transmission of cultural models and the community benefited from their knowledge and experience. Not only were they well integrated, they themselves acted as a vital instrument of social integration; as such, they were the very opposite of a separate group. Now all this has changed. By a paradox peculiar to our modern world, society does its utmost to prolong the life of old people at the very time when it no longer has any use for them. Unfitted for production, poor consumers and unamenable to the expansionist ideology, they have become a nuisance. So we get rid of them as best we can, by way of the old people's home, institutional charity, moral desertion, or desertion *tout court*. Whether relegated to a home or not, they have become an object of social exclusion whose status more and more resembles that of the mentally ill. Just the right climate for autistic art, as Dubuffet might say! Thus society relaxes its cultural hold over those from whom it cannot expect to draw much profit. The majority of old people react to this indifference with some bitterness. But a few of them find that it suits their book, and they turn to the congenial task of making things which it would have been impossible for them to make in a climate of solicitude and integration.

This, I think, accounts for the fact that a large proportion of Art Brut originates in those ghettos of modern society, on the outskirts of our cities: psychiatric institutions, old people's homes and, to a lesser degree (for reasons already noted), prisons. One case among many others is that of the man known as the Prisoner of Basel: it shows the extent to which humble birth, lack of culture, imprisonment, old age and revulsion against the values of social success favor the emergence of spontaneous creations conforming to no pattern.

Joseph G. was born in 1877 in a village near Parma, in northern Italy [1]. His mother, already a widow at his birth, worked in a spinning mill. He never learned to read or write. At the age of ten he entered the service of a local peasant proprietor and became a farmhand. Later he left Italy for France and Germany, and after working as a common laborer became a bricklayer. At the age of thirty he settled with his wife and children in Basel, where he worked hard at his trade and

was gradually integrated into the local population, obtaining Swiss citizenship in 1921 as a burgher of Basel. He even succeeded in setting up a business of his own as a building contractor, his sons taking charge of the books, for he had remained illiterate. In 1927, at the age of fifty, in a fit of jealousy he shot and killed a married woman in Basel with whom he had been carrying on an affair, and tried to kill himself. He was sentenced to six years in prison and served his term. A few months after his release in 1934 he died of coronary sclerosis.

During his imprisonment he was subject to frequent hallucinations, in which he saw the woman he had loved and killed. He was sorry for his wife and expressed contrition for the trouble he had caused her. Apart from the manual labor imposed on the prisoners, he spent his time, his enforced leisure, making the works that concern us here, for unlike his fellow inmates he could not occupy himself reading the newspapers. At first he shaped his statuettes in bread, from the crumb of the loaf, painting and varnishing them when it had dried and hardened. Then he used unbaked clay, which his family brought to the prison for him in bags, and which an understanding jailer doled out to him according to his requirements. He made stands for them, together with any wooden parts, in the prison carpentry shop. He would also dip the statuettes in glue before varnishing and painting them. He could never be prevailed on to give any explanation of the subjects he modelled.

They appear to stand for some kind of carnival, at times a sanguinary carnival, which may perhaps be interpreted as an allegory or parody of life and its social roles. One of the groups represents a collective punishment with a band playing. Another represents a round dance of burlesque figures, together with acrobats and musicians, and also including an observer gazing at them through a spy-glass. Then there is a curious figure striking a pose on a rostrum, surrounded by men and women who are turning their backs to him. There is a gory head of a decapitated man, which might conceivably be meant as a self-portrait. The prevailing mood is one of tragic mockery and caricatural exaltation, a kind of jubilant pessimism in praise of mad-

ness. It is as if Joseph G., having gone as far along the road of social success as his status as an illiterate immigrant would fairly allow, had suddenly disconnected his energies from the social machine and applied them to a dumb show and parody of it, into which he put all the lucidity, openness and intensity of mind of those who have nothing to gain by it and nothing more to lose.

There remains the question of women's contribution to Art Brut, and a surprising contribution it is in view of their sterility in the field of cultural art. It may be explained, I think, in the same way, as the creative return of the socially repressed. For culture does not exert its asphyxiating power uniformly: it redoubles the force of ideological compulsions. It regulates the mechanisms of belonging and exclusion along social lines of demarcation, proceeding by the *intimidation* of oppressed groups. Stendhal observed over a hundred years ago that "every genius born a woman is lost to mankind." One accordingly finds that women get their own back in *forbidden* spheres which lie outside the cultural domain. They are gifted for Art Brut, just as they are for magic, clairvoyance, mediumism and, more generally, for the exercise of all those irrational powers which a male-dominated society runs down and medicalizes under the sarcastic term of "hysteria"—a term whose etymology makes clear its ideological connotation ("hysteria" comes from "uterus").

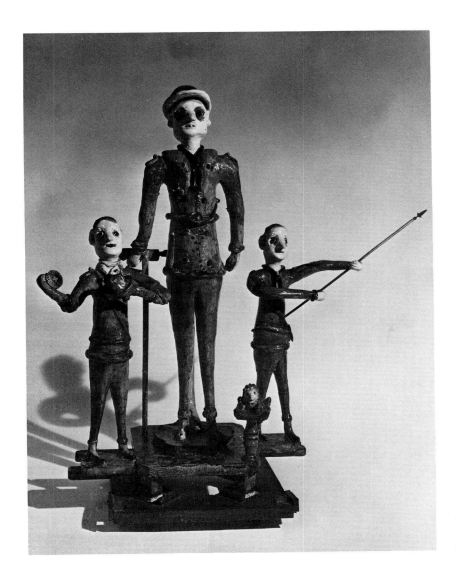

The Prisoner of Basel (Joseph G., 1877-1934):
The Autocrat, Group of Four Figures,
between 1928 and 1934. Unidentified material.

161

Laure Pigeon

Laure Pigeon, according to Dubuffet, who knew her, was considered a very good woman, cheerful, sensible and balanced, but devoid of any aptitude for art, quite unlike her sister-in-law Lily, who was very "artistic" and whose drawings were much admired [6]. The only particular point about Laure was her belief in spiritualism, which she practised alone, without joining any group. Born in Brittany in 1882, she had been brought up by a grandmother who is said to have been strict. At the age of twenty-nine she married a dentist who proved to be unsteady in his profession and in his affections; he pursued other women and the marriage broke up. Laure moved into a boarding house where she made the acquaintance of a young woman named Marthon, who initiated her into spiritualism. Her husband

Laure Pigeon (1882-1965): Unbroken Network of Lines, 23-24 March 1936. Blue ink on drawing paper.

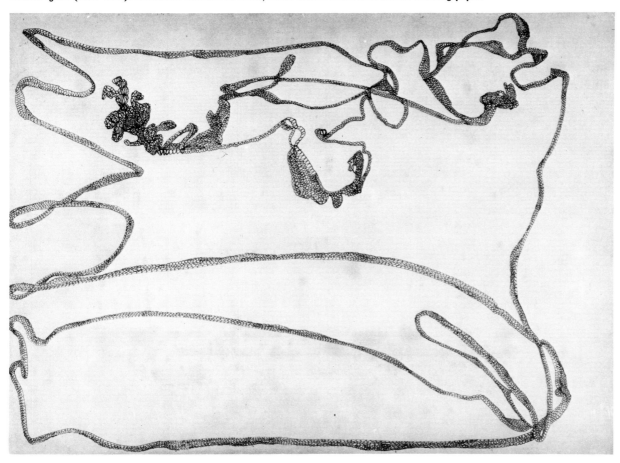

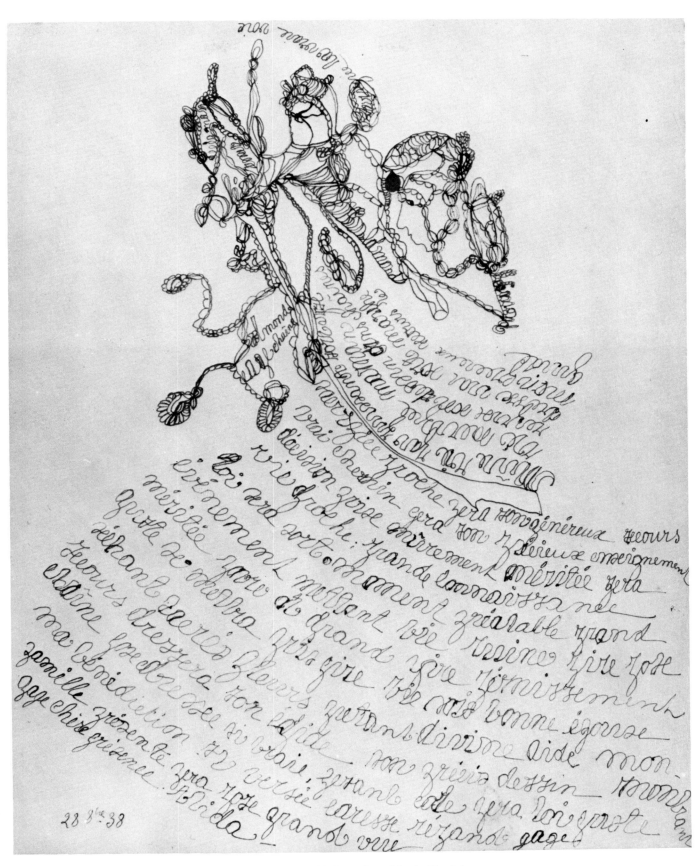

Laure Pigeon (1882-1965): Horseman and Message, 28 October 1938. Page of a notebook. Blue ink.

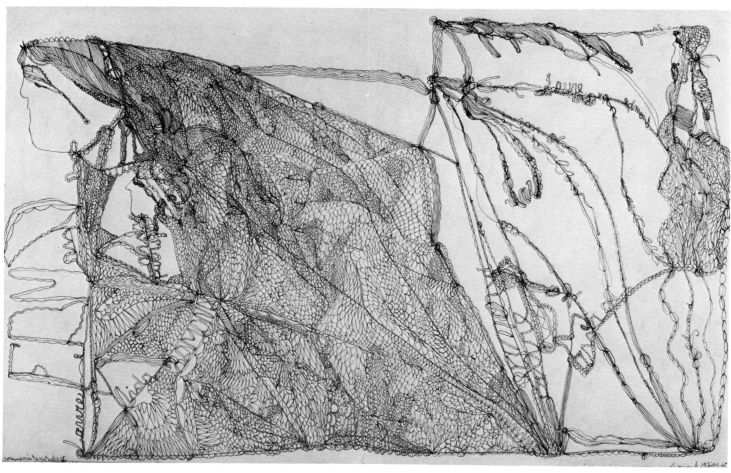

Laure Pigeon (1882-1965): Two Female Profiles with Standing Woman and Inscriptions, 14-23 July 1946. Blue ink.

died in 1953, after a renewed attempt to live together which turned out to be as unsuccessful as before. Laure then lived alone in a charmingly furnished apartment at Nogent-sur-Marne, in the Paris suburbs, until her death in 1965 at the age of eighty-three.

During the last thirty years of her life she had spent most of her time making drawings, to which she attached a value as mediumistic revelation but not as art. She showed them to no one, except her sister-in-law Lily, who took no interest in spiritualism and considered this passion for drawing as a harmless mania. After Laure's death five hundred drawings were found in her apartment, carefully ordered and dated. They fall into two groups. The earlier ones, dating from 1935 to 1953, were done with a pen in blue ink on the pages of a drawing album. They consist of sinuous lines, interweaving at times like ribbons;

proliferating over the whole sheet, they fall now into singular volutes, now into more or less taut networks, now into inextricable tangles. After a time scraps of writing began to emerge from the doodling. Illegible at first, they seem to be a chance product of the linear convolutions. In any case they are caught up in the pattern of the drawing and follow its unpredictable meanders. (This is one of the most striking examples of that continuity between drawing and writing which—see page 104—I have noted as a characteristic feature of untutored creation.) Wavering shapes, stray profiles and looming figures also begin to start up from the sheet, but no sooner are they announced than they merge again into the welter of pen-drawn lines.

The mediumistic character of these drawings comes over at once. To lend her hand as a channel of communication with spirits of the other

world meant, for her, to let her hand run free and roam as it pleased, in a dream of its own, answering to no figurative requirements. Laure seems to have surrendered pliantly, indeed blindly, to a travelling line that leads her nowhere, certainly to no actual representation or achieved form; a line that not only declines to delineate or define silhouettes, but on the contrary splits up surfaces, disunites wholes, scatters forms; a line fundamentally unreflecting and unpredictable, wandering over the sheet and ignoring the shapes which here and there loom up and beg for attention; a line which for that reason responds to the subtlest vibrations of the mind and weaves a mental pattern free of representational interference.

But perhaps she felt that line to be too categorical, too limiting, too definitive. In 1953, when she was seventy-one, Laure renewed her graphic manner. This later group of drawings was done

Laure Pigeon (1882-1965): Two Chairs, 15 December 1961. Blue ink on drawing paper.

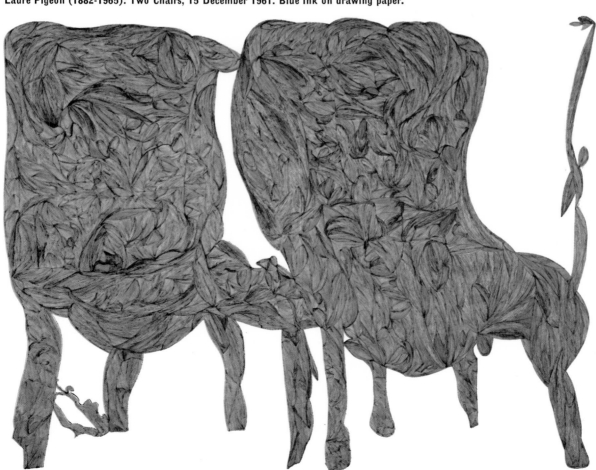

on high quality paper known in France as Ingres paper. Keeping to royal blue ink and a fine-tipped fountain pen, she proceeds now to build up delicate, closely woven textures, through which the white of the underlying sheet shows through to subtle effect. So without actually changing her technique, Laure moved from linear expression to a broader surface treatment, better suited, in her eyes, to the purposes of clairvoyance. In other words, she neutralized the sharpness of her line by clustering lines together, weaving them like braids over the surface instead of cutting it with single lines. The networks are differentiated only by the directional unity of the hatchings; they set each other off, overlap and merge; they modulate space, conjuring up potential shapes and apparitions. Thus the intensification of the line serves paradoxically to abolish limits and increase the generality and ambiguity of forms, which seem to rise up of their own accord, wrought out from within, yet always on the verge of melting away in a fresh outflow of expanding surfaces.

Final Hypotheses

At the end of this survey, it may be of interest to reconsider the question which I raised at the beginning: can Art Brut be said to have a history? After all, from Ferdinand Cheval, who began his Ideal Palace in 1879, to the contemporary creators, the works preserved span nearly a century. Yet it would be a discerning reader indeed who, coming fresh to the works reproduced here, could set them in anything like their true chronological order. Is there, for example, any stylistic reason for dating Wölfli's early work to around 1900 and Ratier's contrivances to the 1960s, rather than the reverse? Ignorant indeed, in contrast, would be the man who could not put in chronological order a painting by Manet, another by Matisse and a third by Robert Rauschenberg!

Is one to infer that Art Brut stands outside history? Actually this is begging the question, for the "history of art" in the usual sense of the term is itself a product of culture. Art history is based on a convention which consists in projecting a line of continuity into the disorder of events, in determining trends and lines of descent, in singling out among the followers those who are precursors and those who are "inspired" leaders. Such history, as framed and shaped by art historians, can never be anything but a renewal of the ideology of the subject, continually extended to include an emerging multiplicity of individuals and works in their due time sequence. And if cultural art seems to be more subject to it than Art Brut, this is because cultural artists deliberately comply with it, out of a desire for integration: their work is designed to abide by certain norms of continuity, so that there is no secret about the underlying assumption, or fiction, of an historical framework into which it duly fits. Even those artists who make a real break with tradition or context go on thereafter, as a matter of course, to compare their contribution with others, to define their position in relation to their predecessors, to seek out an ancestry for themselves or to pinpoint their break with the past—which comes to the same thing. The boldest innovations have the paradoxical effect of endorsing the forms they transgress by setting them up as a

standard. As for historical affiliation, there is no escaping it; the most that can be done is to shift it, for in most cases the transgression of the forms of one period is reinforced by a positive link-up with those of an earlier period taken as a prefiguration (thus Hyper-Realism repudiates cubist and abstract formalism, but rehabilitates the official art of the Second Empire; Conceptual Art rejects pictorial experiments, but reverts to Duchamp's initial inquiries; and so it goes). In this respect, the history of art since the end of the nineteenth century represents no break at all with the academic ideal: for a *simple past*, defined once and for all by the Greeks, it has merely substituted a *complicated past* continually remolded to suit the options of the latest avant-garde.

So while it is true that art history, as chronological continuity, is a cultural fiction *made up* by the historians, one cannot help seeing the extent to which it is at once *unmade* or *remade* by the artists themselves, who give it a kind of retroactive basis. They run a full stroke over the dotted lines of the historian; even better, they forestall history by carrying their own ancestry back to a famous predecessor and thus explicitly marking the starting point of a subsequent movement. They seem intent on integrating themselves into a line of cultural descent. It is as if an ideological reflex led them to lay stress on the law of inheritance at the precise point where they felt it to be most threatened: in their own work.

Makers of Art Brut are different. They are not concerned with abiding by a law or breaking it; they are indifferent to questions of continuity or broken continuity. There is no organic connection between them, nor interaction of any kind. Had Aloïse or Wölfli never existed, or had other works been discovered, that would have made no difference to any other creator. Their trajectories diverge or crisscross but never meet, each going its way with sovereign indifference, like rockets in a display of fireworks. Art Brut does not serve to define anything: it is the name given to what cannot be bound by a definition. It is an upsurge of singularities and intensities of unknown origin. So that one is tempted to see in it the beginnings of a liberation. Who knows, on the ruins of culture possibly a new creation of art

Madge Gill (1882-1961):
Embroidered Dress.
Mercerized cotton thread
and colored wools.

will arise, an offspring of the common people, yet an orphan and outsider, following no established circuit and serving no social purpose, fundamentally anarchistic, intense and fleeting, unfettered by any idea of personal genius, prestige, specialization, belonging or exclusion, knowing nothing of any gap between production and consumption. It would mean the overthrow of all values and the advent of the "common man," a man conforming to no pattern, radically disrespectful and therefore creative, realizing the utopia outlined in Dubuffet's "Prospectus to Amateurs of Any Kind": "There are no more great men and no more geniuses. And so we get rid of these evil-eyed dummies: they were an invention of the Greeks, like centaurs and hippogriffs. We don't need geniuses any more than we do unicorns. We have been so much afraid of them for three thousand years!" [11] The notion of art would be inconceivably extended under the impact of the chain of explosions set off by Art Brut in the limbo of encultured society.

Or, if things work out the other way (as to my regret they probably will), the "mass communications media," as they are called by a staggering contradiction in terms, will prevail and complete the process of normalizing men's minds. At that point Art Brut will be no more than a vestige of the past, the last token of a vanished faculty of invention. As such, it will belong wholly and finally to the museum. As a matter of fact, it has already slipped into it by the back door, since works by Guillaume Pujolle and Otto Stein are to be found reproduced in André Malraux's *The Voices of Silence* (1953). One is sorry to see, though, that Malraux did not even condescend to keep to the common medical convention of giving the first name or initials, and in both cases used the anonymous and ignominious designation of "lunatic drawing." Perhaps in some further installment of his "Museum Without Walls" he will show a more liberal attitude and give back their names to these creators. Provided, of course, that their genealogy can be elucidated. For this, he will only need to call in a real art historian, who will manage to fit them into the pattern of artistic affiliations and influences. He will have no trouble showing that Wölfli took inspiration from the painted panels of peasant cupboards, that Doudin must have been familiar with the folk art of Appenzell, that Lesage took his motifs from traditional embroideries, etc. In short, he will say anything that may help to smother the scandal of *raw creation*. (Only recently it was announced that "the truth had leaked out" and that the postman Cheval had actually built his palace to the designs of a professional architect!) Or perhaps it will be thought unnecessary to call in the art historian and put him to work tracing influences. Art Brut having been set up on the pedestal of this volume, it may be considered that the cultural order of things has been re-established and the case has had its hearing. After all, as Montaigne said, every man is at liberty to understand nothing about anything.

Madge Gill (1882-1961): Architectural Fantasy, 27 October 1951. Black ink on Bristol board.

BIBLIOGRAPHY

Books on Art Brut

[1] *L'Art Brut*, fascicle 1, Publications de la Compagnie de l'Art Brut, Paris, 1964. Preface by Jean Dubuffet; *Palanc l'Ecrituriste, Les dessins médiumniques du facteur Lonné, Miguel Hernandez, Le lambris de Clément, Heinrich Anton Müller, Humbert Ribet*, by Jean Dubuffet; *Le Prisonnier de Bâle*, by Jean Dubuffet and Dr Louis Lambelet; *Benjamin Arneval*, by Dr Jean Oury.

[2] *L'Art Brut*, fascicle 2, Paris, 1964. *Adolf Wölfli*, by Dr Walter Morgenthaler, preface and French translation by Henri-Pol Bouché.

[3] *L'Art Brut*, fascicle 3, Paris, 1965. *Salingardes l'Aubergiste, Le Cabinet du Professeur Ladame: Robert Gie, Julie Bar, Jean Mar, Joseph Heu, Berthe U, Les Télégrammes de Charles Jaufret*, by Jean Dubuffet; *Le Mineur Lesage*, by Jean Dubuffet and Dr Eugène Osty; *Jayet le Boucher*, by Dr Jean Oury and Claude Edelmann; *Les Coquilles de Maisonneuve*, by Michèle Edelmann; *Filaquier le Simplet*, by Gaston Puel.

[4] *L'Art Brut*, fascicle 4, Paris, 1965. *Paul End, Moindre l'Egyptologue, L'écrit du Comte du Bon Sauveur, Jacqueline*, by Jean Dubuffet; *Scottie Wilson*, by Jean Dubuffet, Victor Musgrave and Andrew De Maine; *Emmanuel le Calligraphe*, by Dr Pierre Maunoury; *Guillaume*, by Jean Dubuffet and Dr Jean Dequeker; *Florent*, by Dr Jean Benoiston.

[5] *L'Art Brut*, fascicle 5, Paris, 1965. *Le Philatéliste, Broderies d'Elisa, Joseph Crépin, Rose Aubert, Gaston le Zoologue*, by Jean Dubuffet; *Sylvain*, by Claude Edelmann; *Xavier Parguey*, by Michèle Edelmann.

[6] *L'Art Brut*, fascicle 6, Paris, 1966. *Carlo*, by Vittorio Andreoli, Cherubino Trabucchi and Arturo Pasa; *La double vie de Laure, Simone Marye, Anaïs, Robe nuptiale et tableaux brodés de Marguerite*, by Jean Dubuffet.

[7] *L'Art Brut*, fascicle 7, Paris, 1966. *Aloïse et son théâtre*, by Jacqueline Porret-Forel; *Haut Art d'Aloïse*, by Jean Dubuffet.

[8] *L'Art Brut*, fascicle 8, Paris, 1966. *Messages et clichés de Jeanne Tripier la planétaire, La fabrique d'Auguste, Gustav le démoniste, Pièces d'arbre historiées de Bogosav Zivkovic*, by Jean Dubuffet; *François*, by Dr Pierre Maunoury; *Olive*, by Claude Edelmann.

[9] *L'Art Brut*, fascicle 9, Paris, 1973. *Madge Gill*, by Roger Cardinal; *Nataska*, by Ludovic Massé; *Notes sur quelques dessins de Nataska, Il castello incantato de Filippo Bentivegna, Les manivelles d'Emile Ratier*, by A. Wolff; *Jeanne Ruffié*, by Michèle Edelmann; *Bentivegna*, by Gabriele Stocchi; Collection of Dr Auguste Marie: *Xavier Cotton, Emile Josome Hodinos, F. Kouw, Jules Léopold, L. Edouard, Auguste Merle, Albert Ravallet, Le Comte de Tromelin, Victor-François, Gaston Vil, Le Voyageur Français*, by Michèle Edelmann and A. Wolff, with excerpts from articles by Dr Auguste Marie.

[10] *L'Art Brut*, catalogue of the exhibition *Sélection des collections de la Compagnie de l'Art Brut*, Musée des Arts Décoratifs, Paris, 7 April-5 June 1967. Preface by Jean Dubuffet: *Place à l'incivisme*.

[11] DUBUFFET, Jean, *Prospectus et tous écrits suivants*, Gallimard, Paris, 1967, Vol. 1, pp. 173-457 and 488-538. This book reprints all the texts by Dubuffet published in the fascicles of *L'Art Brut*, N^{os} 1 to 8. It also includes other texts of his to which we refer: *Prospectus aux amateurs de tout genre* (pp. 29-100), *Les statues de silex de M. Juva* (pp. 178-183), *L'art brut préféré aux arts culturels* (pp. 198-201), *Honneur aux valeurs sauvages* (pp. 201-224), *Les Barbus Müller et autres pièces de la statuaire provinciale* (pp. 498-500), and *L'Art Brut* (pp. 513-516), preface to the Art Brut exhibition of 1959 at the Galerie Les Mages, Vence (Alpes-Maritimes), France.

[12] *Catalogue de la Collection de l'Art Brut*, Publications de la Compagnie de l'Art Brut, Paris, 1971.

[13] CARDINAL, Roger, *Outsider Art*, Praeger, New York, and Studio Vista, London, 1972.

Books consulted

[14] BADER, Dr Alfred, "Images de la folie, miroir de l'âme humaine," "La vie et l'œuvre d'Aloyse" and "La vie et l'œuvre de Jules," in *Insania pingens, Petits maîtres de la folie*, Clairefontaine, Lausanne, 1961. English translation, *Though this be madness*, Thames and Hudson, London, 1963.

[15] BARTHES, Roland, *L'empire des signes*, Les Sentiers de la Création, Skira, Geneva, 1970.

[16] BETTELHEIM, Bruno, *The Empty Fortress*, Free Press, New York, 1967.

[17] BIHALJI-MERIN, Otto, *Les maîtres de l'art naïf*, La Connaissance, Brussels, 1972, English translation, *Modern Primitives*, Thames and Hudson, London, and *Masters of Naïve Art*, McGraw-Hill, New York, 1971.

[18] *Bildnerei der Geisteskranken*, catalogue of an exhibition of the Prinzhorn Collection, Heidelberg, at the Galerie Rothe, Heidelberg, October-November 1967.

[19] BLASDEL, Gregg N., "The Grass-Roots Artist," in *Art in America*, New York, September-October 1968, pp. 24-41.

[20] BOURDIEU, Pierre, and DARBEL, Alain, *L'amour de l'art, les musées et leur public*, Editions de Minuit, Paris, 1966.

[21] CHAMPFLEURY (Jules Husson, known as), *Histoire de l'imagerie populaire*, Dentu, Paris, 1869, p. XI.

[22] COOPER, David, *Psychiatry and Anti-Psychiatry*, Tavistock Publications, London, and Barnes and Noble, New York, 1967.

[23] DELALANDE, Jean, *Victor Hugo, dessinateur génial et halluciné*, Nouvelles Editions Latines, Paris, n.d.

[24] DELEUZE, Gilles, and GUATTARI, Félix, *L'Anti-Oedipe*, Editions de Minuit, Paris, 1972.

[25] DEQUEKER, Jean, *Monographie d'un psychopathe dessinateur* [Guillaume Pujolle], *Etude de son style*, Thèse pour le doctorat en médecine No. 82, University of Toulouse, Faculté de Médecine, Toulouse, 1948 (Imprimeur Georges Subervie, 21 rue de l'Embergue, Rodez).

[26] DERRIDA, Jacques, *La voie et le phénomène*, Presses Universitaires de France, Paris, 1967.

[27] EHRENZWEIG, Anton, *The Hidden Order of Art*, University of California Press, Berkeley, 1971.

[28] EHRMANN, Gilles, *Les inspirés et leur demeure*, Editions du Temps, Paris, 1962.

[29] ENCAUSSE, Dr Philippe, *Sciences occultes et déséquilibre mental*, Payot, Paris, 1943.

[30] FOUCAULT, Michel, *Histoire de la folie à l'âge classique*, Paris, 1961. English translation, *Madness and Civilization*, Pantheon Books, New York, 1965, and Tavistock Publications, London, 1967.

[31] FOUCAULT, Michel, *Les mots et les choses*, Gallimard, Paris, 1966.

[32] FREUD, Sigmund, *Three Essays on the Theory of Sexuality*, Imago Publishing Co., London, 1949.

[33] FREUD, Sigmund, *Collected Papers*, III, Hogarth Press, London, 1925.

[34] FREUD, Sigmund, *Inhibitions, Symptoms and Anxiety*, Hogarth Press, London, 1936.

[35] GAUTIER, Théophile, preface to *Album de Gravures* after Victor Hugo, Paul Chenay, Paris, 1863.

[36] GOMBRICH, E.H., *Art and Illusion*, Phaidon, London, 1968.

[37] GOUX, Jean-Joseph, *Economie et Symbolique*, Editions du Seuil, Paris, 1973.

[38] GRIAULE, Marcel, *Arts de l'Afrique noire*, Paris, 1947.

[39] GROHMANN, Will, *Paul Klee*, Abrams, New York, and Thames and Hudson, London, 1954.

[40] HUGO Victor, *Albums spirites*, Bibliothèque Nationale (Carnet 13353) and Bibliothèque Lucien-Grau (manuscripts), Paris.

[41] HUGO, Victor, *Correspondance*, Vol. 1, p. 403, Imprimeries Nationales, Paris, n.d.

[42] IRIGARAY, Luce, "Le schizophrène et la question du signe," in *Recherches*, No. 16, Cerfi, Paris, September 1974.

[43] JANET, Pierre, *L'automatisme psychologique*, Alcan, Paris, 1913, pp. 376-418.

[44] JEAN, André, *Le Palais idéal du Facteur Cheval*, with *Autobiographie du Facteur Cheval et description du Palais idéal*, Imprimerie Nouvelle, Valence, 1937.

[45] JUNOD, Philippe, *Transparence et opacité*, Editions l'Age d'Homme, Lausanne, 1976.

[46] KLEE, Felix, *Paul Klee, Leben und Werk in Dokumenten*, Diogenes, Zurich, 1963.

[47] KLEE, Paul, *Das bildnerische Denken*, edited by Jürg Spiller, Benno Schwabe, Basel-Stuttgart, 1956. English translation, Paul Klee, *The Thinking Eye*, New York, 1961.

[48] KOFMAN, Sarah, *L'enfance de l'art*, Payot, Paris, 1970.

[49] KRIS, Ernst, *Psychoanalytic Explorations in Art*, International Universities Press, New York, 1952.

[50] LAING, R.D., *The Politics of Experience*, Tavistock Publications, London, and Pantheon Books, New York, 1967.

[51] LAING, R.D., *The Divided Self*, Tavistock Publications, London, and Quadrangle Books, New York, 1960.

[52] LAUDE, Jean, *La peinture française (1905-1914) et l'"Art nègre"*, 2 volumes, Klincksieck, Paris, 1970.

[53] LEROI-GOURHAN, André, *Le geste et la parole*, Vol. 1: *Technique et langage*, Albin Michel, Paris, 1964.

[54] LÉVI-STRAUSS, Claude, *Race et Histoire*, Médiations, Paris, 1961.

[55] LÉVI-STRAUSS, Claude, *La pensée sauvage*, Plon, Paris, 1962. English translation, *The Savage Mind*, Weidenfeld and Nicolson, London, and University of Chicago Press, 1966.

[56] LOREAU, Max, *Jean Dubuffet, délits, déportements, lieux de haut jeu*, Weber, Paris, 1971.

[57] MANNONI, Maud, *Le psychiatre, son "fou" et la psychanalyse*, Editions du Seuil, Paris, 1970.

[58] MICHAUX, Henri, "En pensant au phénomène de la peinture," in *Passages*, N.R.F., Paris, 1963.

[59] PICON, Gaëtan, *Victor Hugo dessinateur*, notes and captions by Roger Cornaille and Georges Herscher, La Guilde du Livre, Lausanne, 1963.

[60] PONGE, Francis, *Le parti pris des choses*, Gallimard, Paris, 1942.

[61] PONGE, Francis, *Proêmes*, Gallimard, Paris, 1948.

[62] PRINZHORN, Hans, *Bildnerei der Geisteskranken*, Springer, Berlin, 1923; reprinted 1968. English translation, *Artistry of the Mentally Ill*, Berlin and New York, 1971.

[63] RENNERT, Helmut, *Die Merkmale schizophrener Bildnerei*, G. Fischer, Jena, 1962.

[64] ROBERTS-JONES, Philippe, "Les 'incohérents' et leurs expositions," in *Gazette des Beaux-Arts*, 52, Paris, 1958, pp. 231-235.

[65] SILVY, Maurice, "Les Tours de Watts de Sam Rodillo à Los Angeles," in *Aujourd'hui, art et architecture*, No. 8, Paris, June 1956.

[66] SPITZ, René A., *De la naissance à la parole*, Presses Universitaires de France, Paris, 1968.

[67] STAROBINSKI, Jean, *Les mots sous les mots. Les anagrammes de Ferdinand de Saussure*, Gallimard, Paris, 1971.

[68] SZASZ, Thomas, *The Myth of Mental Illness*, Hoeber-Harper, New York, 1967.

[69] THÉVOZ, Michel, *Louis Soutter ou l'écriture du désir*, Editions l'Age d'Homme, Lausanne, 1974.

[70] TOEPFFER, Rodolphe, *Essais de Physiognomonie*, in *Caricatures*, Geneva, 1845, reprinted by Editions d'Art Albert Skira, Geneva, 1945.

[71] TOEPFFER, Rodolphe, *Réflexions et menus propos d'un peintre genevois*, Hachette, Paris, 1865.

[72] TOEPFFER, Rodolphe, *Mélanges sur les beaux-arts*, Editions Pierre Cailler, Geneva, 1953.

[73] VERILLON, Maurice, "Le Palais idéal du facteur Cheval," in *Gazette des Beaux-Arts*, Paris, September 1970, pp. 159-184.

[74] WIDLÖCHER, Daniel, *L'interprétation des dessins d'enfants*, Dessart, Brussels, 1965.

LIST OF ILLUSTRATIONS

Unless otherwise indicated, all the works reproduced are in the Collection de l'Art Brut, Lausanne, Switzerland. The mention CAB followed by a number refers to the *Catalogue de l'Art Brut*, Publications de la Compagnie de l'Art Brut, Paris, 1971.

INDEX OF NAMES AND PLACES